FUNNY WEATHER

Olivia Laing is the author of three acclaimed works of non-fiction, *To the River* (2011), *The Trip to Echo Spring* (2013) and *The Lonely City* (2016), which has been translated into seventeen languages and sold over 100,000 copies worldwide. Her first novel, *Crudo*, was a *Sunday Times* top ten bestseller and won the 2019 James Tait Memorial Prize. She's a Fellow of the Royal Society of Literature and in 2018 was awarded a Windham-Campbell Prize for non-fiction.

Laing writes on art and culture for many publications, including the *Guardian*, *New York Times* and *frieze*. *Everybody: A Book About Freedom* was published in 2021. She lives in Suffolk.

Also by Olivia Laing

To the River

The Trip to Echo Spring

The Lonely City

Crudo

Olivia Laing

Funny
Weather

ART IN AN EMERGENCY

PICADOR

First published 2020 by Picador

This paperback edition first published 2021 by Picador
an imprint of Pan Macmillan
The Smithson, 6 Briset Street, London EC1M 5NR
EU representative: Macmillan Publishers Ireland Ltd, 1st Floor,
The Liffey Trust Centre, 117-126 Sheriff Street Upper,
Dublin 1, DO1 YC43
Associated companies throughout the world
www.panmacmillan.com

ISBN 978-1-5290-2765-5

5 7 9 8 6

A CIP catalogue record for this book is available from the British Library.

Typeset by Palimpsest Book Production Ltd, Falkirk, Stirlingshire
Printed and bound by CPI Group (UK) Ltd, Croydon, CR0 4YY

Visit **www.picador.com** to read more about all our books
and to buy them. You will also find features, author interviews and
news of any author events, and you can sign up for e-newsletters
so that you're always first to hear about our new releases.

For Ian, Sarah & Chantal, with love

And in memory of Derek Jarman & Keith Collins

'No less acute than a paranoid position, no less realistic, no less attached to a project of survival, and neither less nor more delusional or fantasmatic, the reparative reading position undertakes a different range of affects, ambitions, and risks. What we can best learn from such practices are, perhaps, the many ways selves and communities succeed in extracting sustenance from the objects of a culture – even of a culture whose avowed desire has often been not to sustain them.'

Touching Feeling, Eve Kosofsky Sedgwick

'Oh Dick, deep down I feel that you're utopian too.'

I Love Dick, Chris Kraus

Contents

READING

LOVE LETTERS

TALK

You Look at the Sun

February 2019

IN NOVEMBER 2015, Jennifer Higgie at *frieze* asked if I'd write a regular column for the magazine. I chose 'Funny Weather' as the title because I was imagining weather reports sent from the road, my primary address at the time, and because I had a feeling that the political weather, already erratic, was only going to get weirder – though I by no means predicted the particular storms ahead. The first column was about the refugee crisis. Over the next four years I wrote about many of the rapid and alarming changes that followed on its heels, from Brexit to Trump to Charlottesville, taking in the Grenfell Tower fire, racist killings by the American police, and changes in the law on sex and abortion on both sides of the Atlantic.

Frankly, the news was making me crazy. It was happening at such a rate that thinking, the act of making sense, felt permanently balked. Every crisis, every catastrophe, every threat of nuclear war was instantly overridden by the next. There was no possibility of passing through coherent stages of emotion, let alone thinking about responses or alternatives. It seemed as if people were stuck in a spin cycle of terrified paranoia.

What I wanted most, apart from a different timeline, was a different kind of time frame, in which it might be possible both to feel and to think, to process the intense emotional impact of the news and to consider how to react, perhaps even to imagine other ways of being. The stopped time of a painting, say, or the drawn-out minutes and compressed years of a novel, in which it is possible to see patterns and consequences that are otherwise invisible. The columns I was writing used art – from Poussin and Turner to Ana Mendieta, Wolfgang Tillmans and Philip Guston – as a way of making sense of the political situation, of wringing meaning out of what were becoming increasingly troubled times.

Can art do anything, especially during periods of crisis? In 1967, George Steiner wrote a famous essay in which he observed that a concentration-camp commander could read Goethe and Rilke in the evening and still carry out his duties at Auschwitz in the morning, regarding this as evidence that art had failed in its highest function, to humanise. But this makes art sound like a magic bullet, which should reorganise our critical and moral faculties without effort, while simultaneously obliterating free will. Empathy is not something that happens to us when we read Dickens. It's work. What art does is provide material with which to think: new registers, new spaces. After that, friend, it's up to you.

I don't think art has a duty to be beautiful or uplifting, and some of the work I'm most drawn to refuses to traffic in either of those qualities. What I care about more, and what forms the uniting interest in nearly all the essays and criticism gathered here, are the ways in which it's concerned with resistance and

repair. In this, I'm emphatically informed by an essay the late critic and queer-studies pioneer Eve Kosofsky Sedgwick wrote in the early 1990s. Like many people, I've been puzzling over 'Paranoid Reading and Reparative Reading, or, You're So Paranoid, You Probably Think This Essay Is About You' for years, ever since my friend James first told me about it on a scorching day in the West Village (a piece doing some of that puzzling appears later in this collection).

Though it's written predominantly for an academic audience, 'Paranoid Reading' is about something that affects us all, which is how we make sense of the world, how we approach knowledge and uncertainty, as we are constantly doing in the course of our daily lives, and particularly at times of rapid political or cultural change. Sedgwick begins by describing the paranoid approach, so common and widely practised that we sometimes forget there are alternatives to it. A paranoid reader is concerned with gathering information, tracing links and making the hidden visible. They anticipate and are perennially defended against disaster, catastrophe, disappointment. They are always on the lookout for danger, about which they can never, ever know enough.

Anyone who's spent time on the internet in the past few years will recognise how it feels to be caught up in paranoid reading. During my years on Twitter, I became addicted to the ongoing certainty that the next click, the next link would bring clarity. I believed that if I read every last conspiracy theory and threaded tweet, the reward would be illumination. I would finally be able to understand not only what was happening but what it meant and what consequences it would have. But a

definitive conclusion never came. I'd taken up residence in a hothouse for paranoia, a factory manufacturing speculation and mistrust.

This, Sedgwick explains, is the problem with paranoia as an approach. Though paranoid readings can be enlightening and grimly revelatory, they also have a tendency to loop towards dead ends, tautology, recursion, to provide comprehensive evidence for hopelessness and dread, to prove what we already feared we knew. While helpful at explaining the state we're in, they're not so useful at envisaging ways out, and the end result of indulging them is often a fatal numbness.

At the very end of the essay she briefly, tantalisingly floats the possibility of an altogether different kind of approach, that isn't so much concerned with avoiding danger as with creativity and survival. A useful analogy for what she calls 'reparative reading' is to be fundamentally more invested in finding nourishment than identifying poison. This doesn't mean being naive or undeceived, unaware of crisis or undamaged by oppression. What it does mean is being driven to find or invent something new and sustaining out of inimical environments.

She suggests several artists whose work she considers reparative, among them Joseph Cornell, John Waters and Jack Smith. To this list I would add nearly all of the artists dealt with in these pages, many of whom came from emotionally or literally impoverished backgrounds, who lived in societies that starved them of sustenance and that frequently legislated against or otherwise attempted to curtail and punish their erotic and intellectual lives. All these artists nevertheless made work that bubbles with generosity, amusement, innovation and creative rage.

'It is not only important but *possible* to find ways of attending to such motives and positionalities,' Sedgwick concludes, in a sort of rallying cry for reparative criticism.

> Hope, often a fracturing, even a traumatic thing to experience, is among the energies by which the reparatively positioned reader tries to organize the fragments and part-objects she encounters or creates. Because the reader has room to realize that the future may be different from the present, it is also possible for her to entertain such profoundly painful, profoundly relieving, ethically crucial possibilities as that the past, in turn, could have happened differently from the way it actually did.

Hope doesn't mean being blind to the state things are in, or uninterested in how they got that way. Sedgwick was writing at the epicentre of the Aids crisis, at a time when many of her closest friends and colleagues were dying difficult and painful deaths, and she herself was undergoing treatment for breast cancer. Her hope was hard-won, and in part derived from the powerful role art played during the plague years.

A lot of the material dealt with in these essays is distressing, and I can't blame Trump for all of it. Loneliness, alcoholism, unsatisfactory bodies, harmful gender relations, alarming technology: the usual cheery subject matter. But this isn't a depressing book, and while I have written plenty of negative criticism over the years, that's not the predominant tone here either. *Funny Weather* is populated by artists who move and excite me, who look with sharp eyes at the societies they

inhabit but who also propose new ways of seeing. My primary interest, especially in the Artists' Lives section that forms the first part of this book, has been to understand the context and motivation for what they do – how they came to be artists, what drove them, how they worked, why they made what they did, and how it can expand our own sense of the world. Some of these people are touchstones, with practices so rich, so full of insights and provocations that I am forever drawn back to them. Virginia Woolf, Derek Jarman, Frank O'Hara, David Wojnarowicz, Kathy Acker, Chantal Joffe, Ali Smith: these are the artists who have taught me what it means to be an artist, because of their engagement and generosity, their – to borrow a word from John Berger – hospitality.

What I mean by hospitality is a capacity to enlarge and open, a corrective to the overwhelming political imperative, in ascendance once again this decade, to wall off, separate and reject (the miserable human consequences of which are explored in microcosm in 'The Abandoned Person's Tale', a portrait of a refugee trapped in Britain's indefinite detention system). Much of the work I've focused on was made in the second half of the twentieth century, but I'm not looking backward with nostalgia. I'm going as a scout, hunting for resources and ideas that might be liberating or sustaining now, and in the future. What drives all these essays is a long-standing interest in how a person can be free, and especially in how to find a freedom that is shareable, and not dependent upon the oppression or exclusion of other people.

Gathering together the work of nearly a decade exposes long-term preoccupations, as well as the way ideas morph and

migrate. Many of the artists who have meant the most to me died of Aids; gauging the scale of that loss would be a lifetime's work. I write more than once about the events of 16 June 2016, when a British MP was murdered and a troubling photograph of Nigel Farage began to circulate on the internet. A small sculpture by Rachel Kneebone crops up twice, as does a talismanic encounter with John Berger. An essay on Philip Guston and the Ku Klux Klan contains a paragraph that became central to my novel *Crudo*, while Ana Mendieta and Agnes Martin have become key figures in *Everybody*, the book that will follow this one.

The earliest piece here, and also the most personal, is not concerned with art at all. It looks back to a period in the 1990s when I lived feral in the Sussex countryside. Before I became a writer I had a strange, roving life, dropping out of university to become involved in the environmental direct-action movement, and then training and practising as a medical herbalist. In 2007 I took a swerve into journalism, and was rapidly and miraculously hired as deputy literary editor of the *Observer*. So I cut my teeth first on activism, then on bodies, and only latterly on writing.

In 2009, in the wake of the financial crash, I lost my beloved newspaper job, and two years later I moved to New York, edging at the same time away from literary journalism and towards visual art. It was so exciting to not be writing about writing, to turn instead to works that existed outside of language. The American avant garde was a revelation too, especially the New York School poets, with their loping, capacious, wholly un-English approach to criticism. Art wasn't rarefied or

separate; it was as immediate as sex and friendship, a way of orientating yourself in the world. Its impact and meaning needed rigorous thought, absolutely, but it could be done using ordinary, even casual language.

Frank O'Hara was forever filling his poems with names, and I'm struck, reading back through these essays, by how many deaths they record. John Berger, David Bowie, John Ashbery. PJ, Alastair, HB. Death, the bottom line, the thing no amount of paranoid defences can prevent. While I've been writing this introduction, Jonas Mekas and Diana Athill have also died. Both times I knew because I saw a photograph of them on Instagram. The Mekas image had a caption, drawn from 2007's *To New York with Love*. YOU LOOK AT THE SUN. THEN YOU RETURN HOME AND YOU CAN'T WORK, YOU'RE IMPREGNATE WITH ALL THAT LIGHT.

We're so often told that art can't really change anything. But I think it can. It shapes our ethical landscapes; it opens us to the interior lives of others. It is a training ground for possibility. It makes plain inequalities, and it offers other ways of living. Don't you want it, to be impregnate with all that light? And what will happen if you are?

ARTISTS' LIVES

A Spell to Repel Ghosts

JEAN-MICHEL BASQUIAT

August 2017

IN THE SPRING OF 1982, a rumour started swilling around New York. The gallerist Annina Nosei had some kind of boy genius locked in her basement, a black kid, twenty-one, wild and inscrutable as Kaspar Hauser, making masterpieces out of nowhere to the accompaniment of Ravel's 'Boléro'. 'Oh Christ,' Jean-Michel Basquiat said when he heard. 'If I was white, they would just call it an artist-in-residence.'

These were the kind of rumours he had to work against, but the wild, untutored kid was also a deliberate myth Basquiat constructed about himself, part canny bid for stardom, part protective veil, and as much a way of satirising prejudice as the African chieftain outfits he'd later wear to the parties of wealthy white collectors. His paintings started coming right at the moment that the East Village was shifting from a burnt-out wasteland inhabited by heroin addicts to the epicentre of an art boom. There was a monetisable glamour to being a down-and-out prodigy just then, and he made up out of the whole cloth of his childhood experience all kinds of patchworked, piece-meal selves, playing off people's expectations of what a grubby,

dreadlocked, half-Haitian, half-Puerto-Rican young man might be capable of.

He was a street kid, true, a teen runaway who'd slept on benches in Tompkins Square Park, but he was also a handsome, privileged boy from a Park Slope brownstone who'd gone to private school, followed by a stint at City-As-School, a destination for gifted children. Though he didn't have a formal art education, he and his mother Matilde had been frequenting museums since he was a toddler. As his girlfriend Suzanne Mallouk recalled of a trip to the Museum of Modern Art, 'Jean knew every inch of that museum, every painting, every room. I was astonished at his knowledge and intelligence and at how twisted and unexpected his observations could be.'

When Basquiat was seven, a car hit him while he was playing basketball in the street in Flatbush. He spent a month in hospital with a broken arm and internal injuries so severe his spleen had to be removed. The gift his mother gave him then, a copy of *Gray's Anatomy*, became his foundational text and talisman. He loved discovering the orderly interior architecture of the body, but he also loved the way a living thing could be reduced to the clean lines of its component parts; scapula, clavicle, three views of the shoulder joint. Later he would be similarly drawn to collections on cave art, hieroglyphs and hobo signs, the universe resolved into elegant pictorial symbols that encoded complex meanings.

1968 was a year of ruptures. Around the time he got out of hospital his parents separated and his father got custody. Disintegration and rearrangement: these are the bad feelings that lurk at the back of all those endless diagrams he made,

obsessively recounting and relating the disparate things of the world, though whether he was trying to uphold order or testifying to its impossibility is not always easy to ascertain.

As a boy Jean-Michel made cartoon versions of Hitchcock films, but in the blackout year of 1977 he graduated to making his mark on the skin of New York itself. He came to prominence first not as a painter, but as a graffiti artist, part of the duo SAMO, short for same old shit, who bombed the walls and fences of downtown with enigmatic phrases. A bebop insurgent, he travelled the nocturnal city with a spray-can in his overcoat pocket, attacking in particular the high-art zone of Soho and the Lower East Side. ORIGIN OF COTTON, he wrote outside a factory, in his distinctively loose-jointed capitals, no spines on the Es, SAMO AS AN ALTERNATIVE TO PLASTIC FOOD STANDS. The statements were so poised in their assault on art-world inanities that many observers believed they were by a disaffected conceptual artist, someone already famous. SAMO FOR THE SO-CALLED AVANT GARDE. SAMO AS AN END TO THE POLICE.

There is a graphomanic quality to almost all of Basquiat's work. He liked to scribble, to amend, to footnote, to second-guess and to correct himself. Words jumped out at him, from the back of cereal boxes or subway ads, and he stayed alert to their subversive properties, their double and hidden meanings. His notebooks, recently published in a facsimile by Princeton University Press, are full of stray phrases, odd or sinister combinations, like CROCODILE AS PIRATE or DO NOT DRINK / STRICTLY FOR / SUGARCANE. When he began painting, working up to it by way of hand-coloured

collaged postcards, it was objects he went for first, drawing and writing on refrigerators, clothes, cabinets and doors, regardless of whether they belonged to him or not.

The summer of 1980 through to the spring of 1981 was a boom year, never mind that he was mostly penniless, picking up girls at clubs so that he had somewhere to spend the night. He showed his work for the first time in the scene-defining *Times Square Show*, which also featured Kenny Scharf, Jenny Holzer and Kiki Smith. He had the starring role in the legendary lost film *New York Beat*, which was about the post-punk Manhattan scene (it became mired in financial problems and wasn't released until 2000, as *Downtown 81*). And in February 1981 he was included in *New York/New Wave* at PS1, the show that flipped him from hungry outsider to hot property.

Basquiat was homeless during filming, and so broke that he was thrilled when his co-star Debbie Harry gave him $100 for one of his first paintings – less than a millionth of the price reached by his work in 2017. It's salutary to look at *Cadillac Moon* now, with its Twomblyish neutrals, its scumbled regions of accomplished and obscuring white and grey, behind which are visible ranks of capital As, spelling out a lexical scream, alongside cartoon cars, shackles and TV sets. At the bottom there is a sequence of names, from left to right a crossed-out SAMO, followed by AARON, a name Basquiat often incorporated into his paintings, probably after the baseball player Hank Aaron, and then his own bold signature.

There it all is: the mature elements of Basquiat's work, worldly, reticent, communicative, crude and expert all at once. In palette and simplicity it's a visual rhyme to the very late

Riding with Death, painted in the heroin wasteland of 1988, Basquiat's last year, in which a black man rides on a four-legged white skeleton, against an awesomely reduced background, a burlap-coloured scrim, of absolutely nothing at all.

*

A Basquiat alphabet: alchemy, an evil cat, black soap, corpus, cotton, crime, crimee, crown, famous, hotel, king, left paw, liberty, loin, milk, negro, nothing to be gained here, Olympics, Parker, police, PRKR, sangre, soap, sugar, teeth.

These were words he used often, names he returned to, turning language into a spell to repel ghosts. The clear use of codes and symbols inspires a sort of interpretation-mania on the part of curators. But surely part of the point of the crossed-out lines and erasing hurricanes of colour is that Basquiat is attesting to the mutability of language, the way it twists and turns according to the power status of the speaker. Crimee is not the same as criminal, negro alters in different mouths, cotton might stand literally for slavery but also for fixed hierarchies of meaning and the way people get caged inside them.

'Everything he did was an attack on racism and I loved him for this,' Mallouk says in *Widow Basquiat*, the poetic account of their shared life by Jennifer Clement. She describes him in the Museum of Modern Art sprinkling water from a bottle, hexing the temple. 'This is another of the white man's plantations,' he explains.

After Basquiat, Mallouk became involved with another young artist, Michael Stewart, who in 1983 was arrested and beaten into a coma by three police officers after graffitiing a

subway station wall. He died thirteen days later. The officers, who claimed Stewart had a heart attack, were charged with criminally negligent homicide, assault and perjury, but found not guilty by an all-white jury. It is thought he was killed by an illegal chokehold, as Eric Garner would be thirty-one years later.

'It could have been me,' Basquiat said, and set about painting *Defacement (The Death of Michael Stewart).* Two cartoonish cops with malevolent Mr Punch faces and raised nightsticks wait to rain blows on a black boy, who Basquiat has drawn faceless in an overcoat, passing between them into the blue sky. Unlike the portrait of another black martyr, Emmet Till, by the white artist Dana Schutz that caused so much controversy at the 2017 Whitney Biennial, Basquiat chooses not to show Stewart's destroyed face. Instead he writes a question in Spanish: ¿DEFACIMENTO? To spoil the surface or appearance of something, with a pen or some other kind of weapon.

The pen couldn't kill, but it could reveal the dysfunction of foundational myths. Over and over, he redrafted America's history, the ongoing brutalising dynamic of racism and its long legacies. He painted slave auctions and lynchings, cartoon-style, livid, and he also made scathing accounts of what we might now call everyday racism. One of his obsessions was black talent and what happened to it, the way that jazz musicians and sports stars – Sugar Ray Robinson, Charlie Parker, Miles Davis – might accrue fame and money and yet remained trapped in a white system, exploited and belittled, still susceptible to being bought and sold.

What did his version of American history look like? It

looked like *Alto Saxophone*, 1986, with its cargo of monkeys, their lips stitched shut – code for speak no evil – and at the bottom of the beautiful coloured page a small black figure turning away, arms up, and next to it the words DEAD BODY© in tiny print. It looked like *Untitled (Sea Monster)*, 1983, or *Untitled (Cruel Aztec Gods)*, also 1983: graphic representation of power through the centuries, scratching in and crossing out the names of kings and popes, and in the middle in block caps the words UNINHABITED BY WHITE MEN©. It looked like the raging heads made with oil stick and graphite and crayon and acrylic through the full span of his career, sometimes so scribbled over it seems as if they're in the process of being torn apart or spun like sugar.

All the time, Basquiat was becoming more and more successful, more wealthy and famous. And yet he still couldn't reliably hail a cab in the street. Fine, limos instead. He bought expensive wines, Armani suits to paint in, like any artist who's suddenly made it big, yet the anecdotes about his spending were and continue to be passed on with a casual glaze of racism, as if there was something unusually revealing about his appetites. It was lonely, he was lonely, the only black man in the room, prodigy as status too close to toy. 'They're just racist, most of those people,' he's quoted as saying in Dieter Buchhart's *Now's the Time*. 'So they have this image of me: wild man running – you know, wild monkey man, whatever the fuck they think.'

One of his closest friends in the years of his success was Andy Warhol. The first time Warhol mentioned Basquiat in his diary, on 4 October 1982, was as 'one of those kids who

drive me crazy.' It didn't take long, though, before they were embroiled in a full-blown friend-romance, among the most intimate and lasting of both their lives. They collaborated on over 140 paintings, one-tenth of Basquiat's total output, worked out and went to parties, had manicures and talked for hours on the phone. Those who believe Warhol incapable of love might take a look at his diary, as he frets endlessly over his friend's gargantuan drug consumption, the way Basquiat keeps nodding out on the Factory floor, falling asleep in the middle of tying his shoes. The partnership ended in 1985, after Basquiat was stung by a bad review of their joint show at the Tony Shafrazi gallery, which described him as succumbing to the forces that would make him an art-world mascot, though the friendship stuttered on.

JUNK AND CIGARETTES, practically the last words in his notebooks, beyond a list of famous names, the words AMATEUR BOUT and the place he hailed from, NEW YORK. There was nothing heroic or glamorous about Basquiat's addiction. It came with the usual detritus: hitting girlfriends, accruing debts, falling out with beloved friends. He tried to stop but couldn't, and in the end he died in the apartment he rented from Warhol on Great Jones Street on 12 August 1988, of acute mixed-drug intoxication. In its obituary, the *New York Times* observed that Warhol's death the preceding year 'removed one of the few reins on Mr. Basquiat's mercurial behaviour and appetite for narcotics.'

Maybe so, but in that somnolent, junk-sick, grieving final year, he assembled masterpieces, among them *Eroica*, with its intricate map of heroes and villains, some barely visible beneath

the black and white pentimenti, the repentance marks that Basquiat made his signature. Among the vanishing names is Tennessee Williams, another prodigy who'd died of his addictions, who'd tried to express how and for whom power functions in America.

*

These days Basquiat is among the most expensive artists in the world, his images franchised and replicated everywhere from Urban Decay blusher pots to Reebok trainers. You could scorn the commercialisation, but isn't it what he wanted, to colour every surface with his runes?

He's a cash cow, just as he predicted, making rich white people richer, but maybe his spells retain their secret power. They could hardly be more necessary, since the forces against which he arranged himself are unequivocally on the rise, white men parading unmasked and with torches through the streets of Charlottesville and Boston, chanting 'blood and soil'.

'Who do you make a painting for?' he was asked in a filmed interview in October 1985, and he was silent for a long time. 'Do you make it for you?' the interviewer continued. 'I think I make it for myself, but ultimately for the world you know,' Basquiat said, and the interviewer asked him if he had a picture of what that world might be. 'Just any person,' he said, because he knew that change is coming all the time, from everywhere, and that if those of us who are leaning on the doors get out the way, freedom might be a possibility – yeah, boom, for real.

Nothing but blue skies

AGNES MARTIN

May 2015

ART MUST DERIVE from inspiration, Agnes Martin said, and yet for decades she painted what seems at first glance to be the same thing over and over again, the same core structure subject to subtle variations. A grid: a set of horizontal and vertical lines drawn with a ruler and pencil on canvases six feet high and six feet wide. They came, these restrained, reserved, exquisite paintings, as visions, for which she'd wait sometimes for weeks on end, rocking in her chair, steadying herself for a glimpse of the minute image that she'd paint next. 'I paint with my back to the world,' she famously declared, and what she wanted to catch in her rigorous nets was not material existence, the earth and its myriad forms, but rather the abstract glories of being: joy, beauty, innocence; happiness itself.

A late starter, Martin kept on going, working right through her eighties; a stocky, apple-cheeked figure with cropped silver hair, dressed in overalls and Indian shirts. She produced the last of her masterpieces a few months before her death in 2004, at the grand old age of ninety-two. But she was also so ambivalent about pride and success and the ego-driven business of making

a name for yourself that in the 1960s she abandoned the art world altogether, packing up her New York studio, giving away her materials and disappearing in a pickup truck, surfacing eighteen months later on a remote mesa in New Mexico.

When she returned to painting in 1973 the grids had gone, replaced by horizontal or vertical lines, the old palette of grey and white and brown giving way to glowing stripes and bands of very pale pink and blue and yellow. Sippee Cup colours, the critic Terry Castle once called them, and their titles likewise address states of pre-verbal, infantile bliss. *Little Children Loving Love, I Love the Whole World, Lovely Life*, even *Infant Response to Love*. And yet these images of absolute calm did not arise from a life replete with love or ease, but rather out of turbulence, solitude and hardship. Though inspired, they represent an act of will and extreme effort, and their perfection is nothing if not hard-won.

Her story begins on an isolated farm in the Canadian province of Saskatchewan. She was born on 22 March 1912, the same year as Jackson Pollock, another child of wide-open prairies and enormous skies. In a documentary made in 2002, Mary Lance's *With My Back to the World*, Martin claimed she could remember the exact moment of her birth. She had entered the world, she told Lance, as a small figure with a little sword. 'I was very happy. I thought I would cut my way through life . . . victory after victory,' she declares, laughing. 'Well, I adjusted as soon as they carried me in to my mother. Half of my victories fell to the ground.' She pauses. 'My mother had victories,' she says, and her candid, weather-beaten face darkens.

She believed that she was hated as a child. Silence was her mother's weapon and she used it ruthlessly. Martin told her

friend, the journalist Jill Johnston, that she had been emotionally abused, and yet she could also wring a value from some of the harsh lessons of her childhood, where a stony Scottish Calvinism did little to ameliorate maternal sadism. Her mother liked seeing people hurt, but her sternness did inculcate self-discipline, while the enforced solitude fostered self-reliance. The lessons stuck. Whether they always served her well or not, discipline and renunciation continued to be the watchwords of Martin's existence, right through to old age.

It was a long time before she thought of becoming an artist. A fine swimmer, she tried out as a teenager for the Olympic team, placing fourth. Later she trained to be a teacher, spending her itinerant twenties in remote schools out in the woods of the Pacific Northwest. In 1941, she went to New York City, where she studied Fine Arts at Teachers College, part of Columbia University. For the next fifteen years, she shuttled back and forth between schools in New York and New Mexico, slowly developing herself as a painter. Little of her work from this period has survived, owing to her habit of destroying anything that failed to match up to the exacting vision of her maturity. This is why it sometimes seems that Martin sprang into existence fully-formed, absolute in her commitment to geometric abstraction.

False starts, circling, a gaining of territory. Then, at the age of forty-five, she settled at the suggestion of her then dealer, Betty Parsons, in a studio community established in abandoned shipping lofts on the ramshackle waterfront of lower Manhattan. Coenties Slip was home to a group of young and predominantly gay artists – among them Jasper Johns, Robert

Rauschenberg, Robert Indiana and Ellsworth Kelly – bent on differentiating themselves from the more established abstract expressionists uptown, with their grating machismo.

Though a good decade older than the other residents, Martin felt at home in this place of experimentation and monastic discipline, of 'humour, endless possibilities, and rampant freedom.' A famous photograph shows her up on the roof with a group that includes Indiana and Kelly as well as a small boy and a dog, camped with coffee and cigarettes beneath the skyscrapers of the financial district. She sits smiling on the very edge of the roof, her hands jammed in her coat pocket, something of the overseer still about her stance.

Her first residence on the Slip was a hundred-foot-long former sailmaker's loft, with no hot water and walls that didn't quite meet the soaring ceiling. In this chilly space, increasingly austere geometric abstractions – regimented spots, squares and triangles in nocturnal palettes – resolved themselves into the repeating pattern of the grid. These new works began to be shown as part of the emerging movement of minimalism, though she personally regarded herself as an abstract expressionist, her subject: feeling, only anonymous and unadorned.

<p style="text-align:center">*</p>

Martin often described a painting from 1963, *Trees*, as her first grid. In fact, she'd been making them since at least the beginning of the decade, first by scratching lattices into paint and then by pencilling ruled vertical and horizontal lines onto canvases, sometimes embellishing the hatchings with dabs or lines of colour; even sheets of gold leaf. 'Well,' she told an interviewer,

'when I first made a grid I happened to be thinking of the inno-
cence of trees and then this grid came into my mind and I
thought it represented innocence, and I still do, and so I painted
it and then I was satisfied.'

Tiffany Bell, the co-curator with Frances Morris of the 2015
Martin retrospective at Tate Modern, observes of the early grids
that 'it is as though the energy of a Pollock drip painting has
been stretched out and carefully sustained over time.' Emphat-
ically ambiguous, they refuse artistry, reducing painting to the
simplest of mark-making procedures at the same time as ex-
ceeding themselves with their grandeur of scale and grave
beauty. The longer you look, the more impressive their insistent
neutrality becomes. Forget confessional art. This is withholding
art, evading disclosure, declining to give itself away.

Take 1961's *The Islands*. Against a buff-coloured ground, neat
pencilled lines form a succession of tiny boxes. With the excep-
tion of a border something like the fringe of a rug, these elegant
rows have been seeded with hundreds of tiny paired dots of pale
yellow paint, which from a distance translate into a shimmering
veil. Everything is relentlessly the same, and yet out of this same-
ness arises an image unlike anything that went before.

It isn't easy to catch the workings of these paintings in
words, since they were designed to dodge the burden of rep-
resentation, to stymie the viewer in their incorrigible habit of
searching for recognisable forms in the abstract field. They
aren't made to be read, but rather responded to, enigmatic
triggers for a spontaneous upwelling of pure emotion. Martin
was influenced by Taoism and Zen Buddhism, and there is a
driving interest in her work in cutting through materiality. In

an interview with the artist Ann Wilson she explained: 'Nature is like parting a curtain, you go into it. I want to draw a certain response like this . . . that quality of response from people when they leave themselves behind, often experienced in nature, an experience of simple joy . . . My paintings are about merging, about formlessness . . . A world without objects, without interruption.'

Merging and formlessness can be blissful, but losing a solid sense of the self is also terrifying, as Martin knew. She was diagnosed with paranoid schizophrenia in early adulthood, and her symptoms included auditory hallucinations, spells of depression and catatonic trances. Her voices, as she called them, directed almost every aspect of her life, sometimes punitive and sometimes protective. According to Nancy Princenthal's 2015 biography, *Agnes Martin: Her Life and Art*: 'although the voices didn't tell her what to paint – they seemed to steer clear of her work – the images that came to her through inspirations were fixed and articulate enough to suggest a relationship between visions and voices: she heard and saw things that others didn't.'

During the Coenties Slip period, she was hospitalised repeatedly. One winter, she fell into a trance in a church on Second Avenue, triggered when she heard the first few notes of Handel's *Messiah* (although she loved music, it was often too emotionally stimulating). Another time, she was admitted to the chaotic Bellevue psychiatric hospital after being found wandering Park Avenue, uncertain of who or where she was. Before friends located her and had her moved to more salubrious environs, she was given shock therapy.

Though a solitary figure, Martin was not entirely alone

during these years. She had relationships with women, among them the groundbreaking fibre artist Lenore Tawney and the Greek sculptor Chryssa (later famous for her work in neon). Like many gay people in the pre-Stonewall era, she was deep in the closet, at least once denying that she was a lesbian at all – a statement that must be taken with a pinch of salt, considering that she once snapped at Jill Johnston in response to an interview question about feminism, 'I'm not a woman.'

It's tempting to read these formidable tensions and turbulences into the paintings: to convert the grid into a closet or cell, a system of traps or an endless maze. But Martin was adamant that personal experience had nothing whatsoever to do with her work. In her copious writing she was insistent about what meanings they did and didn't contain: not ideas, and certainly not personal emotions or biographical elements. She was opposed to critical readings, going so far as to cancel a prestigious retrospective at the Whitney in 1980 because they insisted on a catalogue. The paintings were the thing: the paintings and the emotional responses they engendered in the viewer.

*

And then she disappeared. In the sweltering summer of 1967, Martin renounced art altogether. Over the years, she gave an assortment of reasons for her departure. She'd been living in a beautiful studio on South Street, with cathedral ceilings, so close to the river that she could see the expressions on the sailors' faces. One day, she heard that it was going to be torn down. In the same post she received notification that she had won a grant, enough to purchase a pickup truck and an

Airstream camper. Her friend Ad Reinhardt, whose black paintings she loved, had just died; her relationship with Chryssa had ended, and anyway she'd had enough of living in the city. The voices, too, were in agreement. 'I could no longer stay, so I had to leave, you see,' she explained decades later. 'I left New York because every day I suddenly felt I wanted to die and it was connected with painting. It took me several years to find out that the cause was an overdeveloped sense of responsibility.'

No one is sure where she went. Like Huck Finn, she lit out for the territories, travelling off-grid, into open space. She re-emerged at a café-gas station in Cuba, New Mexico in 1968, pulling in and asking the manager if he knew of any land for rent. By chance, his wife had a property available, and so, at the age of fifty-six, Martin moved up to a remote mesa twenty miles across dirt roads from the nearest highway. No electricity, no phone, no neighbours; not even a shelter to move into. For the first few months, she focused her energy on building, working from scratch and mostly alone. She made a one-room dwelling out of adobe bricks she shaped herself, and then a log-cabin studio from trees she cut down with a chainsaw. It was in this latter space that she began to inch towards art again, first prints, then drawings, then the luminous work of her maturity.

The best guide to Martin's life from here on is the evocative *Agnes Martin: Paintings, Writings, Remembrances*, by her friend and dealer Arne Glimcher, the founder of Pace Gallery. In June 1974, Agnes appeared out of the blue at Pace and asked if they'd like to show her new work. She invited Glimcher to come and view it, posting him a hand-drawn map, at the bottom of

which she'd scrawled 'bring ice thanks Agnes'. When he arrived, after an arduous journey from New York, she fed him mutton chops and apple pie before allowing him into the studio. There, she showed him five new paintings, made of either horizontal or vertical stripes in ice-blue and a red so watered it was hardly pink. At sixty-two, Martin had found a new language, a mode of expression in which she continued to communicate for thirty more years.

Sometimes the bands she made were sombre, in troubled driving strokes of slaty grey, but more often they are buoyant, elegant stacks of dilute acrylic paint. Layers the colour of sand and apricots, layers the colour of morning sky; flags for a borderless state, a new republic of ease and freedom. Her process was always the same. She waited until she saw her vision: a tiny full-colour version of the painting to come. Then came the painstaking labour of scaling up, filling pages with scribbled fractions and long division. Next, she'd mark two lengths of tape, using a short ruler to pencil the lines onto a gessoed canvas. Only then did she begin to apply colour, working very fast. If there were displeasing drips or blots or other errors, she'd destroy the canvas with a knife or box cutter, sometimes even hurling it off the mesa, before beginning again once or twice or seven times, which is to say that every mark in an Agnes Martin painting is intentional, wholly meant.

Their meticulous geometries have intense effects on the viewer. At the London outpost of Pace, I saw *Untitled #2*, 1992: five blue bands separated by four repeating runners of white, watery orange and salmon-pink. Up close, the pencil lines wobbled over the weave like an ECG. There were two hairs stuck to

the canvas; five peach splatters the size of fingernails. The eye seized on these small details, on the infinitesimally darker patches where two brush strokes had collided, because there was nothing else to grasp: no view, no closure, just a radiant openness, as if the ocean had come into the windowless room.

This feeling of freefall is not to everyone's taste. Over the years, a surprising number of Martin's paintings have been vandalised. One viewer used an ice-cream cone as their weapon. Another attacked with a green crayon, while at a show in Germany, nationalists hurled rubbish. The grids in particular seem to attract embellishment. Martin herself thought it was narcissistic, a kind of horror vacui. 'You know,' she said ruefully, 'people just can't stand that those are all empty squares.'

<div align="center">★</div>

Learning to withstand emptiness was her own speciality, her given task. Her years in New Mexico were marked by a withdrawal from worldly things, a life of renunciation and restriction that often sounds masochistic, though Martin insisted the intention was spiritual, an ongoing war against the sin of pride. The voices were strict in their limitations. She wasn't allowed to buy records, own a television, or have a dog or cat for company. Over the winter of 1973 she lived off nothing but preserved home-grown tomatoes, walnuts and hard cheese. Another winter it was Knox gelatin mixed with orange juice and bananas. When she was evicted from the mesa after an argument with the owners, she rang Glimcher, telling him she'd lost everything, even her clothes. 'It's a sign I've been living too grandly,' she announced cheerfully. 'It's another test for me.'

Ironically, Martin's reclusiveness, her spartan existence, contributed to her growing status as the desert mystic of minimalism, something she both resisted and fed. During this period, she began to give public lectures that managed to be bossy and self-effacing, mixing the language of Zen sermons with the babyish burblings and deliberate repetitions of Gertrude Stein, whose poems she was fond of declaiming. Martin was adept at using language opaquely, creating a screen of words that could veil her from the gaze of the world. Like her enigmatic, resistant paintings, her statements are designed to express something beyond the reach of ordinary understanding, weapons in a campaign to devalue the material and elevate the abstract. 'When you give up on the idea of right and wrong, you don't get anything,' she told Jill Johnston. 'What you get is rid of everything, freedom from ideas and responsibilities.'

Towards the end of her life, even the strictures began to dissolve. As she aged, Martin became happier and more social, as well as considerably more wealthy. In 1993, she moved into a retirement community in Taos, New Mexico, driving each day to her studio in a spotless white BMW, one of the few extravagances in a life still dedicated to extreme material simplicity. Other things that gave her pleasure were the novels of Agatha Christie (themselves, as Princenthal observes, ingenious repetitions on the same core structure), occasional Martinis and the music of Beethoven. To Lillian Ross in 2003, she said: 'Beethoven is really *about* something. I go to sleep when it gets dark, get up when it's light. Like a chicken. Let's go to lunch.'

It was in this period that objects began to return to her canvases; a final swerve in a life dedicated to absolute obedience

to vision. Triangles, trapezoids, squares: black geometric shapes, arising out of drained and sober fields. In one of the most striking of these paintings, *Homage to Life*, 2003, a severe black trapezoid looms out of a wash of exquisitely agitated putty grey (reviewing it in the *New Yorker*, Peter Schjeldahl observed: 'It looks thoroughly deathly to me'). And her very last work was, of all things, a tiny drawing of a plant, barely more than three inches high: a tottering ink line that attests at long last to the material things in which beauty temporarily makes its home.

After that, she set down her pencil. Her final days, in December 2004, were spent in the infirmary of the retirement home, surrounded by a few of her closest friends and family members. In his memoir, Glimcher describes sitting and holding her hand, singing her favourite 'Blue Skies', a song they'd often sung together while she drove him through the mountains, her foot on the gas, exhibiting a queenly disregard for speed limits and stop signs. Sometimes she'd chime in from her bed with a few wavering lines.

She wanted to be buried in the garden of the Harwood Museum in Taos, near a room of paintings she'd donated, but New Mexico law forbade it, and so, in the spring after her death, a group assembled at midnight and scaled the adobe walls with a ladder. It was a full moon, and they dug a hole under the roots of an apricot tree, placing her ashes in a Japanese bowl lined with gold leaf before scattering them in the earth. A beautiful scene, but as Martin knew, 'beauty is unattached, it's inspiration – it's inspiration.'

Keeping Up with Mr Whizz

DAVID HOCKNEY

January 2017

AS A SMALL boy in Bradford, David Hockney would watch his father paint old bicycles and prams. 'I love that, even now,' he remembered decades later. 'It is a marvellous thing to dip a brush into the paint and make marks on anything, even a bicycle, the feel of a thick brush full of paint coating something.' He knew he was going to be an artist, even if he wasn't sure exactly what an artist did. Design Christmas cards, draw signs, paint prams: it didn't matter, so long as his job involved the unmatched sensuality of making marks.

He'll be eighty this July: the best-known living British artist, his verve and curiosity undiminished. In 1962, he spent a painstaking day lettering a note to himself on a chest of drawers at the end of his bed. 'Get up and work immediately,' it said, and he's been obeying ever since. From monumental paintings of swimming pools and seething summer fields to tender, meticulous pencil portraits, from cubist opera sets to vases of flowers drawn on iPads or sent by fax machines, Hockney has always been a relentless reinventor, an artist who appears familiar while refusing to stay still.

These twists and turns in thematic preoccupations and new techniques do not represent a lack of discipline or focus. Instead, they're staging posts in Hockney's great quest, his attempt to remake the solid world in two dimensions. What do things look like, really, to stereoscopic human eyes, connected to a human heart and brain? Never mind the camera, with its rigid cyclopean vision. There is a better way of seeing, though it might take a lifetime to master.

<p style="text-align:center">★</p>

He was the fourth of five children, born in 1937 to creative, politically radical working-class parents. His father had been a conscientious objector and was a lifelong campaigner for nuclear disarmament, while his mother was a Methodist and vegetarian (years later, asked by *Women's Wear Daily* what he found beautiful, he picked his mum). From the off, Hockney was canny if not outright Machiavellian at pursuing his ambitions. At Bradford Grammar, art was only taught to people in the bottom form. 'They thought art was not a serious study and I just thought, "Well, they're wrong." ' A bright scholarship boy, he promptly went on strike, idling in all his other subjects in order to gain access. At sixteen, his parents finally consented to art school, first in Bradford and then, in 1959, at the Royal College of Art.

A cheeky lad in cartoonish glasses and weird, elegant clothes, he stood out at the RCA immediately, not least for the Stakhanovite intensity of his working day. Drawing was the foundation, the bulwark of his buoyant self-belief. If you could draw, he reasoned, you could always make money. The bloke

selling sketches in the park was a comfort, not a fear, though in fact before he'd even graduated he was already making substantial money from his work.

In the late 1950s, abstract expressionism – the sploshes and splashes of Jackson Pollock – was casting a long shadow over British art. At first Hockney played along, but the figure burned at him, a source of illicit fascination. It took a fellow student, the American R. B. Kitaj, to nudge him towards representation, suggesting he try mining his real interests for subject matter. Their conversation unlatched a door. Hockney had known he was gay since boyhood. Reading the poets Walt Whitman and C. P. Cavafy in the summer of 1960, both of whom attested freely to their love of men, he saw a way of inhabiting his sexuality that was at once frank and fruitful. Desire could be his subject; he could make what he described as 'propaganda' for queer love. The paintings came fast. In *We Two Boys Together Clinging* pastel escarpments of pink and blue announce a mood of romance, while in *Adhesiveness* two squat scarlet figures like pornographic Mr Men engage in oral sex, one sporting an alarmingly fanged mouth nicked straight from Francis Bacon.

Coming out so emphatically took courage. Until the 1967 Sexual Offences Act, homosexual acts between two men were illegal even in private. These new images were a political act, as well as a fantasy he willed into being, in particular *Domestic Scene, Los Angeles*, in which a lanky pink boy in pinny and socks soaps the back of a naked hunk standing beneath a solid blue jet of water. Hockney was imagining Californian permissiveness before he'd even been there, conjuring a utopia that would become both his home and best known subject.

Mr Whizz, as his new friend Christopher Isherwood nick-named him, first visited L.A. in 1964, and immediately recognised a scene in need of a chronicler. The swimming pools, the sprinklers and jungle foliage, the taut, tan people in their glass houses full of expensive primitive sculpture were simultaneously raw material and aesthetic problems to be solved. Light on water, iridescent ribbons of glitter, a splash: he could deploy all the lessons of abstraction here, among them Helen Frankenthaler's trick of diluting acrylic paint with deter-gent, so it would flood the canvas with reflective pools of colour. As for the people in his paintings, the lovers and friends, the central question was how to depict bodies in space while simultaneously capturing something of the relationship, the currents of emotion between them.

That many of his subjects were famous, the glamorous beau monde of Tinseltown and Swinging London, can distract from the seriousness of his investigation, the weirdness of his solu-tions. The first of his double portraits was 1968's *Christopher Isherwood and Don Bachardy*. The novelist sits in hawkish profile, eyes locked on his much younger lover. A bowl of fruit, under-scored by a priapic cob of corn, distorts the horizontal line into a triangle, forcing the viewer's gaze to circle restlessly round the canvas.

This marriage of artificiality and liveliness returns in a visionary portrait of the curator Henry Geldzahler sitting on a pink sofa, haloed by a glowing window. Standing to his left is the rigid, transfigured form of his boyfriend, Christopher Scott, who in his belted trench coat has something of the air of a messenger angel, inspiring Kynaston McShine to compare the

painting to an annunciation. Though both men's feet rest emphatically on the same tiled floor, they exist in different orders of reality.

★

Over the next few years, Hockney's work became increasingly naturalistic, culminating in portraits like *Mr and Mrs Clark and Percy* and 1972's melancholy *Portrait of an Artist*, in which his former lover Peter Schlesinger peers coolly down at a distorted body moving through the troubled light of a swimming pool. At first, naturalism had felt like freedom, allowing him to spring away from his contemporaries' obsession with flatness, their need to labour the artificiality of a painting. He became fascinated by one-point perspective, a development that co-incided with a growing interest in photography.

But by the mid-1970s, naturalism too had become a trap, a convention of seeing that failed to accurately capture the world. 'Perspective takes away the body of the viewer. You have a fixed point, you have no movement; in short, you are not there really. That is the problem,' he observed. 'For something to be seen, it has to be looked at by somebody and any true and real depiction should be an account of the experience of that look-ing.' In short, he wanted to invite the viewer inside the picture.

The two main zones in which he discovered his new approach were opera and the camera. In 1974 he was commis-sioned to design a production of Stravinsky's *The Rake's Progress* at Glyndebourne and over the next decade he returned repeat-edly to set design, gripped by the puzzle of incorporating real bodies into artificial spaces.

The camera was a problem, but it could also offer solutions far removed from voguish photorealism. In his 1982 exhibition *Drawing with a Camera* he showed the composite cubist portraits he called 'joiners', made by collaging Polaroid photos, an approach that quickly inflected his paintings too. The eye is bounced continually, alighting on small details; though the image is still it gives an illusion of motion, capturing the subject's joggling hands and shifting emotional weather.

New technologies were always a thrill. Just as mastering etching, lithography and aquatint had opened horizons for possible pictorial constructions, so too did the photocopier and fax machine, the latter fondly described by Hockney as 'a telephone for the deaf'. He became so addicted to sending friends enormously complex images, comprising hundreds of pages to be pieced together by the recipient, that he created an imaginary institute, The Hollywood Sea Picture Supply Co. Est. 1988. The smartphones and tablets of the new millennium would prove equally irresistible.

Hockney first realised he was going deaf in 1978, when he couldn't hear the voices of female students in a class. He painted his hearing aid in cheerful red and blue, but the diagnosis depressed him, especially when he remembered how isolating deafness had proved for his father. The loss was progressive, gradually inhibiting his ability to hear conversations in groups or in the noisy restaurants he'd once loved. There were compensations, though. He suspected it induced a compensatory sharpening of his vision, clarifying in particular his sense of space.

The other great loss in those years was Aids. Over the

course of the 1980s and early 1990s, dozens and dozens of his closest friends and acquaintances died, among them the film director Tony Richardson and the model Joe McDonald. 'I remember once going to New York and visiting three separate hospitals. It was the worst time of my life.' Years later, he confided to a friend that he did sometimes consider suicide, adding 'we all have a deep desire to survive, because we like the experience of loving.'

You might expect death to darken his palette, but what emerged at the century's end were revelatory landscapes, completely devoid of the loved people of old: spectacles perhaps of absence but also of renewal. In 1997, Hockney was back in Yorkshire, making daily visits to his friend Jonathan Silver, who was dying of cancer and who suggested he might make a subject of his native county. Driving each day across the Wolds, he was struck by 'the living aspect of the landscape.' It was seasonality that captivated him now, the slow decline and stubborn regeneration of the natural world. 'Some days were just glorious, the colour was *fantastic*. I can see colour. Other people don't see it like me, obviously.'

The Yorkshire paintings that emerged over the next decade were vast, often made from multiple canvases joined together. Damp, fecund England, as luxuriant as a Matisse, the hedgerows writhing with renewed life. There's something cartoonish and unadulterated about them, even gluttonous: a need to seize the mad abundance before it becomes something else, bud to leaf, puddle to ice, the endless migration of matter through form.

★

Hockney has long since attained the status of national treasure, a cardiganed dandy vocally impatient with the nannying anti-bohemia of the twenty-first century. In 1997 he was awarded the Order of Companion of Honour by the Queen, and in 2011 the first volume of Christopher Simon Sykes's biography *Hockney* was published.

A small stroke in 2012 didn't inhibit his interest in breaking new ground. Card players have his attention now. Sometimes these group portraits have the look of photographs, and then you spot one of his own paintings hanging on the wall, a witty rejoinder to different kinds of pictorial truth. But the wit, the lightness, the sheer exuberance of Hockney's constructions don't mean that nothing more weighty is taking place. 'If you come to dead ends you simply somersault back and carry on,' he once said. The English are perennially suspicious of this kind of acrobatic ability, finding it easier to commend the diligent ploughing of a single furrow. When faced with negativity or bafflement to new avenues and experiments, Hockney's response has often been to note tersely that he knows what he's doing.

Learning to look, that's what he's been up to, and learning too that looking is a source of joy. Asked a few years ago about the place of love in his life, he answered: 'I love my work. And I think the work has love, actually . . . I love life. I write it at the end of letters – "Love life, David Hockney". '

The Elated World

JOSEPH CORNELL

July 2015

THE BOX IS the central metaphor of Joseph Cornell's life, just as it is the signature element of his exquisite and disturbing body of work, his factory of dreams. He made boxes to keep wonders in: small wooden boxes that he built himself in the basement beneath the small wooden house he shared with his mother and disabled younger brother, the two fixed stars of his existence.

As a boy, he saw Houdini perform in New York City, escaping from locked cabinets, wreathed in chains. In his own artwork, which he didn't begin until he was almost thirty, he made obsessive, ingenious versions of the same story: a multitude of found objects representing expansiveness and flight, penned inside glass-fronted cases. Ballet dancers, birds, maps, aviators, stars of screen and sky, at once cherished, fetishised and imprisoned.

This tension between freedom and constriction ran right through Cornell's own life. A pioneer of assemblage art, collector, autodidact, Christian Scientist, pastry-lover, experimental film-maker, balletomane and self-declared white-magician, he

roved freely through the fields of the mind while inhabiting a personal life of extremely narrow limits. He never married or moved out of his mother's house in Queens and rarely voyaged further than a subway ride into Manhattan, despite being besotted with the idea of foreign travel and particularly with France.

He was on friendly terms with almost every artist who passed through New York during the middle years of the twentieth century – among them Duchamp, Motherwell, Rothko, de Kooning and Warhol – and yet he was also solitary, stuck in himself, a hermit who said to his sister in the last conversation they ever had, 'I wish I hadn't been so reserved.' Though he longed for larger horizons (the title of the Royal Academy's 2015 retrospective is *Wanderlust*), he didn't attempt to physically escape his circumstance, choosing instead to master the difficult knack of conjuring infinite space from a circumscribed realm.

*

Cornell was born on Christmas Eve 1903 in Nyack, a village just up the Hudson from Manhattan. Nyack was also the childhood home of Edward Hopper, another rangy, solitary artist fixated with scenes of voyeurism and enclosure (though they didn't meet, he taught one of Cornell's sisters to draw at summer school). In 1910, his beloved brother was born. Robert had cerebral palsy, struggled to speak and was later confined to a wheelchair. From the beginning, Joseph considered him his personal responsibility, which is part of why he never left home.

The family's early years were a whirl of parties and trips to the enchanted playgrounds of Coney Island and Times Square. But in 1911 Cornell's father, an exuberant textile designer and

salesman, was diagnosed with leukaemia. When he died a few years later it became unhappily apparent that he'd been living well beyond his means. Confronted by sizeable debts, Mrs Cornell sold up and moved the family to New York City, renting a succession of modest houses in the heart of working-class Queens. She wangled her oldest son a place at the prestigious Phillips Academy, but he was unhappy and friendless there and left in 1921 without so much as a diploma to his name. Unable to draw or paint, he had no notion of becoming an artist and that autumn took the first of many grinding jobs as a salesman in Manhattan. He hated the work and often suffered from physical ailments, among them migraines and stomach aches.

What leavened those years was the city itself. Any free time he had was spent luxuriating in what he described as 'the teeming life of the metropolis'. He prowled the avenues and lingered in the parks: a gaunt, handsome man with burning blue eyes, leafing through racks of second-hand books and old prints, haunting flea markets, movie houses and museums, pausing sometimes to feast on stacks of donuts and prune twists, greedy too for glimpses of pretty young girls.

The city he favoured was neither glamorous nor exclusive, but democratic: an arcade whose astonishments might equally be found at a Saturday matinee at the Metropolitan Opera or in the lit boulevards of Woolworth's. He built up an extensive private museum from his excursions, toting home treasure in the form of rare books, magazines, postcards, playbills, librettos, records and early films. Stranger things, too: shells and rubber balls, crystal swans, compasses, bobbins and corks.

First you acquire the materials and then you put them

together. Cornell's career as an artist began when he encountered surrealism in the early 1930s. The touch-paper was seeing *La femme 100 têtes* by Max Ernst, a collaged novel that introduced him to the idea that art was not necessarily a matter of applying paint to canvas, but could also be made from real objects, estrangingly combined. Inspired, he began to make collages of his own, sitting with scissors and glue at the kitchen table of 37-08 Utopia Parkway, his home from 1929 until his death in 1972. He worked mostly at night, his mother asleep upstairs and Robert dozing in the sitting room, surrounded by model trains.

In this period, Cornell also began to assemble what he called *dossiers* on his favourite subjects: folders crammed with cuttings and photographs of the ballerinas, opera singers and actresses he worshipped, among them Gloria Swanson and Anna Moffo. Other ongoing *explorations*, which sometimes ran for decades, were meticulously catalogued by way of topic: Advertisements, Butterflies, Clouds, Fairies, Figureheads, Food, Insects, History, Planets. Categorisation mattered to Cornell, though so too did intuitive leaps and flights of fancy. 'A clearing house for dreams and visions,' he called his files; part research project, part stalking, part devotional act.

By the mid-1930s, he'd discovered the two great mediums of his maturity: shadow boxes and films made by re-editing found footage. One of the most striking among the latter category was *Rose Hobart*, which he made by chopping up the B movie *East of Borneo* and splicing it back together as a series of lingering, blue-tinted glimpses of the actress Rose Hobart, wrapped in a trench coat, intercut with enigmatic footage of jungle foliage

and swaying palms. According to Deborah Solomon's biography, *Utopia Parkway*, at the first screening Salvador Dali was so overcome with jealousy that he knocked over the projector, an incident Cornell found abidingly distressing.

Because of his lack of a formal art education and the unusual nature of his domestic circumstances, Cornell is often depicted as an outsider artist, but in fact he was in the swim of things from the start. He took his early collages to the gallerist Julian Levy, who liked them so much they appeared in the ground-breaking *Surréalisme* show in 1932, alongside Dali and Duchamp. His first shadow box, *Untitled (Soap Bubble Set)*, was in *Fantastic Art, Dada and Surrealism*, a major exhibition at the Museum of Modern Art in 1936. Other artists were quick to see the value of his inventions (something that continued right through the successive waves of surrealism, abstract expressionism and pop art). Despite his shyness he developed sustaining friendships, though he was never wholly comfortable with the business aspect of the art world.

In the winter of 1940, he took the bold step of resigning from his job. He set up a studio in the basement and began to concentrate on boxes, a project that would occupy him for the next fifteen years. The early versions used ready-made shells, but he soon began to build the frames himself, learning by trial and error to make mitre joints and use a power saw. Next, he'd age the box with layers of paint and varnish, sometimes leaving them in the yard or baking them in the oven. Prosaic work, followed by the poetry of assemblage, of finding the right objects or images to convey the subtle, transient feelings – nostalgia, say, or joy – that he experienced on his voyages through the

city and which he logged in his voluminous and ardent diary (itself a collage composed of scribbled notes on napkins, paper bags and ticket stubs).

The boxes came first one by one, and then in sets or families. *Medici Slot Machines*: a succession of composed princesses and slouching princes gaze sorrowfully from simulacrums of vending machines, which offer but do not relinquish a child's treasury of jacks, compasses and coloured balls. *Aviaries*: lithographs of parrots cut from books and perched in cages decorated with watch-faces or arranged as if for a shooting gallery. *Hotels and Observatories*: celestial lodging places for travellers passing between worlds.

*

Cornell found it agonising to sell these precious objects, frequently changing galleries and dealers so that no one person had too much control over his work. What he preferred was to give them away, especially to women. Cornell adored women. A deeply romantic man, he was cripplingly physically reserved, not helped by a jealous mother who repeatedly told him sex was repulsive. He longed to touch, but looking and fantasising were safer and had their own satisfactions. His diaries are filled with accounts of the women and especially teenage girls (*teeners*, he called them, or *fées*) who caught his eye in the city, entries that are sometimes sentimental or painfully innocent, but are also lecherous and downright creepy.

Mostly he didn't make contact, and when he did – presenting a bouquet to a cinema check-out girl; mailing an owl box to Audrey Hepburn – he was often rebuffed. Being the object

of a fantasy is claustrophobic, airless, frightening, since what is desired is the outer shell and not the inner person. Plenty of people admired Cornell's boxes, but no one wanted to live inside them. Nonetheless, he built productive friendships with many women artists and writers, among them Lee Miller, Marianne Moore and Susan Sontag, who later told Deborah Solomon, 'I certainly was not relaxed or comfortable in his presence, but why should I be? That's hardly a complaint. He was a delicate, complicated person whose imagination worked in a very special way.'

The most fertile of his alliances was with Yayoi Kusama, the Japanese avant-garde artist famous for her all-encompassing use of dots. They met in 1962, when Kusama was in her early thirties. According to her autobiography, *Infinity Net*, their relationship was both erotic and creative, though his mother did her best to quash it, once throwing a bucket of water over them as they sat kissing beneath the quince tree in the back yard. In the end, Kusama withdrew, exhausted by the claustrophobic intensity of Cornell's claims on her attention, the marathon phone monologues that could go on for hours, the dozens of love notes that appeared in her mailbox daily.

As Cornell's reputation grew, his production of boxes slowed. Instead, he returned to the two mediums with which he'd begun: collages and movie-making. In his late films, which he began in the mid-1950s, he no longer used found footage but instead employed professional collaborators to record material at his command, which he then edited. There's no better way of experiencing how he saw the world than by watching these celluloid records of his wandering, wondering gaze.

One of the best examples is *Nymphlight*, made in 1957 with the experimental film-maker Rudy Burckhardt. A twelve-year-old ballet dancer roams Bryant Park, the tree-lined square next to the New York Public Library. The camera's eye is perpetually distracted by small movements, by quickenings and quiverings. A flock of pigeons performing their aerial ballet; water gushing from a fountain; the movement of wind in leaves. Halfway through, it becomes enraptured by a succession of people, among them a woman with a dog, an elderly vagrant, who gazes back impassively, and a trash-collector. It's hard to think of another artist who might have looked with such loving, serious attention at someone collecting garbage. What *Nymphlight* demonstrates is the equanimity of Cornell's vision, his capacity for finding beauty in the most unprepossessing of physical forms.

The last years were the hardest. In 1965 Robert died of pneumonia, and the following year Cornell's mother also died. In 1967, he was the subject of two major retrospectives, at the Pasadena Art Museum and the Guggenheim, as well as a lengthy profile in *Life* magazine. An ecstatic culmination of a life's work, one might think, assuming that what was being angled for was fame, which had never been Cornell's interest or aim.

Alone in the house on Utopia Parkway, he was ravaged by loneliness, and particularly by a longing for the physical contact he'd never really managed to attain. He hired assistants, mostly art students, to cook for him and help organise his work. He was visited by many devoted friends, but there still seemed to be something that kept him apart from other people: a pane of glass he couldn't quite break open or unlatch. And yet he never

lost his ability to look and be moved – bowled over, even – by the things he saw, from birds in a tree ('cheery-upping of insistent Robin') or shifts in the weather to the marvellous traffic of his dreams and visions.

'Gratitude, acknowledgement & remembrance for something that can so easily get lost,' he wrote in his diary on 27 December 1972, two days before he died of heart failure, inadvertently summing up the abiding genius of his own work. Then, perhaps glancing up at the window, he added his final words: 'Sunshine breaking through going on 12 noon' – a last record of his long romance with what he once called the elated world.

For Yes

ROBERT RAUSCHENBERG

November 2016

TOWARDS THE END of his relentlessly inventive life, Robert Rauschenberg confided an anxiety. He was worried that his mission to introduce the world to itself by way of the spectacular mirror of his art could fail, not because he lacked energy or talent, but because he might 'run out of world'.

If his work can be summed up in a single word, it is combination: a prodigal wedding of disparate and unlikely objects and techniques. Best known for making the hybrid painting-sculptures he called 'combines' out of litter gleaned from New York's streets – light bulbs, chairs, tyres, umbrellas, street signs and cardboard boxes were recurring motifs – this self-described 'loosest, weirdest artist' was a technical pioneer in multiple disciplines, moving restlessly on as soon as he mastered a new form. Over the decades, he expanded the limits of painting, sculpture, printmaking, photography and dance. 'The artist of American democracy,' Robert Hughes called him, 'yearningly faithful to its clamor, its contradictions, its hope and its enormous demotic freedom.'

Milton Ernest Rauschenberg (Robert was a name he cooked

up after musing all night in a Savarin coffee shop) was born on 22 October 1925 in Port Arthur, a run-down oil-refinery town on the Texas coast. As a boy, Rauschenberg fantasised about becoming a preacher, an ambition he dismissed once he realised it would prevent him from dancing, a lifeline for a tongue-tied, dyslexic kid. His sensitive disposition brought him into repeated conflict with authority, starting with his father, a keen duck-hunter disgusted by a son who refused to handle a gun (years later, on his deathbed, Rauschenberg senior confided balefully: 'I never liked you, you son-of-a-bitch'). After dropping out of pharmacy school for declining to dissect a frog, Rauschenberg was drafted into the Navy in 1944, where he was made a neuro-psychiatric technician in the Hospital Corps after once again asserting his refusal to kill.

Throughout those years he drew perpetually, covering his bedroom furniture in scarlet fleurs-de-lys and colouring por-traits of cadets with his own blood for lack of paint. But the notion that this might exceed a hobby didn't strike him until he was on furlough in California. He wandered into the Huntington Library and came upon two paintings he recog-nised from the backs of playing cards: Gainsborough's *Blue Boy* and Thomas Lawrence's *Pinkie*. Confronted by the swoony, enduring originals, he realised for the first time that artists existed, and furthermore that he could become one too.

After the war ended he went to art school on the GI Bill, sampling the Académie Julian in Paris, where he met his future wife Susan Weil. In 1948 they settled together at Black Mountain, the experimental, anti-hierarchical arts college in North Carolina. The head of painting was Josef Albers, a

refugee from the Nazi closure of the Bauhaus. His rigorous approach to colour and composition made him the most significant teacher in Rauschenberg's life, though their native styles were anything but complementary. 'Albers's rule is to make order,' Rauschenberg observed. 'As for me, I consider myself successful when I do something that resembles the lack of order I sense.'

Together with Weil, Rauschenberg began experimenting with photograms, where objects are placed directly on photosensitive blueprint paper, initiating a habit of collaborating with lovers that would persist to the end of his life. The couple married in 1950 and separated a year later, shortly after the birth of their son Christopher. Back at Black Mountain he began a passionate affair with a fellow student, Cy Twombly, as well as developing a productive, sustaining friendship with another queer couple: the avant-garde composer John Cage and the dancer Merce Cunningham.

Rauschenberg described the encrusted *Black Paintings* and flat, shining *White Paintings* that arose from this tumultuous period to the gallerist Betty Parsons as 'almost an emergency'. It was hardly an understatement. With the five panels of the *White Paintings*, he opened the door to minimalism, breaking away from the ruling cult of abstract expressionism and its macho insistence on emotional authenticity.

By applying white house paint with a roller, Rauschenberg deliberately avoided incident or gesture. They were pure surface: the first and most extreme manifestation of Rauschenberg's conception of art as a mirror for capturing the outside world. Look long enough, and you'd start to see shadows and reflections;

an absence-that-wasn't which inspired Cage to make *4'33"*, his famous composition that deploys silence to expose a symphony of random ambient sound.

*

Of all the ground-breaking years in Rauschenberg's life, 1953 was a doozy. That spring, he settled in New York after returning from a European tour with Twombly. In his cold-water loft on Fulton Street he set about a series of paintings made of exalted and impoverished materials: dirt, grass seed that grew and died, mould, clay, lead and gold. He spent a painstaking month unmaking his notorious *Erased de Kooning Drawing*, a work of conceptual art before conceptual art had been conceived. He also began his *Red Paintings*, chaotic collages assailed with a voluptuous repertoire of drips, splashes and smears. And on a street corner that autumn he met a young Southern painter called Jasper Johns.

Nicknamed 'the Southern Renaissance' by Cage, Johns and Rauschenberg were lovers, collaborators and co-conspirators, a factory of two, egging each other into ever more daring exploits. Dirt poor, they worked as window-dressers, veiling this shameful commercial activity with the pseudonym Matson Jones Custom Display. Speaking to Rauschenberg's biographer Calvin Tompkins decades on, Johns said: 'We were very close and considerate of one another, and for a number of years we were each other's main audience. I was allowed to question what he did, and he could question what I did.'

Neither had yet achieved much purchase on the outside world. Reviews and sales for the exhibition of *Red Paintings* in

1954 were as dismal as they'd been for Rauschenberg's previous shows. The only rave came from the poet and curator Frank O'Hara, who wrote presciently in *Art News*: 'He provides a means by which you, as well as he, can get "in" the painting . . . For all the baroque exuberance of the show, quieter pieces evince a serious lyrical talent.'

What does it mean to get in a painting, and what might you do once you get there? Would it be domestic or dangerous, erotic or dreamy? All these possibilities smear and slide in 1955's sublime *Bed*, the best known of Rauschenberg's combines. In lieu of canvas, he requisitioned his own bed clothes, assaulting pillows, sheet and a friend's quilt with gory, libidinal gouts of red, blue, yellow, brown, black paint and stripy toothpaste. A crime scene, one critic sneered, though the ecstatic nocturnal residue is also subversive: a closeted gay man airing filthy laundry in pre-Stonewall public.

Making the combines, Rauschenberg felt he was cracking 'the secret language of junk'. They could be composed of anything: a goat corseted by a tyre; a stuffed bald eagle fished from the bin of one of Teddy Roosevelt's Rough Riders, the volunteer cavalry for the Spanish-American War. One of the very first, *Untitled (Man with White Shoes)*, contained – deep breath – fabric, newspaper, a photograph of Jasper Johns, a handwritten letter from Rauschenberg's son, a drawing by Cy Twombly, glass, mirror, tin, cork, a pair of the artist's socks and painted leather shoes, dried grass and a taxidermied Plymouth Rock hen.

There's a limit to how much world you can cram into a sculpture, and as Rauschenberg's success and financial security

grew he became fascinated by replication. Back in 1952, he'd experimented with transfer drawing, and in 1958 he embarked on a grand project of illustrating Dante's *Inferno* using lighter fluid to transfer images onto paper. In 1962, Andy Warhol introduced him to a far more sophisticated technique: the wizardry of using photographic images to silkscreen canvases.

Now he could reuse and resize his own photos and those he snipped from newspapers and magazines, giving him an unprecedented power of composition. Anything could be incorporated: John F. Kennedy; a water tower; Bonnie and Clyde. As he observed of the silkscreen paintings: 'It's as much like Christmas to me as using objects I pick up on the street.' He was giddy for them, until in 1964 he was awarded the Golden Lion at Venice Biennale. Terrified of stasis, the next day he called his New York studio and asked his assistant to burn all the screens.

<div align="center">★</div>

Focusing on any one aspect of Rauschenberg's life risks distorting the kaleidoscopic whole. Throughout the 1950s, he was as involved in dance as art, designing sets, scores, lighting and costumes — headdresses like 'inhabited seashells'; a two-man horse suit — for Paul Taylor and the Merce Cunningham Dance Company. An 'awkward, but beautiful addition to my work,' he called it: a collaborative antidote to 'the privateness and loneliness of painting'.

The possibilities of bodies mingling on a stage excited him. His own forays into the form were characteristically surreal: roller-skating in *Pelican* with a kind of huge umbrella made of parachute silk lashed to his back; abseiling from a skylight into

a drum of water for *Elgin Tie*. He was always pushing forward, willingly lowering himself into new elements. In 1966, he co-founded the forward-thinking Experiments in Art and Technology (E.A.T.), an organisation that arranged ambitious collaboration between artists and engineers, inaugurating a far more technologically sophisticated era of art-making that paved the way for the digital art of the present.

The 1970s, by contrast, were less frenetic. Rauschenberg moved to the luscious Captiva Island in Florida, establishing a substantial compound of studios and houses in the jungle. Inspired by a trip to India, the most beautiful work from those years involved a newly subtle use of fabric. In the enigmatic *Hoarfrost* series he used the old solvent technique to transfer ghost images from newspapers onto shrouds of chiffon and cotton. The *Jammers* were even more simple: bright lengths of silk, slung from rattan poles, like washing lines or prayer flags.

The world gnawed at him. He wanted to get out into it: to scoop it up, to show it to itself. In 1982, a chance conversation with a cook while working on a project at a paper mill in China kick-started his most ambitious work. The Rauschenberg Overseas Cultural Interchange was an attempt to engage artistically with countries that were culturally isolated or where freedom of expression and movement was limited. Announcing the launch of ROCI at the United Nations in December 1984, he said: 'I feel strong in my beliefs . . . that a one-to-one contact through art contains potent peaceful powers and is the most non-elitist way to share exotic and common information, seducing us into creative mutual understandings for the benefit of all.'

Rauschenberg had initially hoped for public or corporate funding, but in the end he footed nearly all the $11 million bill for ROCI himself. His own work did not at the time command sufficiently high prices, so he sold early pieces by friends, including a Warhol and a Jasper Johns, as well as mortgaging his house to fund the immense eleven-country tour. Between 1985 and 1990, he visited Mexico, Chile, Venezuela, China (the first solo show by a living Western artist since the Communist Revolution in 1949), Tibet, Japan, Cuba, the USSR, Malaysia, Germany and the USA, working with local artists for weeks before hosting a substantial exhibition in each country. By 1991, over two million people had seen a ROCI show.

'At once altruistic and self-aggrandizing, modest and over-bearing,' the critic Roberta Smith wrote of this unprecedented project, while the Soviet poet Yevgeny Yevtushenko described it as 'one of the symbols of a spiritual perestroika of our society'. No other artist could have done it; no one else came close to Rauschenberg's stamina or appetite, his hubris and self-confidence, his outsized faith.

There was no question of running short of inspiration. For many artists the avalanching awards and wealth of later life come with an unwelcome diminishment of ideas, but Rauschenberg was still avid for discoveries in his eighties. Digital printing thrilled him, and he was making and exhibiting new work with the help of studio assistants even after 2002's stroke (right hand paralysed, he simply learned to paint with his left). His 1997 retrospective was the largest ever American one-man show. It far exceeded the capacity of the Guggenheim, spilling out into two other museums. A glut, you might call it,

lifting the title of a late series; a lavish extravagance. He was equally generous with what had become a substantial fortune, donating heavily to Aids research, education and environmental causes, though he never came out publicly.

When he died on 12 May 2008 of heart failure, the *New York Times* described him as an artist 'who time and again reshaped art in the 20th century'. In a wheelchair, he'd still dreamed of photographing the entire world, inch by inch, asking friends to snap the most boring details they could find. Nothing was beneath his regard, and no one exceeded his vision for art as a kind of an alternate planet, equally vast in scope and scale. 'I'm for yes,' he said firmly. 'No excludes. I'm for inclusion.'

Lady of the Canyon

GEORGIA O'KEEFFE

June 2016

FORGET THE MORNING GLORIES and orificial irises, with their attendant readings of flamboyant female sexuality. If there is a painting that encapsulates the mysteries of Georgia O'Keeffe, it's of something far more humble, far less glamorous. An adobe wall of a house, a smooth brown expanse capped by sky and punctured by a door, a rough black rectangle of absolute negative space.

O'Keeffe liked to paint the same thing again and again, until she had penetrated to its essence, unravelling the secret of her attraction. The flowers, the blowsy petunias and jimson weed, were superseded by New York cityscapes and then by cow skulls and miscellaneous animal bones, surreally aloft over the clean blue skies and dry striated hills of New Mexico.

This was the landscape that unlatched her heart, and it was during her time there in the 1930s that she began to obsess over the wall with a door in it, located in the courtyard of a tumble-down farmstead in Abiquiú. First she bought the house, a process that took a full decade, and then she set about documenting its enigmatic presence on canvas, creating almost

twenty versions. 'I'm always trying to paint that door – I never quite get it,' she announced. 'It's a curse the way I feel – I must continually go on with that door.'

The attraction was a puzzle, and yet walls and doors figure large in the story of O'Keeffe's singular life. How do you make the most of what's inside you, your talents and desires, when they slam you up against a wall of prejudice, of limiting beliefs about what a woman must be and an artist can do? O'Keeffe didn't kick the wall down – hardly her style – but instead set her considerable canniness and will at prising a new route in.

In terms of her painting, never mind the innovations she brought to bear on her private life, she forged a passage to a world of openness and freedom, as frightening as it was exhilarating. 'I've always been absolutely terrified every single moment of my life,' she said, 'and I've never let it stop me from doing a single thing I wanted to do.'

*

She was a farm girl first, raised in the wide-open prairies of Wisconsin. Her mother had hoped to be a doctor and several aunts never married, instead pursuing independent careers. The family style was cool and austere, a high store set on self-reliance. Born on 15 November 1887, Georgia was the eldest daughter, ministering to a brood of sisters. Her first memory was 'of the brightness of the light – brightness all around' and she resolved to be an artist at the age of eleven.

Dogged commitment to this ambition got her to the Art Institute of Chicago at seventeen, but her apprenticeship

was long. A spell in New York at the Art Students League introduced her to the pleasures of an urban social life, and the concomitant realisation that art would require relinquishment as well as ambition. 'I first learned to say no when I stopped dancing,' she said. 'I liked to dance very much. But if I danced all night, I couldn't paint for three days.'

A downturn in the family fortunes made college an unaffordable luxury. Instead, in common with her contemporary Edward Hopper, O'Keeffe attempted commercial art, though like him she loathed the silliness of the commissions. As it often would in her life, illness forced a shift in course. She caught measles, and as she was convalescing at home in Virginia her mother was diagnosed with tuberculosis, then invariably fatal. Worn down and despairing, she decided to abandon painting for good, a resolution that stuck until 1912.

It was teaching that saved her, offering a model of a financially independent life. Between 1912 and 1918, teaching was O'Keeffe's mainstay and anchorage. She took jobs all over the South, living in deep seclusion in South Carolina and out on the Texas Panhandle. The harsh landscape suited her. 'I was there before they ploughed the plains. Oh, the sun was hot, and the wind was hard, and you got cold in the winter. I was just crazy about all of it . . . The beauty of that wild world.'

She cut an extraordinary figure back then: a rural modernist among the cows, in severe black suits and Oxfords, a man's felt hat jammed on her black hair. As a teacher in Amarillo she plumped for a hotel frequented by cowboys; in another boarding house she caused consternation by asking to paint the woodwork black. Conscientious with her students, she spent

much of her private time alone, hiking and camping in the canyons, getting high on the electric drama of the prairie sky.

Between jobs, she delved back into education, studying at the University of Virginia and Teachers College in New York. The city might have been short on cattle drives but it did offer enrichments of its own. In Manhattan she saw the work of Picasso and Braque and read Kandinsky's *Concerning the Spiritual in Art*. Even more influential was her introduction to the revolutionary notions of Arthur Dow: a mild-mannered professor who created an innovative approach to art. Inspired by Japanese painting, Dow prioritised composition over imitation, encouraging individual aesthetic decision-making, both on the canvas and in ordinary life. Doing things with style: this became the O'Keeffe creed, affecting everything from how she dressed herself and furnished her houses to what she did with her brush.

You learn the lessons, and then you put them into practice, a process that demands seclusion and intense effort. October 1915. O'Keeffe banned herself from colour, working solely in charcoal. Each night, after the long day's lessons, she sat on the wooden floor of her room in Columbia, trying to set down on a sheet of paper her most impassioned feelings. She worked right through Christmas, frantic with frustration, until she succeeded in developing a strange new language of abstract forms, swirling and intertwining like flames or buds. *The Specials*, she called them: her first authentic, truly independent work.

★

Picture the young Georgia O'Keeffe and you conjure two kinds of images. In the first, she is buttoned up, reserved, a spartan figure composed of monochromatic parts: white skin, black eyes, white shirt, black jacket, hands twisted like a flamenco dancer, hair pulled sharply back or hidden beneath a bowler hat. In the second, she is categorically unbuttoned, tumbling sleepily out of a white chemise or dressing gown, her breasts and belly bared, witchy locks tumbling over her shoulders.

Both images are the creation of the same man: the photographer and gallerist Alfred Stieglitz, a didactic visionary who helped establish modern art in America. In 1915, a friend of Georgia's sent him the charcoals without her knowledge. Struck, he exhibited them in a group show, catalysing one of the most fertile art partnerships of the twentieth century. O'Keeffe had first encountered Stieglitz at his gallery 291 back in 1908, when she was at the Art Students League. She visited an exhibition of Rodin drawings, finding the erotic content and atmosphere of noisy debate antithetical to her tastes. Later, though, she became enamoured of Stieglitz's aesthetic and an ardent subscriber to *Camera Works*, his photography magazine. While she was horrified to discover her own work had been hung on the walls without her permission, the discovery of a kindred spirit who supported her innovations was the boost she needed.

At first they wrote: an explosion of letters that carried on right through their lives, reaching a grand total of twenty-five thousand pages. When O'Keeffe caught Spanish flu in 1919 they were close enough for Stieglitz to suggest he care for her in Manhattan, though he was married and almost three decades

her senior. He visited her sweltering buttercup-coloured studio every day, armed with his camera. After a febrile month of this he forced his wife's hand by bringing O'Keeffe to the marital home. Emmeline walked in on them mid-photoshoot and threw him out, providing the exit he'd craved for years.

Back in Texas, O'Keeffe had foreseen the damage love might do to her cherished independence, writing to a friend: 'don't let it get you Anita if you value your peace of mind – it will eat you up and swallow you whole.' Finding a way of balancing these countervailing needs would bedevil her for twenty years. Stieglitz supported her painting, but he also set immense demands on her energy and time, insisting on a frenetic social life that ate away at the calm focus her work required. Then there was his insistence on seeing her as a kind of erotic child-woman, the epitome of feminine truth and virtue. As Roxanne Robinson puts it in her biography, *Georgia O'Keeffe*: 'Like most, Stieglitz's pedestal was uplifting but would give her little room to move.'

Oppressive gender stereotypes also affected readings of O'Keeffe's work. In 1919, she returned to oil, producing her first flowers as well as apples, avocados and other pleasingly rounded forms. Stylised, tightly cropped and enlarged (Stieglitz's photography was an influence, as was the work of her friend Paul Strand), the flowers excited her with their chambers and contours, their frills and fleshy folds, their latent potential for abstract form. But these subtleties were lost on the critics. Primed by an exhibition of the Stieglitz nudes of her, they saw a revelatory exposé of female sexuality. In her work as well as being, O'Keeffe had become an unwilling lightning rod for

men's constricting ideas about that baffling creature, the female of the species.

In response, she painted a skyscraper. 'When I wanted to paint New York, the men thought I'd lost my mind,' she said later. 'But I did it anyway.' Her evening streets are peopleless and light-besotted, honing in on sunspots and streetlamp haloes, a small moon surfing clouds above canyons of glowing concrete and glass. Everything is stylised and smoothed, not painted from life so much as patterned imaginatively, to encode feelings of longing, loneliness, contentment.

The skyscrapers were a triumphant territory grab, but difficulties lay ahead. In 1927, Georgia had surgery for a benign lump in her breast. That same year a woman began to frequent Stieglitz's new space, The Intimate Gallery, nicknamed The Room. Stieglitz, always drawn to pretty girls, began an ill-concealed affair with the married Dorothy Norman, intensifying O'Keeffe's claustrophobia about the way their shared life was organised, the strangulating sense of no longer being the author of her days.

Penned up in Manhattan or at Stieglitz's family home on Lake George, she chafed against the landscape, the noise, the requirements of sociability. Now there was the added pain of infidelity, the humiliation of betrayal. She began to take long trips to New Mexico. Separation helped, as did the dizzying sense of being committed to her needs, the demands of her taste and talent. All the same, the triangle took a toll, reaching its crisis in 1932.

Walls again. That spring, O'Keeffe was invited to paint a mural in the women's powder room at the new Radio City

Music Hall. She agreed to the project despite minimal payment because she'd long fancied the challenge of painting 'big', summoning the largest of her visions. Stieglitz, who loathed public art and liked to control his wife's fees, was livid when he heard, co-opting his friends to simultaneously inform Georgia of her idiocy and persuade her to be more friendly to his mistress.

Never one to be swayed by a crowd, Georgia stuck firm, only to discover that the plaster of the new building wasn't going to be dry in time. Unable to apply paint, increasingly uneasy, she pulled out, and tumbled into a full-blown breakdown. She couldn't eat and wept for days on end. New York's crowded streets were appalling, and she became cripplingly agoraphobic. At the beginning of 1933, while her white flowers hung in Stieglitz's gallery, she was hospitalised for psychoneurosis.

<p style="text-align:center">★</p>

At the age of ninety-six, Georgia O'Keeffe was interviewed by Andy Warhol, another creator of a purely American vernacular. She told him about the landscape that was her most cherished home and subject, the wild expanses of New Mexico. 'I have lived up there at the end of the world by myself a long time. You walk around with your thing out in the field and nobody cares. It's nice.'

From the beginning, New Mexico represented salvation, though not in the wooden sense of the hill-dominating crosses she so often painted. O'Keeffe's salvation was earthy, even pagan, comprised of the cold-water pleasure of working unceasingly at what you love, burning anxiety away beneath the desert

sun. Back in 1929 she'd spent a summer in Taos with the painter Beck Strand. The pair were taken up by a local community of powerful independent women, among them Mabel Dodge Luhan, the formidable heiress and art patron, and the Honourable Dorothy Brett, a stone-deaf Englishwoman who carried a knife in her boots. A single scene epitomises the season's dykey aesthetics: O'Keeffe and Strand in swimsuits, washing the Ford they'd just learned to drive. In the absence of cloths they polished it with sanitary towels – Georgia was nothing if not enterprising – before stripping and giddily hosing each other.

New Mexico was nourishing, but part of its nourishment was the way everything was pared back to essentials, the flab cut away. Georgia was getting down to the bones of things, loving the hard, stripped land and the tough, stringent way it forced her to live. Bones were beautiful, with their apertures and cavities, their bleached resilience. She painted them suspended impossibly against the sky, pink and white calico roses tucked coquettishly where ears once were. In 1931 she'd set a cow skull against draped stripes of red, white and blue. As Randall Griffin observes in *Georgia O'Keeffe*, it was another territory grab, 'calculated to provoke and to cast O'Keeffe as an emphatically national artist', not a woman gazing at her own genitals but an American, bent on capturing the nation.

After her breakdown in 1933, she dispensed with half measures. She had compromised emotionally and it had almost destroyed her; now her primary commitment would be to her own work. Summers were henceforth spent in New Mexico, while the winter's mad socialising went on without her. As a

consequence of her increased happiness, things ran better between her and Stieglitz, though he missed her painfully, bemoaning her absence in long tormented letters. His growing frailty exposed the gulf of years between them, but also the abiding nature of their bond. The knack of arranging things in idiosyncratic ways might have been Georgia's greatest gift, extending from the construction of her paintings to how she solved the puzzle of reconciling two people's competing needs.

Her base in those years was Ghost Ranch, a dude ranch in Rio Arriba County. Initially she rented a room, but in 1940, as her commitment to the place grew, she bought a small adobe house. 'As soon as I saw it, I knew I must have it,' she said, adding in a letter to Arthur Dove: 'I wish you could see what I see out the window – the earth pink and yellow cliffs to the north – the full pale moon about to go down in an early morning lavender sky . . . pink and purple hills in front and the scrubby fine dull green cedars – and a feeling of much space – It is a very beautiful world.'

What she liked to do was look and then retreat, spending days at a time deep in the landscape, making sketches in the back of her Ford. In Manhattan for the winter, she painted from memory, dispensing with all but the essentials, trying to capture the heart of it: the scent of sagebrush and cedar, the way it felt at dusk like you could climb a ladder right into the sky, the faraway brought magically nearby.

In May 1946 O'Keeffe had a retrospective at the Museum of Modern Art, the first for a woman artist. Later that summer, Stieglitz was struck by a kind of seizure. When notified by his doctor, O'Keeffe elected to remain at Ghost Ranch. He seemed

to recover, only to suffer a massive stroke. No time to pack. A plane, and then a bedside vigil, taken in turns with the hated Dorothy Norman.

He died in the small hours of 13 July, and Georgia buried him in a plain pine coffin. It had a pink satin lining, and on the night before the funeral she ripped it out and sewed a new one from white linen. An elegant anecdote, though it might be added that she did not cremate Stieglitz with her watercolour *Blue Lines*, as he'd asked her to years before, and that in the grieving days after his death she rang Norman and banished her from the gallery for good.

*

'As you come to it over a hill, it looks like a mile of elephants – grey hills all about the same size with almost white sand at their feet,' O'Keeffe wrote of the Black Place, a remote range of ashy hills that inspired her more than any other location. The paintings she made there tip geological form over the threshold of abstraction: the serried hills smashed into shards of grey and puce, bifurcated by yolk-coloured cracks or spills of oily black.

Hills like elephants sounds an echo of Hemingway, and there is something of his habits of compression at work in O'Keeffe, a desire to erase everything extraneous, to convey emotion without confessing it directly. She painted very flat, making surfaces so smooth she once compared the sensation to roller-skating. The risk here is blandness, but it can also pro-duce – *The Black Place*, 1943, say – cleanly assembled structures that quiver with unvoiced feeling.

After she had dealt with Stieglitz's estate, O'Keeffe abandoned

the city for good, wedding herself to this enigmatic place. She'd bought the Abiquiú house a few months before his death, for $10. It took a decade to rebuild, the bulk of the labour done by her friend and housekeeper Marie Chabot. Finished, it looked and felt like being inside a shell. The rooms were kept almost empty, the nun-like daybed and long stripped table floating in whitewashed space.

Elegance shares a border with crankiness, independence with selfishness, and O'Keeffe was by no means a saint. As she grew older, she became more ornery, battling with friends and staff alike. At the same time, she made a garden in the desert, a fruitful life composed of hard, keen work, one eye always out for a new subject. Her last great series came in the mid-1960s: the sky above clouds, a perspective she'd been thrilled to discover from aeroplane windows. These are the strangest of her paintings, almost childlike in their simplifications and cradle-colours, the white clouds floating like lily pads on rapturous expanses of blue and pink.

Live long enough and you might find yourself the toast of a new generation. In 1970, O'Keeffe was the subject of a substantial retrospective at the Whitney. Again, the honour was accompanied by a serious blow. 'I'd been to town and was going home,' she told Warhol. 'And I thought to myself, "Well the sun is shining, but it looks so grey." ' The greyness was the beginning of macular degeneration, which would claim first her ability to paint, and then her capacity to see.

And then a stranger came knocking, a beautiful young man, though as in a fairy tale he had to try three times before he was granted admittance. Juan Hamilton was twenty-seven, a drifter

with artistic ambitions. Despite the age gap, a closeness developed between them. O'Keeffe doted on Hamilton, encouraging his pottery and allowing him to take increasing control of her finances, her houses and her friendships.

In 1978 she signed an unwitnessed document giving him power of attorney, shortly after which he purchased a mansion and three Mercedes in her name. And when she died on 6 March 1986, at the age of ninety-eight, a 1984 codicil to her will revealed that she'd left him the majority of her estate, although all previous wills had prioritised charitable donations.

In the contentious aftermath, an unpleasant story emerged from the house staff, who said that the day the codicil was signed, O'Keeffe had believed she was marrying Hamilton; dressed in white and surrounded by flowers, she had not understood what she was signing. The family went to court, and after complex negotiations Hamilton agreed to hand over a substantial amount of the estate to create the non-profit Georgia O'Keeffe Foundation.

It was a messy end, though what it perhaps reveals is the immense control that simplicity, elegance and calm require. Without O'Keeffe's sharp-eyed, sharp-tongued, exacting presence, chaos loomed. She made it happen, those simple scenes that are anything but, opening a door to a new way of portraying her country, a new kind of woman's life. 'Making your unknown known is the most important thing,' she said, 'and keeping the unknown always beyond you.'

Close to the Knives

DAVID WOJNAROWICZ

March 2016

YOU MIGHT NOT BE familiar with the American artist and activist David Wojnarowicz's name, but if you're of a certain age, you've probably seen at least one image by him. His photograph of buffalo tumbling off a cliff was used as the cover of U2's *One*, taking his art to a global audience a few months before his death in 1992 of Aids-related complications. Wojnarowicz was only 37 when he died, but he left behind an extraordinary body of work, particularly considering the uncongenial circumstances of much of his short life. A refugee from a violent family, a former street kid and teen hustler, he grew up to become one of the stars of the febrile 1980s East Village art scene, alongside Kiki Smith, Nan Goldin, Keith Haring and Jean-Michel Basquiat.

His paintings were what made him famous – livid, densely symbolic visions, a kind of twentieth-century American Dreamtime. But paint was by no means his only medium. His first serious work of art, made in the early 1970s, was a compelling series of black and white photographs of a man wearing a paper mask of the poet Arthur Rimbaud. This enigmatic,

expressionless figure drifts through the piers and diners of New York, a dispossessed flâneur.

In the years that followed, Wojnarowicz worked with film, installation, sculpture, performance and writing, making things that testified to his perspective as an outsider, a gay man in a homophobic and violent world. One of the greatest and most abiding of all these works is *Close to the Knives*, an autobiography-cum-essay collection first published in America in 1991. A memoir of disintegration, he called it, alluding both to its chopped-up, collaged structure and to the landscape it maps: a place of loss and danger, of transient beauty and resistance.

Wojnarowicz was driven to document the undocumented, to record and bear witness to scenes that most people never encounter. As a small boy, he and his siblings were kidnapped by their alcoholic father. In the suburbs of New Jersey they were beaten repeatedly, while neighbours pruned their flowers and mowed their lawns. Later, during the plague years of the Aids crisis, he watched his best friends die horribly, while religious leaders pontificated against safe-sex education and politicians advocated quarantine on islands.

It filled him with rage, the brutality and the waste: 'and I want to throw up because we're supposed to quietly and politely make house in this killing machine called America and pay taxes to support our own slow murder, and I'm amazed that we're not running amok in the streets and that we can still be capable of gestures of loving after lifetimes of all this.'

★

Knives opens with a visceral essay about Wojnarowicz's home-less years: a boy in glasses selling his skinny body to the paedophiles and creeps who hung around Times Square. He recalls days on broiling Manhattan blocks when he was so exhausted and malnourished he began to hallucinate that rats were carrying children's arms and legs in their mouths. As a young man, Wojnarowicz had been inspired by the Beats, and that rangy, jagged tone is everywhere in his work, conjuring the strident world of the streets with an energy that recalls John Rechy's *City of Night* or Genet's *The Thief's Journal*.

Being homeless was a nightmare that took years to emerge from, but the streets were also a place of wildness and freedom, a source of attraction throughout Wojnarowicz's life. Much of the most beautiful writing here concerns cruising on the dere-lict Chelsea piers, looking for sex in the vast decaying rooms that extended out over the filthy Hudson River. 'So simple,' he writes, 'the appearance of night in a room full of strangers, the maze of hallways wandered as in films, the fracturing of bodies from darkness into light, sounds of plane engines easing into the distance.'

What does it mean if what you desire is illegal? Fear, frus-tration, fury, yes, but also a kind of political awakening, a fertile paranoia. 'My queerness,' he once wrote, 'was a wedge that was slowly separating me from a sick society.' In an essay entitled 'In the Shadow of the American Dream', he describes what it's like to live like this, with the knowledge that 'some of us are born with the cross-hairs of a rifle scope printed on our backs or skulls'. Out on the road, driving across the deserts of Arizona, he picks up a stranger in the restroom at Meteor Crater. They

drive down a service road to embrace: two humans licking each other's bodies, each with one eye fixed to the windscreen, the rear-view mirror, watching for the spark of a trooper car in the distance; each knowing that their act of desire could lead to a beating or prison, even to death.

*

And then death did come, in the most brutal way imaginable. The blind terror of life in the plague years: 'the people waking up with the diseases of small birds or mammals; the people whose faces are entirely black with cancer eating health salads in the lonely seats of restaurants.' One by one, friends die; 'piece by piece, the landscape is eroding and in its place I am building a monument made of feelings of love and hate, sadness and feelings of murder.'

The heart of *Knives* is the title essay, which deals with the sickness and death of the photographer Peter Hujar, Wojnarowicz's one-time lover, his best friend and mentor, 'my brother my father my emotional link to the world'. Nothing I have ever read matches the fury and grief of this writing, the sheer horror of watching a loved one flailing against a premature death sentence. There was no reliable treatment for Aids back then. Wojnarowicz describes a nightmarish drive with the emaciated, furious Hujar to Long Island to visit a doctor who claims to have had good results with typhoid shots. He isn't really a doctor, it turns out, though his waiting room is filled with dozens of desperate Aids patients.

Hujar died on 26 November 1987. Unflinching as ever, Wojnarowicz recorded his passing, standing by his body to take

twenty-three photographs of 'his amazing feet, his head, that open eye again', before raising his hands in helplessness and breaking down. Ragged with grief, he was plunged into a confrontation with mortality, especially after his own diagnosis a few months later. As a young man, he'd often engaged in self-destructive behaviour, dabbling with heroin, treating himself with reckless disregard. Now he wanted to grapple with those dark impulses, to understand their cause.

In the final, gargantuan essay, 'The Suicide of a Guy Who Once Built an Elaborate Shrine Over a Mouse Hole', he investigates the suicide of a friend, mixing his own reflections with interviews with members of their shared circle. Again, the writing is remarkable: a full-bore, high-stakes confrontation with mortality. It closes with an unsparing description of a bullfight in Merida, Mexico. An incantation repeats like a tolling bell: 'Smell the flowers while you can.' It sounds simple, until you remember the many forces geared against health and love, the courage it took to commit to pleasure.

*

Of all the many voices from the margins, Wojnarowicz is among the most commanding, writing at a pitch of white-hot urgency. And yet *Close to the Knives* is not simply a diatribe, let alone anything resembling dry political analysis. Instead, it's a kind of intensely alive hybrid: a work of radical honesty that uses the most intimate of experiences, particularly sexual, as a way of prying open the devastating way in which political systems work to exclude and silence the unwanted.

'It is exhausting, living in a population where people don't

speak up if what they witness doesn't directly threaten them.' Wojnarowicz was not only alert to his own experience. Politicised by his sexuality, by the violence and deprivation he'd experienced, he was attentive to anyone whose experience was erased by what he called 'the pre-invented world' or 'the one-tribe nation'. During the course of *Knives* he touches repeatedly on other struggles, from police brutality towards people of colour to the erosion of abortion rights.

It's twenty-four years since Wojnarowicz died, and yet his struggle has lost none of its relevance. We might like to think that the world he documented ended with combination therapy, or with marriage equality, or with any of the other liberal victories of the past two decades. But the forces he spoke out against are as lively and malevolent as ever. Even his old enemies are back in circulation.

The presidential candidate Ted Cruz is on record praising the late Senator Jesse Helms, a civil-rights opposer dedicated to fighting federal funding for work by gay artists (Wojnarowicz was a particular target). As for Hillary Clinton, she provoked a furore by celebrating the Reagans at Nancy Reagan's funeral for starting a national conversation on Aids, 'when, before, nobody would talk about it'. As if. In fact the Reagan administration was notable for its long refusal to mention the issue of Aids, a silence that had appalling consequences.

As the rallying cry of Aids activists made clear, 'Silence = Death'. From the very beginning of his life Wojnarowicz had been subject to an enforced silencing, first by his father and then by the society he inhabited: the media that erased him, the courts that legislated against him and the politicians who

considered his life and the lives of those he loved expendable.

In *Knives* he repeatedly explains his motivation for making art as an acute desire to produce objects that could speak, testifying to his presence when he no longer could. 'To place an object or piece of writing that contains what is invisible because of legislation or social taboo into an environment outside myself makes me feel not so alone,' he writes. 'It is kind of like a ventriloquist's dummy – the only difference is that the work can speak by itself or act like that magnet to attract others who carried this enforced silence.'

Clinton apologised for her statement at Nancy Reagan's funeral, but that didn't entirely quell the furore. Within hours of her comment, a photograph began to circulate on social media. It showed a lanky man from behind, wearing a denim jacket hand-painted with a pink triangle and the words IF I DIE OF AIDS – FORGET BURIAL – JUST DROP MY BODY ON THE STEPS OF THE F.D.A. (the Food and Drug Administration, then dragging its feet over Aids research).

It was Wojnarowicz, of course: still finding novel ways to be heard, to counter untruths. Not long before he died, he made a photograph in the desert of his own face, eyes closed, teeth bared, almost buried beneath the dirt, an image of defiance in the face of extinction. If silence equals death, he taught us, then art equals language equals life.

A Great Deal of Light

SARGY MANN

January 2019

I LIKE THIS ROOM. It's on the edge of things, not quite open, not quite closed, a little lightbox high above the sea. People, maybe the same four, five, six people, gather there in bathing suits, slouching on the mint/buttercup/tangerine-coloured couch, wrapped in a white towel or fiddling with their hair. A girl in a black bikini kneels at the window, elbows on the sill. The sun licks her ankles, casts a rose-pink wash, bowls long shadow legs right through the picture plane.

The room has an unusual geometry, what Sargy Mann, talking into his tape recorder, might have described as *very exciting*. It's up a flight of steps. There is no door, only an open balustrade. Sometimes a figure approaches, often a man in a white shirt and hat. All of these paintings draw from the well of Matisse; all could be titled *Luxe, Calme et Volupté*, and not just for the repeating architecture of infinity pools, the expensive chlorine rectangle lapped by a receding bar of ultramarine. They are testimonials to the abundant pleasures of light and space, the idle hour between swim and beer when everyone drifts into the same small room to pass the time together.

Sargy Mann began what he sometimes called the *Little Sitting Room* or *Infinity Pool* paintings in 2010 and worked on them for the last five years of his life. He'd gone completely blind five years before, when a detached retina in his left eye put paid to the final vestiges of his vision. His sight, never good, had diminished incrementally over decades, starting in 1972 with the diagnosis of cataracts. Though it should be catastrophic for a painter, there were compensations to diminished vision. For a start, he had to look far harder than most people, to puzzle out all the components of a scene – depth, colour, geometry, light – rather than relying on the misleading instantaneity of so-called perfect sight, the simplifications and frank corruptions the brain makes out of constantly seething visual data.

In her 1974 essay 'Seeing', Annie Dillard writes covetously about the experiences of a group of people blind from birth who recovered their sight after cataract operations in the nineteenth century. Their brains hadn't ever learned how to make sense of visual information and so for a time they saw the world unprocessed and unsorted: a flat, depthless dazzle of colour patches, some bright and some so black they looked like holes. Trees glowed like flames; each visitor had a madly unique face. If only someone had given them brushes, Dillard writes, 'then maybe we all could see colour-patches too, the world unravelled from reason'.

Like Monet, one of his favourite painters, Mann had yellow-brown cataracts, which meant that after they were removed his brain continued to compensate for the diminishment of cool colours. For weeks, blues, greens, violets and magentas were

almost painfully magnificent, an 'Aladdin's cave' of heightened visual intensity that filled his landscapes of the period with chinks and streamers of near-Fauvist colour. Years later, in India, everything abruptly turned a wonderful apricot, palm trees marmalade, sea fig-pink.

Sometimes he saw spectral haloes; when his sight was very poor, he assembled a view piecemeal by gazing at it through a telescope given to him by Moorfields Eye Hospital. Audio diaries and collages of enlarged photographs took the place of sketchbooks. Suffering from oedema of the cornea, he took a hair dryer to the National Gallery, plugged it in and calmly dried his soggy, waterlogged eye in order to see the paintings. There was always a way of adjusting, capitalising on as well as compensating for the shift.

That said, total blindness might have marked the end of his time as a painter (he glumly contemplated sculpture), if it hadn't been that his head was already full of pictures. Two days before the detached retina, he'd come back from a trip to Cadaqués, a fishing village in northern Spain, where he'd been casting around for new subjects with the help of his son Peter. In the audio diaries he made there, you can hear his combined excitement and bafflement as, tapping up and down steps with his white stick, he'd discovered exactly the kind of complex, dazzlingly coloured view he loved to paint.

Pottering about in the now-permanent darkness of his studio, he remembered the presence of a stretched canvas. Might as well give it a shot. His palette was always laid out in the same configuration. He rarely mixed colours in advance, but scumbled, glazed or layered directly on the canvas. To his

surprise, it wasn't as hard as he'd expected. He could play blind-fold chess and this was a not dissimilar process. What mattered was constructing and adjusting the image in his mind, measuring and re-measuring with his stick, making a kind of haptic map or under-drawing with lumps of Blu-Tack before laying on the zones of colour. 'It was difficult all right,' he said, 'but it had always been difficult.'

The Cadaqués paintings came fast, culminating in 2006's *Black Windows*, with its strange, divergent, guileful perspective. The sombre figure looking through light into blackness could be read metaphorically, were it not for the abundant distractions along the way, the lush, almost abstract slabs of Schmincke magenta, emerald green and yellow ochre. 'Still,' as Van Gogh wrote to Theo in 1882, 'a great deal of light falls on everything.'

Taught by Frank Auerbach and Euan Uglow in the early 1960s, Mann came up under the influence of the School of London, but before he went to art school he had trained as an engineer. It was those skills he drew on now, as well as the deep reservoir of a life's accumulated close seeing. He was trying to do what he had always done: figure out how to resolve three dimensions into two; represent curved space on flat; shrink without distorting; get a sense of believable space that wasn't illustrative but rather captured what being there had actually felt like. Like Bonnard he rarely painted in front of the actual scene. Doing it in the dark was a challenge, but not – measuring stick in hand – an impossibility.

After the Cadaqués paintings were finished, the difficulty was what to turn to next, since no new landscapes in Portugal or Italy would be discoverable. For a while he painted his wife

Frances sitting in a chair, a set-up apprehended entirely by way of touch. It was while he was working on these paintings that he realised he was no longer tethered by the reality of colour. 'You silly bugger,' he said to himself when he got up to cover the ugly brown chair with a white dust sheet, 'you won't be able to see it. You can make the chair any colour you like.' If he couldn't see colour, he was no longer under an obligation to record it accurately, but could instead assemble colour chords that were purely decorative. At last, his paintings could be as saturated as he liked.

The problem of a subject lingered. Back in 2001, he'd designed a sitting room at the top of the stairs in his Suffolk house, with a glass wall on one side. He'd always found it a fascinating space to paint. The light fell from multiple angles and there was the curious black hole of the stairwell. On 4 September 2008, he came in from his studio to get a jersey. Lingering on the stairs, he was astonished to realise that the configuration of balustrade and steps was very close to that of Bonnard's terrace at Ma Roulotte.

Mann was passionately interested in Bonnard. He went to the 1966 retrospective at the Royal Academy twenty-four times, and in 1994 had co-curated *Bonnard at Le Bosquet* at the Hayward Gallery. It wasn't just the free, intuitive use of colour he loved, but also the radical treatment of space, in particular Bonnard's wide angles, his constant nudging of how much you could cram inside the frame (a field of view of 60 degrees was common; Mann found two paintings that spanned an 'incredible' 130 degrees). Mann too was always expanding the field of vision, greedy to capture the periphery of the gaze.

Still standing on the stairs of his house, he began to talk animatedly into his tape recorder, walking himself inch by inch towards an entirely new approach. *Imagined painting. Felt myself moving in that familiar, exciting space of the stairwell. Perhaps having the sea through the windows. Space and architecture out there is very reminiscent. Absolutely no reason why not. A whole wallop of sea. Very exciting.*

For a start, the sitting room had the virtue of being small. He could populate it with real, known people: his wife, his sons and daughters, standing or sitting at the necessary fingertip reach by which he was confined. The walls, the steps: all this was accurately mappable. He could be, as he put it, 'answerable' to it. But what happened outside could be assembled more freely. As with colour, so with landscape: what he could no longer perceive he was legitimately free to invent.

As a little boy in the 1940s Sargy loved making camps and dens. The pleasure of building spaces from which you could see and not be seen became more acute after his father, with whom he did not get on, returned from the war. Something of this childish glee animates the *Little Sitting Room* paintings: the sense of being in a safe place, at once contained and open, with multiple escape routes. Louise Bourgeois, by no means an influence of Mann's, attested to a similar kind of pleasure in containment in her sculptural installations *Cells*, describing them as 'a place to go, a place you need to go, a transitory protection'.

In a funny way, Mann's blindness set him free, not least in terms of colour. He'd always shied from the figure, preferring unpopulated or at best distantly or vaguely peopled landscapes. Now, he was brought forcibly to the human body. After his

blindness, figures had to be touchable, which meant they loomed large in the frame, especially considering the enormous heft of his canvases. Like Bonnard's wife, towelling herself three or four feet away from her husband, the figure's closeness presented appealing problems of perspective, not least the ongoing desire to avoid foreshortening, to maintain real anatomical proportions.

As too with Bonnard's wife, the closeness of bodies in Mann's late paintings also carries an emotional charge for the viewer, since we do not normally find ourselves so close to other people, especially when they are practically naked, unless we are intimate with them. At the same time, a possible overspill of tenderness is resisted by the featurelessness of the figures, their blocky, bulky quality, as well as the strangeness of the perspective and the rigorous geometric accounting. It's this weird warmth/coolness as much as the stupendous palette, the deft unseeing strokes of a master colourist, that accounts for the depth charge of these paintings. Nothing much is happening, but everyone that matters is in the room.

Sparks through stubble

DEREK JARMAN

January 2018

I FIRST CAME to *Modern Nature* a year or two after its publication in 1991, certainly before Derek Jarman's death in 1994. It was my sister Kitty who introduced me to his work. She was ten or eleven then and I was twelve, maybe thirteen.

Strange kids. My mother was gay, and the three of us lived on an ugly new development in a village near Portsmouth, where all the culs-de-sac were named after the fields they'd destroyed. We were happy enough together, but the world outside felt flimsy, inhospitable, permanently grey. I hated my girls' school, with its homophobic pupils and prying teachers, perpetually curious about the 'family situation'. This was the era of Section 28, which banned local authorities from promoting homosexuality and schools from teaching its acceptability 'as a pretended family relationship'. Designated by the state as a pretended family, we lived under its malign rule, its imprecation of exposure and imminent disaster.

I can't remember now how Derek first entered our world. A late-night Channel 4 screening of *Edward II*? Kitty was immediately obsessed. For years she'd watch and re-watch his

films in her room late at night, Jarman's most unlikely and fervent fan, bewitched in particular by the scene of Gaveston and Edward dancing together in their prison, two boys in pyjamas moving together to the sound of Annie Lennox singing 'Every Time We Say Goodbye'.

It was the books that did it for me. I fell for *Modern Nature* at once. Returning to it this winter I was astounded to see how thoroughly my adult life was founded in its pages. It was here I developed a sense of what it meant to be an artist, to be political, even how to plant a garden (playfully, stubbornly, ignoring boundaries, collaborating freely).

I became a herbalist in my twenties under its lingering spell, charmed by the endless litanies of plant names – woody nightshade, hawkweed, restharrow – interspersed with fragments from old herbals, Apuleius and Gerard on the properties of the sorcerer's violet and the arum lily. When I came to write my first book, *To the River*, it was Jarman's voice I channelled.

In the early 1990s, Derek was always in the paper or on the radio. He was one of the very few well-known people in Britain to make his HIV status public, and so he became a kind of figurehead. 'I've always hated secrets,' he explained of his decision, 'the canker that destroys.' He was vocally incensed by the prejudice, the censorship, the lack of research and funds, but he was also charming, witty and full of mischief.

He feared the announcement would threaten the viability of his future as a film-maker, since he could no longer be insured. He knew too that he'd be the subject of tabloid hate, a visible target for Aids panic. It wasn't paranoia. In his 2017 diary for the *London Review of Books*, Alan Bennett recalled

sitting behind Jarman at the 1992 premiere of *Angels in America*. He'd slightly grazed his hand on the way to the theatre and was 'desperate lest Jarman turn round and shake hands. So I shame-fully kept mum.' In the interval he raced upstairs and got a plaster, after which he felt able to say hello. Bennett relayed the story, he explained, 'as a reminder of the hysteria of the time, to which I was not immune'.

It's hard to express how bleak and frightening those years were. There was no internet, that addictive mutation of Dr Dee's magical mirror. You knew so little. Even sick, Derek was a testament, blazing, blatant, to possibility. We looked at him and knew there was another kind of life: wild, riotous, jolly. He opened a door and showed us paradise. He'd planted it himself, ingenious and thrifty. I don't believe in model lives, but even now, a quarter century on, I ask myself, what would Derek do?

<p style="text-align:center">★</p>

Derek Jarman began the diary that became *Modern Nature* on 1 January 1989 by describing Prospect Cottage, the tiny pitch-black fisherman's house on Dungeness beach he'd bought on impulse for £32,000, using an inheritance from his father. After decades in London, he finally had the opportunity to return to his first love, gardening.

At first glance, Dungeness was hardly a promising location for a besotted plantsman. Nicknamed the fifth quarter, it was a place unlike anywhere else, a microclimate of extremes, plagued by drought, gales and leaf-scorching salt. In this stony desert, overlooked by a looming nuclear power station, Jarman set

about conjuring an unlikely oasis. Like all his projects, it was done by hand and on a shoestring budget. Hauling manure, digging holes in the shingle, he cajoled old roses and fig trees into bloom with the same irrepressible charm he applied to actors.

In its early pages, *Modern Nature* reads not unlike Gilbert White or Dorothy Wordsworth, a scholarly account of local flora and fauna mixed with scraps of antiquarian lore. Jarman had a painter's facility for capturing the shifting tones of sea, sky and stone, and his sharp eyes were busy ferreting out unlikely abundance on the beach. Horned poppy and sea kale grew from the shingle; there were bluebells, mullein, viper's bugloss, broom, gorse, lizards and dozens of different types of butterflies.

But as he explained to the painter Maggi Hambling, his interests did not entirely square with those of a stately Victorian naturalist. 'Ah, I understand completely,' she replied. 'You've discovered modern nature.' The definition was ideal, encompassing both reeling nights cruising on Hampstead Heath and the waking nightmare of HIV infection. His capacity to write honestly about sex and death – self-evidently the most natural of states – makes much contemporary nature writing seem prissy and anaemic. Derek still seems to me the best as well as the most political nature writer, because he refuses to exclude the body from his sphere of interest, documenting the rising tides of sickness and desire with as much care and attention as he does the discovery of sea buckthorn or a wild fig.

Building a garden was Jarman's characteristically energetic, fruitful response to the despair of what was, pre-combination therapy, a near-certain death sentence. It was a stake in the

future, and it also led him into remembrance of the past. As he reacquainted himself with the plants he'd doted on as a boy – forget-me-not, sempervivum, clove-scented gillyflower – he was cast back to the gardens of his own peripatetic and unhappy childhood.

His father was an RAF pilot, and the family moved often. As a child Jarman had lived in sprawling splendour on the banks of Lake Maggiore in Italy, in Pakistan and Rome. While billeted in Somerset, a wall of the house gave way under a tidal wave of honey, made by wild bees that had congregated in the attic. A sensitive child, Derek found in gardens a zone of magic and possibility, a ripe alternative to the violent regimentation of military life. He remembered building nests from grass clippings and poring over the luxuriant coloured plates of *Beautiful Flowers and How to Grow Them* on rainy days. His father bandied floral insults: pansy, lemon; once, or so a relative said, he threw his small son through a window.

A garden, especially a neglected garden, was also powerfully erotic. At prep school, miserably adrift, temperamentally unsuited to the code of muscular Christianity, Derek had his first sexual experiences with another lost boy, licking and caressing in muddy ecstasy in a glade of violets. The lovely feeling, the boy called it. Inevitably they were discovered, the first and most agonising experience of being cast from Eden, a trauma he replicated in film after film.

School. He called it Paradise Perverted: beatings in place of embraces, the miserable little boys in their poorly fitting suits torturing each other, starved of affection, estranged from their bodies. He carried with him into early adulthood a corrosive

sense of shame, an inability to speak of, let alone act upon, his real desires. 'Frightened and confused, I felt I was the only queer in the world.'

Modern Nature is suffused with regret for this wasted time, the strangulated years before Jarman finally gathered the resolve to come out at art school and begin – joy of joys – having sex with men, that still illicit act, the paradise regained of reciprocated desire.

<center>★</center>

The classical education Jarman received marked him in more benign ways, too. It's plain even in the changeable weather of a diary that he oscillates continually between two selves, the rebel and the antiquarian. There's the wicked scourge of the system, yes, the queer experimenter who delights in making Mary Whitehouse wince. But there's also the traditionalist who doesn't possess a credit card and hides the fax machine in a laundry basket, who grieves the loss of rites and structures, the teeming vegetable gardens of Kent made obsolete by supermarkets, the Elizabethan bear pit in Bankside torn down by developers.

Jarman is not exactly nostalgic here, and certainly not in the Little England sense. He was against walls and fences; for conversation, collaboration, exchange. As he says on the very first page: 'My garden's boundaries are the horizon.' What enraptured him was a heraldic, romantic, maybe half-imaginary England. 'The Middle Ages have formed the paradise of my imagination,' he writes dreamily, 'not William Morris's journeyman Eden but something subterranean, like the seaweed and coral that floats in the arcades of a jewelled reliquary.'

As a student at King's College London in the 1960s he'd been taught by the architectural historian Nikolaus Pevsner, whose knowledgeable eye could detect the multiple timeframes at play in every haphazard English city or country scene. To Jarman there were times when it seemed the past ran very close, almost touchable – a feeling he shared with Virginia Woolf and which he made manifest in films like *Jubilee* and *The Angelic Conversation*, his time-travelling enchantments.

England's losses were melancholy. The sharper blade was Aids. Jarman's diary is punctuated by death, the premature and cataclysmic loss of so many of his friends. 'Old age came quickly for my frosted generation,' he writes grievingly, and dreams often of the dead. On Thursday 13 April 1989, he records a phone conversation with his beloved Howard Brookner, the brilliant young New York film-maker. Brookner had by then lost the power of speech and for twenty minutes communicated by way of a 'low wounded moaning', a devastation magnified by the technological wizardry that couldn't cure him but sent his voice speeding halfway round the earth.

Aids contributed too to a sense of impending apocalypse. Faced daily by the baleful spectacle of the power station Dungeness B, which one day appeared to explode in a cloud of steam, Jarman fretted over global warming, the greenhouse effect, the hole in the ozone layer. Would there be a future? Was the past irreparably destroyed? What to do? Don't waste time. Plant rosemary, red-hot poker, santolina; alchemise terror into art.

★

But wait! I don't want to neglect the other Derek, the mischief-maker, chatty and irrepressible as his neighbour's thieving crow, flirting in Compton's bar, gossiping and plotting over cakes from Maison Bertaux. He steals cuttings from every plant he sees, fulminates against tabloid editors, the National Trust, ticket machines and Channel 4 controllers, and then concludes disarmingly by revelling in his own good fortune, his late-flowering joy.

'HB, love,' a hospital scrawl. The deepest source of his happiness was the Hinney Beast, the nickname he bestowed on his companion, Keith Collins. Extraordinarily beautiful, Collins was a computer programmer from Newcastle. They met at a screening in 1987 and by the time the diary began were living and working together, shuttling between Prospect Cottage and Phoenix House, Jarman's tiny studio on Charing Cross Road.

'I'm an old colonel and he's a young subaltern,' Jarman told the *Independent* in 1993, for their 'How We Met' column, to which HB replied: 'Our relationship is very unusual – we're not lovers or boyfriends. I tell you what we're like: James Fox and Dirk Bogarde in *The Servant*. I'm always saying things like: "If I may be so bold, sir, my quiche comes highly recommended."' Shadow-boxing, popping out of cars like a Jack-in-the-box, taking three-hour baths, in which he balanced bowls of corn flakes and prayed with his head under water, HB is a vivid presence in *Modern Nature*. He teases and soothes Jarman, cooks his supper, acts in the films and makes even the editing suite run smoothly.

Film was a more intransigent beloved. 'I had foolishly wished film to be home, to contain all the intimacies,' Jarman

writes, but bringing his vision into the world required endless compromise and frustration. It was the giddy delight of the shoot he loved, the improvised, gorgeously costumed chaos, flying by the seat of his boiler suit, restaging images snatched from dreams.

The contemplative periods at Prospect Cottage were increasingly interrupted by a whirlwind of projects, as he attempted to squeeze decades of work into a handful of years. In the two years covered by the diary, Jarman made *The Garden* and the films for the Pet Shop Boys' first tour, which he also directed, as well as beginning work on *Edward II* and painting sometimes five canvases a day. There was so little time, so many ideas to make material.

All this activity came to an abrupt halt in the spring of 1990, when he found himself on the Victoria Ward of St Mary's Hospital, Paddington, battling TB of the liver while the poll tax riots raged outside. His hospital diaries are notable for their ongoing cheer, despite what was plainly agony and terror. Dressed in 'Prussian blue and carmine jimjams', he logged the torments of sight loss and drenching night sweats with curiosity and good humour. Returned to a state of absolute physical dependency, flooded by memories of his own unhappy infancy, he discovered to his abiding joy that he was surrounded by love.

*

The diary ends in hospital, the opening litanies of plant names replaced by those of the drugs that were keeping him alive. AZT, Rifater, Sulphadiazine, Carbamazepine, the grim lullaby of the early 1990s. But Jarman would rise from his

hospital bed and go on to make *Edward II*, *Wittgenstein* and *Blue*, his magisterial late films. He crammed much more than seems possible into the next four years, before dying at the age of fifty-two.

I wish he'd had longer. I wish he was still here, buoyant and fizzing, cooking up something out of practically nothing. The range and scale of his work is dizzying: eleven feature films, each pushing the bounds of cinema, from *Sebastiane*'s Latin to *Blue*'s unchanging screen; ten books; dozens of Super-8 shorts and music videos; hundreds of paintings; set designs for Frederick Ashton's *Jazz Calendar*, John Gielgud's *Don Giovanni*, and Ken Russell's *Savage Messiah* and *The Devils*; not to mention the iconic garden.

There's no one like him now. The other day I read a tweet from a journalist defending people who write gutter pieces by saying: 'Journalism is a dying industry and writers need to pay their rent. We're certainly not rich enough to choose our morals over the need to survive.' I could imagine Derek laughing at that. His whole life was a refutation of her shabby logic. Imagine thinking morals are a luxury for the super-rich!

He saw film as a dying industry and still he kept on making them, not waiting for funding or permission but picking up a Super 8 and assembling a cast of friends. When he and the designer Christopher Hobbs needed a set in *Caravaggio* to look like Vatican marble, they painted a concrete floor black and flooded it with water, an illusion of plenitude that was somehow plenitude in its own right, because of its imaginative richness: a richness comprised not of hard cash, but of resourcefulness and effort. His entire fee for *War Requiem* was £10. He

had enough to eat, what else was there to do but the work he loved? On always to the next thing. 'The filming, not the film.'

Here's another line that has stayed with me for more than twenty years. It's from *Modern Nature*, and recurs in *Chroma* and *Blue* (Derek was an inveterate recycler of favourite shots and lines). It's borrowed loosely from the Song of Solomon, a more gentle relic of the Christianity that had made his childhood so bitterly unhappy.

> For our time is the passing of a shadow
> And our lives will run like
> Sparks through the stubble.

It's how we all go, in and out of the dark, but oh, to have given off such a blaze.

FUNNY WEATHER:
FRIEZE COLUMNS

A Stitch in Time

December 2015

THE LIGHT'S BEHIND THEM. Four men, somewhere on the border between Greece and Macedonia. Can't go forward, can't go back. The man on the left has his eyes closed. He's unshaven, a single freckle on his temple. The light is tangling in his hair, running down his forehead and catching on his chin. Head bowed, careful as a surgeon, the man opposite him is sewing up his mouth. The blue thread runs from lip to hand. The sewn man's face is absolutely still, upturned to the sun.

I don't know where I first saw this photograph. Maybe it washed up on my Twitter feed. Later, I searched for it again, typing 'refugee lip sewing' into Google. This time there were dozens of images, almost all of men, lips sewn shut with blue and scarlet thread. Afghan refugee, Athens. Australian immigration centre in Papua New Guinea. *Stuck on Balkan borders, a first smattering of snow.*

The mouth is for speaking. But how do you speak if no one's listening, how do you speak if your voice is prohibited or no one understands your tongue? You make a migrant image, an image that can travel where you cannot. An Afghan boy who spent three years on Nauru, the off-shore processing camp for refugees trying to reach Australia, told the website *Solidarity*:

'My brother didn't sew his lips but he was part of the hunger strike. He became unconscious and was sent to the hospital. Every time someone became unconscious we would send a picture to the media.'

The first time I encountered lip-sewing as protest was in Rosa von Praunheim's 1990 Aids documentary, *Silence = Death*. One of the interviewees was the artist and activist David Wojnarowicz. A former street kid, a gay man who had recently been diagnosed with Aids, he talked with great eloquence and fury about the different kinds of silence ranged against him. He spoke of what it had been like to grow up queer, the need to keep his sexuality secret because of the omnipresent threat of violence. He spoke of the silence of politicians, whose refusal to confront Aids was hastening his own oncoming death. And as he talked, footage he'd collaged together appeared on screen: a kaleidoscope of distress, later titled *A Fire in My Belly*. Ants crawl over a crucifix; a puppet dances on its strings; money pours from bandaged hands; a mouth is sewn shut, blood trickling from puncture wounds.

What is the stitched mouth doing? If silence equals death, the biting slogan of Aids activists, then part of the work of resistance is to make the people who are being silenced visible. Carefully, carefully, the needle works through skin, self-inflicted damage announcing larger harm. 'I think what I really fear about death is the silencing of my voice,' Wojnarowicz says. 'I feel this incredible pressure to leave something of myself behind.'

You make an image to communicate what is unsayable in words. You make an image to go on beyond you, to speak when you no longer can. The image can survive its author's

death, but that doesn't mean it is immune to the same forces of silencing that it protests. In 2010, nearly two decades after Wojnarowicz died of Aids at the age of thirty-seven, *A Fire in My Belly* was removed from a landmark exhibition of gay art at the Smithsonian, following complaints from right-wing politicians and the Catholic League. This time, the stitched mouth became a symbol of censorship. At protests, people held up posters of Wojnarowicz's face, lantern-jawed, implacable, five stitches locking shut his lips.

Both images are in front of me now. Stitches in time, reporting from the past. David is dead. God knows where the man on the Greek border is. In other photos from the same protest, men sit or stand on train tracks, holding hand-lettered signs on scraps of dirty cardboard: *ONLY FREEDOM* and *OPEN THE BORDER*. They are bare-chested, in blankets, ranked against police with riot shields and bullet-proof vests. The word 'stitch' is a double-edged prayer. It means the least bit of anything – the stigmatised, say, or the devalued. And it means to join together, mend or fasten, a hope sharp enough to drive a needle through flesh.

Green Fuse

March 2016

THE DAYS ARE OPENING UP, the streets covered in a rain of blossom. Slow burn, the torch of spring lit, a time-lapse rush of green. Maybe I'm looking harder this year. Bad news keeps drifting in. Chris has lost her sight. Last summer, two tiny tumours seeded in her brain, located just beneath her optic nerve. As they grew, her vision deteriorated. By winter, the lights had gone out altogether.

Nature is a strange factory, relentless in its productivity. We like to think life and death are opposite states, but it's all tangled up together, the cherry blossom and the cancer: a never-ending production of more, a monstrous fecundity – Dylan Thomas's green fuse that drives the budding flower but also blasts the roots of trees.

I've been thinking about that force, running implacably through roots and branches. A few months ago, a friend intro-duced me to the work of Rachel Kneebone, an artist who creates monumental, frighteningly complex sculptures out of porcelain. I've never seen anything that so purely captures the indifference of vitality, the way life is always shifting into death and out again.

Kneebone builds towers, or maybe pits, of body parts:

hundreds upon thousands of elegantly extended, gleaming legs, triumphant and appalling. You look and see a flower; you look again and see a cock. What are these excrescences, that might be animal or mineral or vegetable, that might be melted wax or human hands? They can't help but recall the worst obscenities of human behaviour, the genocidal reduction of individuals to piles of limbs, and at the same time they are weirdly ecstatic, a smorgasbord of mutating forms.

My friend has a piece by Kneebone: a porcelain bough caught in the act of bursting into bloom. Last night, I went to look at it. Cupped fleshy petals, tendrils that resemble veins, shaped and glazed and fired and hung on the white wall. The cat was sleeping beneath it on his chair. As I stood there, my phone rang. A New York number. PJ is dead. PJ has died at the age of twenty-seven.

It isn't academic, art. It's about emergency exits and impromptu arrivals, things coming and going through the ghastly space where a person once was. That same day I'd been to the *Death on the Nile* exhibition at the Fitzwilliam Museum in Cambridge. The dim and crowded rooms were filled with century after century of Egyptian objects made to contain the dead, from jars made of river mud to the most elaborate of anthropoid coffins.

The coffins weren't just receptacles for bodies. They were conversion chambers, places in which the soul, the *ka*, could temporarily take refuge. Some were fantastically decorated with images meant to facilitate resurrection in the afterlife. The wooden coffin of Henenu had been painted with a pair of eyes on the eastern side, so that the occupier could magically see the

rising sun and so be restored to life. Others were filled with icons designed to host the *ka*, or provide for it in the other-world.

These objects attested to a leaky universe, a perpetual-motion machine, energy rushing from form to form, a vast migration through space and time. In this transcendental vision, the human body was just another vessel, a decorated shell. Towards the end of the show I came across a vitrine dedicated to the burial of Nakhtefmut. His body had been lost or discarded by tomb robbers or Victorian curators, but the objects that accompanied it were still intact. Four battered statuettes, with the carved heads of a baboon, a jackal, a falcon and a man; stubborn attendants to a long-completed disappearing act.

Beside them was a small blackened object. A bouquet of dried spring onion and garlic, the wall text explained, threaded onto shards of palm, picked in some fertile delta three thousand years ago. There it was again: Thomas's green fuse, now dark with age, still humming with the power that once passed through it.

You are welcome

June 2016

16 JUNE 2016: a bad day. In the morning I saw a video on Twitter of British football fans throwing coins at refugee children in the streets of Lille, followed by a photograph of Nigel Farage posing against a hoarding showing a long line of Syrian refugees, walking away from a war zone, walking heads bowed through foreign fields. A few hours later, an MP was shot dead outside a library with a home-made gun. That same week in America, forty-nine people were murdered at Pulse, a queer club in Orlando. On the campaign trail, Trump compared immigrants to snakes. At his rally in Greensboro a journalist overheard: 'Immigrants aren't people, honey.'

Like you, maybe, I'm trying to make sense of this summer, to work out the best way to respond. Here's a thing that's stuck in my mind. Late last autumn I went to see John Berger speak at the British Library. Eighty-nine, his face craggy, bent almost double with arthritis. Someone in the audience asked him about refugees, how we should react to the crisis, and he sat there tugging at his shock of white hair, as he did after every question, physically wrestling with his thoughts. And then he said: 'With hospitality.'

I don't want to write another word about Trump or guns

or hatred. Instead I want to write about spaces where hospitality happens. First, a fisherman's hut at the Whitstable Biennial. Inside I watched *Boat People*, a short film by Sarah Wood about migration, from the earliest humans walking their way out of Africa to the present-day frenzy for borders and walls. It worked a kind of magic, that film, a re-humanising spell, telling the stories of actual people and setting them within the context of Nelson and Turner, of Britain's long, salt-spattered centuries at sea. Here's one of the stories, a snippet from an interrupted life.

> A woman living in exile turns to me and, almost shouting, says – 'We just want to buy tomatoes at the market. We just want to go to the cinema when we want. It is hard enough that we get ill and die. We don't want to be hurt and killed.' Everyone in the room around us stops pretending they can't hear what the woman's saying. Everyone has listened after all. Everyone turns round to us and agrees . . . This contact between strangers, for a moment, feels like coming home.

For a minute, sitting in that close, dark space, I had a sense of openness, of light. Among the found footage of boats and waves, a repeating image of Derek Jarman's hands, stringing a necklace of flints in the bright butter-yellow gorse of his garden at Prospect Cottage in Dungeness. We don't have to live like this. There are other ways to conduct yourself, to apprehend the world.

The last time I had that light, bright feeling was at Marc Hundley's show *New Music* at Canada, a gallery in the Lower East Side, which I went to see three times over a single weekend

in New York. Hundley's work isn't political, exactly, but it's about a kind of hospitality to feeling, a tolerance and openness that feels radical in its own right. Like Wood, he uses found material in his prints, often lines from pop songs, the sort of things that circulate in your head, acquiring personal meaning.

One of the prints was of Bowie's beautiful, alien face. Emblazoned across it were the words 'But I can see it's not okay', from the song 'Letter to Hermione'. Another, so lovely I wanted to steal it, had a silhouette of summer trees against the deep ocean blue of twilight. 'Hey Moon,' it said, repurposing John Maus, 'it's just you and me tonight.' They sound so simple, but they're not. Being in the gallery gave me a feeling like being out on a lake. Clouds moving overhead, a breeze. Wary, but game for the adventure. On fundamentally friendly terms with mental states and other beings. Do you know what else was in the room? A hand-made bench. Sit down, you look tired. Whatever else might happen, I want you to know you're welcome here, that you're always welcome beside me.

Faking It

September 2016

THERE WERE TWO DEAD MOLES in the wood, beached a few yards from one another, blood still wet on their noses. I'm on the verge of starting a new book, flinging the windows open, encouraging a breeze. Starting is like dowsing, like trying to find an unmarked path. I keep going away, keen to steer clear of my house. Marazion, Budleigh, Aldeburgh: seaside towns, marooned in time. In Lyme Regis I unzipped the top pocket of my suitcase and found a forgotten Penguin, slightly bent. *Ripley Under Ground* by Patricia Highsmith, the second in a loose quintet written between 1955 and 1991.

The only one I'd read before was *The Talented Mr Ripley*, which charts the transformation of Tom Ripley from awkward arriviste to murderer, imposter, bon viveur, dispatching the playboy Dickie Greenleaf and stepping gleefully into his well-made shoes. What's so great about authenticity anyway, when you can bag the life you deserve? Why not wriggle into a richer self – *il meglio, il meglio!* – even if it means dispatching the original with a blow to the head and shunting his bleeding corpse into the sea?

In *Ripley Under Ground*, Highsmith refines her unsettling take on fakes and fraudulence, relocating operations to the art

world. Tom – smoother now, gleaming with wealth – has been busily masterminding the production and sale of forged paintings by an artist, Philip Derwatt, whose suicide he's concealed. Composed in fleshy, muddy reds and browns, Derwatts are characterised by multiple outlines (an effect I imagine as something like early Auerbachs, though Highsmith was apparently inspired by the Vermeer forger Han van Meegeren). Like Tom, the paintings are lifelike at a distance, coming disconcertingly to pieces at close range. His favourite is, of course, one of the many forgeries. 'It was the restless (even in a chair), doubting, troubled mood of it which pleased Tom; that and the fact that it was a phoney. It had a place of honour in his house.'

I love these books, which play on the communal terror of being exposed while still taking pleasure in the artistry of the fraud. Tom isn't just concealing murders; he's hiding the ugly, unsophisticated boy he once was; the frightened face he used to wince at in the mirror. The things he buries are forever rising to the surface, misdeeds returning like waterlogged corpses. No wonder you root for him. Who wouldn't like to outrun their ugliest self, the gauche, the ignorant, the tacky? Who hasn't copied or adopted, who isn't frankly two-faced? 'I have long been lucky enough to feel real,' Maggie Nelson says in *The Argonauts*, but in Highsmith's world realness is rarely a steady state.

Tom wants to pass as rich, but he also wants to punish them with his forgeries, to mock their discernment, to sabotage their sophistication. It's terrifying, the capacity of things to betray us. When I first moved to a city where the fear of vulgarity was acute, I took to carrying around a blatantly fake Prada bag. 'I

want to be at least as alive as the vulgar,' Frank O'Hara says in 'My Heart', though sometimes it's a case of being less dead than the tasteful.

Highsmith bestowed on Tom her own loves and frustrations: dahlias, harpsichords, the IRS. A lesbian and an alcoholic, she understood how it felt to have to construct false selves. Once you strip away the veneer of plot, the best book of the Ripliad, *The Boy Who Followed Ripley*, is plainly the story of a closeted gay man on a spree in Cold War Berlin, the brutally divided city. In drag at Der Hump, Tom abruptly queers the issue of the fake. His habit of switching selves comes into focus as a high-stakes game of passing. Constantly serving realness of one kind or another, a fabricator and fabulist, he pulls the rug out on reality. The dodgy art, the artful dodge, making things up from out of the air.

Doing the Watusi

December 2016

I'D LIKE TO SEE a whale in the wild. I've only seen killer whales in aquariums in the 1980s, jumping through hoops, breaching and turning in chlorine-blue pools. Nomadic animals in holding tanks, never losing the urge to travel, a hundred kilometres through open water every day. Do you feel the constriction of other bodies in your own? A minute ago I opened my laptop and read an article about a woman being sued by her unborn embryos. The estranged husband had given them names: Emma and Isabella.

Every day it seems like there's a new law governing what you can and can't do with your body. In Ohio, they're proposing women can't have an abortion if the foetus has a heartbeat, which starts at six weeks, when it's the size of a lentil, smaller than a popcorn kernel, smaller than a fingernail. Meanwhile in the UK, the Digital Economy Bill is set to ban internet porn sites from showing what they call 'unconventional sex acts': fisting, urination, spanking that leaves marks. I didn't mean to commit civil disobedience, I just wanted to watch porn on my computer, to have jurisdiction over my own orgasms, to reproduce in my own time, or not at all.

One night last autumn I went on my own to see *to a simple,*

rock 'n' roll . . . song, Michael Clark's farewell to Bowie at the Barbican. There were women sitting on either side of me, talking quietly about a heart attack, a care home. The dancers came on stage, making their glacial suite of movements to two piano pieces by Erik Satie. I'd like to say they moved like automata, but that's not true. What was beautiful was watching their disciplined, pliant bodies straining on the edge of mechanization, up on one wobbling leg like monochrome flamingos, right at the threshold of human capability.

The soundtrack to the next act was 'Land', Patti Smith's incantatory epic of borderline experience: a hammered-out vision of extremis that begins with a boy being pushed in a hallway. Physical states slam into each other, switchblade to needle to cock, the drugged body to the fucked body to the corpse. Out here, in Smith's delicious sea of possibilities, what else is there to do but dance?

I was in row G, craning forward. Three figures, in black vinyl flares, were going all out, arms snapping like alligators, limbs folding into croissants. No more wobbles. Like Patti says, 'got to lose control and then you take control'. I could feel it in my chest, the body's hunger to wheel in and out of contact, freely. One hold in particular stuck in my mind. A dancer with a shaved head and epicene face leant into a handstand that turned into an inverted lift. Arms outstretched, ankles locked behind his partner's head, he hung in surrender before being lowered to the ground. Tenderness: I'll take it wherever it comes.

After the American election, I fell asleep each night packing a bag in my mind. A map, a compass, cash, a torch. What kind

of disaster did I think was coming? Everything was eroding: language, truth, civil rights. I saw a T-shirt the other day that said ACTIVISM, but I'm not sure £65 slogans are going to help. 'The people have the power': another Patti Smith lyric, but once you fetishise the people you're only a few steps away from 'enemies of the people' or 'the people have spoken' or any of those other devices for shutting down debate.

I don't know about the people, but I still believe in solidarity, old-fashioned as it sounds, and I still believe that the root of solidarity lies in the common inheritance of our bodies – which remain subject, however unequally, to sickness, loss, old age and death. It's a sea of possibilities. Even now, it's all up for grabs. The human animal, mobbed by desire, terrified of difference, pursuing their lynchings and pogroms, when they could be out here with the rest of us, doing the watusi in the dark.

Bad Surprises

February 2017

AROUND THE TIME that Donald Trump was sworn in as the 45th President of the United States, I started thinking about an essay by Eve Kosofsky Sedgwick, the late goddess of queer theory. 'Paranoid Reading and Reparative Reading, or, You're So Paranoid You Probably Think This Essay Is About You' was written in the 1990s. I'm not very paranoid, but I do think it's got a strange proleptic handle on the times in which we find ourselves.

If you were a habitué of Twitter that spring, the chances are you saw a daily bloom of conspiracy theories, proliferating by way of screenshot slabs of text, key sentences illuminated in blue. Some linked Trump to Putin, or traced the dark flood of money through shell corporations, the ugly traffic of influence and information, the backwash of rumour and deliberate mistruth. Most of these essays were well-meaning, and many may also have been accurate, but something about their triumphant tone made me uneasy. We need to know what's going on, but how much detail is useful, and what do you do once you've got it?

This is the predicament to which Sedgwick addresses her formidable intelligence. What she suggests is that the paranoid

imperative towards exposure, which has long achieved domin-
ance as a critical approach, might not be the only way of
dealing with a crisis. A paranoid reading, she writes, is above
all defensive, attempting to forestall the pain of being caught
unawares: 'There must be no bad surprises . . . paranoia requires
that bad news be always already known.'

Necessarily cynical, it is also weirdly naive. The paranoid
reader puts their faith in unveiling hidden acts of violence,
believing if the awful truth is only revealed, it will automatically
be transformed, 'as though to make something visible as a
problem were, if not a mere hop, skip, and jump away from
getting it solved, at least self-evidently a step in that direction.'
As if the Muslim ban hasn't been gratifying to certain appetites;
as if evidence of systematic racism might in itself alter the ten-
dencies of white supremacists, let alone come as news to anyone
on the receiving end.

At the end of her essay, Sedgwick sketches the bones of an
alternative approach. A reparative reading isn't lodged in the
need to predict and prepare for disaster. It might be engaged in
resistance, or concerned with producing some other reality
altogether, but it's driven by a seeking of pleasure rather than
an avoidance of pain – which isn't to say that it's any less atten-
tive to the grim realities of loss and oppression.

Sedgwick died of breast cancer in 2009 at the age of fifty-
eight, so she's never going to elaborate on what she meant by
reparative reading, but I imagine it might be something like a
poem Eileen Myles read at the London Review Bookshop on
19 January 2017. Years ago Myles had run for president, and she
closed the night with a new poem, 'Acceptance Speech', her

own version of a presidential address. It was the night before Trump's inauguration and the vision she unfolded was the utopian inverse – painful! thrilling! – of what he'd say the following day. Under Myles, the White House would be a homeless shelter, there'd be twenty-four-hour libraries, free trains, free education, free food, archery for everyone, sure, why not?

It felt reparative, listening to that; it felt like my imaginative ability to frame utopias and then to move purposefully towards them might have been restored, at least for a minute, at least inside those book-clad walls. Oh, I don't know. A week or two later I went to Hackney Wick to see my friend Richard Porter's play *Planes* at the Yard. It's a monologue with two musicians, really just Rich talking on stage, telling the story of his sister's suicide, which coincided with the disappearance of Malaysian Airlines Flight 370.

It's a play, I think now, about those two ways of reading the world, about the pull towards paranoia, to building narratives of blame and punishment, and about what happens if you don't. Over and over, he sorted through the facts – a missing plane, a blood-soaked scarf, a car parked on a country lane – assembling them into patterns, finding a way to exist alongside them. The disaster had already happened, the bad surprise was finally here. The question was what would happen now, how to live on alongside loss and rage, how to not be destroyed by what are manifestly destructive forces. It felt like the room got bigger as he talked, until we were all sitting in an enormous space, a cathedral of potential, in which the future was as yet unsketched.

The Fire This Time

June 2017

WHAT'S THE RELATIONSHIP between art and disaster? A fire
starts, it moves from room to room and then engulfs a building.
People are trapped inside, people throw their children out of
the windows. A scene drawn from Dante's *Inferno*: 'The more
I looked up,' an eyewitness to the Grenfell Tower fire in London
said, 'floor upon floor, endless numbers of people. Mainly the
kids, because obviously their voices, with their high-pitched
voices – that will remain with me for a long time. I could hear
them screaming for their lives.'

When the Houses of Parliament went up in flames on the
evening of 16 October 1834, Turner was among the crowd that
lined the south bank of the river. Over the next year he turned
his sketches into two paintings. In *The Burning of the Houses of
Lords and Commons*, the tiny, toppling facade of Westminster
Hall is dwarfed by an incandescent wall of light, plunging
upwards into the damaged smoky sky, gilding the bridge,
doubled in the water, where dark crouching figures watch from
boats.

Set it down: as spectacle and artefact, as testimony, witness
report and permanent record. The sky is rose-pink, rose-yellow
patched with blue; the sky is very lovely, full of small gold darts

of burning debris. Here's the first challenge: how not to aestheticise a tragedy. No one died in the Burning of Parliament, knowledge that makes Turner's rapturous account of flames more palatable. And sometimes the beauty of the spectacle is part and parcel of its horror, as in Henry Green's fourth novel *Caught*, published in 1943, which draws on his experience in the Auxiliary Fire Service during the London Blitz.

Green has the volunteer fireman Richard Roe describe the air raids to his wife in conventional terms, confessing meanwhile to himself a more disturbing visual record. 'What he had seen was a broken, torn-up dark mosaic aglow with rose where square after square of timber had burned down to embers, while beyond the distant yellow flames toyed joyfully with the next black stacks which softly merged into the pink of that night.' How sinister that prettiness is, as something softly, joyfully unmakes a city, black stacks and embers standing in for the human dead.

After Grenfell, when the fire was out but only a few of the bodies had been found, let alone identified, I spent an afternoon reading testimony from the trial that followed another preventable conflagration. The Triangle Shirtwaist Factory Fire took place in a sweatshop on the upper floors of the Asch Building in the Lower East Side of New York on 11 March 1911. 146 people were killed in that fire, predominantly women and girls employed as garment workers.

Like the inhabitants of Grenfell, many of these women were recent immigrants. They couldn't escape because the company owners had a practice of keeping the doors locked during working hours, so instead they burned to death or dashed

themselves on the street below. There is an extraordinary photograph of their ranked bodies being identified in the morgue, in coffins like cots, their torsos wrapped in sheets, their faces bloodied and staring, eyes open, mouths ajar.

The factory owners, whose names were Isaac Harris and Max Blanck, were subsequently tried for manslaughter. The complete transcript of the trial that followed is online, and so it's possible to lean through time and hear the harrowing details of that afternoon. 'After I looked I seen the girls running and then of course the smoke and flames come up which prevented me to try to go back, and I turned back.' 'I went to put my foot down, and I don't know what it was – something soft – I think dead bodies, or I don't know what.'

This testimony catches the chaotic sparks and ashes of the moment and fixes them in history, as the Grenfell Tower Inquiry will also do. Laws are changed on accounts like this, which isn't to say that the people responsible for the deaths are always held to account. The two owners of the Triangle Shirtwaist Factory were both acquitted. Two years later, Blanck was arrested again for locking the door in his factory during working hours. He was fined $20.

The Body-Snatchers

August 2017

THEY CAME OUT of nowhere, Philip Guston's Klan paintings, which is to say through a channel that opened up in his memory, connecting the violent year of 1968 with the agitations of his youth. How could you keep painting abstractions, walls of exquisitely distressed paint, when there were bleeding bodies in the streets? It had been a year of assassinations, first Martin Luther King in April and then Robert Kennedy in June. In August, like everybody else, he was watching the Democratic Convention on TV: ten thousand protestors, mostly peaceful, mostly young, getting beaten down with billy clubs by twenty-three thousand police and National Guardsmen. It made a hole in him, and out of the hole the hooded men appeared.

Guston painted his first Klansman that year; his first, that is, since the 1920s, when he'd had a series of run-ins with the Klan in Los Angeles, in their guise as strike-breakers. In response he rendered the Klansmen as evil incarnate, drawn and serious, a lynched man hanging from a crooked tree evidence of their hellish work.

In the 1960s paintings, the Klansmen were cartoonish, worn out: a tired, evil joke. 'I felt, like everybody, disturbed

about everything to such an extent that I didn't want to exclude it from the studio, from what I did,' he explained in 1974. 'I conceived of these figures as very pathetic, tattered, full of seams. I don't know how to explain it. Something pathetic about brutality, and comic also.' He gave them cigars to smoke, cartoon cars to drive. Sometimes their robes were splattered in blood. Sometimes they painted themselves, puffing on a cigarette as they rendered the blanks of their eyeholes.

This time, Guston wasn't looking from afar. This time, he was inside the frame. Someone, some bozo, was underneath the hood, peering out at the world through slits in cloth. You have to bear witness, Guston kept saying, but he meant more than merely watching events unfold. He wanted to know what it felt like to *be* evil, to live with it on a daily basis. In his studio in 1970 he scribbled notes on a yellow legal pad: 'What do they do afterwards? Or before? Smoke, drink, sit around in their rooms (light bulbs, furniture, wooden floor), patrol empty streets; dumb, melancholy, guilty, fearful, remorseful, reassuring one another?' Reading this calls to mind the poet Claudia Rankine's Racial Imaginary Institute, conceived of in 2016 to investigate the ways in which the structure of white supremacy in American society influences our culture. Guston knew who the victims were. Like Rankine, what he wanted to know was who did it.

At around the same time, his canvases were filling up with objects, what he called tangibalia. Some of it was comic detritus, sandwiches and beer bottles, and some of it was sinister, disquieting, bizarrely upsetting. There were light bulbs dangling from cords, falling bricks; there were piles of bodies, piles

of limbs, piles of discarded jackets and shoes. Guston knew exactly what the fruits of those night drives were. He knew the end game of white supremacy. It wasn't necessary to show the lynched body, just the post-match litter, the possessions after the people had been dispensed with.

Inevitably I thought of those paintings as I watched footage of the Klan marching through Charlottesville and Boston, anonymous, impervious, refusing to face up to their cruelties and crimes. Old ghosts on parade, immune to reason, back in the limelight, their fists like pink hams.

On 23 October 1968, Guston was in conversation with Morton Feldman at the New York Studio School. He'd been thinking a lot about the Holocaust, he said, especially about the extermination camp Treblinka. It worked, the mass killing, he told Feldman, because the Nazis deliberately induced numbness on both sides, in the victims and also the tormentors. And yet, a small group of prisoners had managed to escape. 'Imagine what a process it was to unnumb yourself, to see it totally and to bear witness,' he said. 'That's the only reason to be an artist: to escape, to bear witness to this.' He didn't mean escape as in run away from reality. He meant act. He meant unspring the trap. He meant cut through the wire.

Dance to the Music

December 2017

BACK IN THE AUTUMN, I started reading *A Dance to the Music of Time*, Anthony Powell's virtuosic cycle of twelve novels charting a group's shifting fortunes over the course of the twentieth century. I wanted something glacial, something that regarded the progression of history from an immense distance; an antidote, if you like, to the impossible mounting-up of news of the present day.

Powell came up with the idea for *A Dance* in the Wallace Collection in London in 1945, while looking at Poussin's painting of the same name. He describes the picture on the very first page: 'Human beings, facing outward like the Seasons, moving hand in hand in intricate measure: stepping slowly, methodically, sometimes a trifle awkwardly, in evolutions that take recognizable shape: or breaking into seemingly meaningless gyrations, while partners disappear only to reappear again, once more giving pattern to the spectacle: unable to control the melody, unable, perhaps, to control the steps of the dance.'

It's this combination of pattern and meaninglessness that I love about Powell. People complain about his snobbery, but the titles and grand houses are just window-dressing. The books are about time, how we move through it together, in funny little

bands, how it disperses and diminishes us; how hard it is to grasp the actual role we're playing.

The novels that comprise *A Dance* are unusually painterly, unusually concerned with surface and light, and unusually populated by canvases both fictional and actual. While I was reading, I had a hankering to see the Poussin for myself. I'd been dipping into T. J. Clark, too: *The Sight of Death*, his besotted account of visiting two Poussins daily for six months.

Clark's Poussin, like Powell's, is a conjuror of inhuman time frames, of people moving minutely through a dispassionate world, in which a reflection in a puddle has as much value and interest as a man running pell-mell away from the grotesque spectacle of a corpse devoured by a snake.

Poussin's *A Dance* is still at the Wallace Collection, the Wallace Collection is still in Manchester Square. I walked there on a cold winter morning. Cutting through Burlington Arcade, past the windows of silk pyjamas and cologne, I bumped into a novelist I've known for a long time and we had a brief conversation about whether there's such a thing as a bad painting, a Powellish exchange in a Powellish place.

The Wallace Collection was almost empty. I drifted through the violet and empire-green rooms, with their washed-silk walls, the flotillas of Canaletto and Claude in gilt frames inducing a feeling of somnolence and remove. The Fragonard girl still hung on her swing, suspended in thick air; a goose lay perpetually unplucked on a kitchen table. Nothing beats paint for stopping time cold.

The Poussin was at the end of a room. It was smaller than I'd expected, somehow uglier, preposterous and depressing at

the same time. Four dancers, a plump pink breast, two putti, Father Time muscle-bound and grey, Apollo's chariot bucketing through the complicated sky. It was theatrical and faintly ridiculous, creating drama and coldly dispersing it. The landscape was dismal and unpromising, inappropriate for celestial revels. Some god or minion was up in the clouds, scattering confetti, but the outlook was not good, was in fact what Powell might describe as 'uncompromisingly clear'.

The next morning, I read an obituary written by a friend of mine, the painter Matt Connors. In it, he wrote: 'I had such a clear visual image in my head, of a group of friends walking through the streets, as Shannon and I often did, and one of them suddenly being held back for some reason, like he was stuck at a turnstile while the other friends had to keep on walking.'

This struck me as exactly what *A Dance* is really about. Powell started it at forty, the same age as Poussin when he started to paint his reeling figures. It's the age at which you begin to notice how strange time is, how it repeats and returns, how the group you travel with is inexorably diminished. On you go, go you must, bound feet moving on damp ground. The weather isn't looking good, time's running out, a shrapnel of light falls whitely on the birch.

Paradise

March 2018

A GOOD OMEN, at last. I was in my garden, trimming dead leaves from the hellebores. The sky was very blue, and as I looked up a little plane flew overhead and drew a smiling face. The smile lingered after the other features had dissolved, a Cheshire-cat grin, spreading south.

Is gardening an art form? If it is it's the kind of art I like, bedded in the material, nearly domestic, subject to happenstance and weather. Most of the winter had been very bleak. The smile was an aberration. The days were short and grey and riddled with bad news. I developed a habit of spending Sundays with seed catalogues and lists of old roses, plotting floral fireworks that wouldn't go off for months. Such consolations are nothing new. In her diary of 1939, Virginia Woolf records hearing Hitler on the radio. Her husband Leonard was in the garden he'd painstakingly constructed at Monk's House, their damp green cottage in Rodmell, East Sussex. 'I shan't come in,' he shouted. 'I'm planting iris, and they will be flowering long after he is dead.'

It was true. Gardening situates you in a different kind of time, the antithesis of the agitating present of social media. Time becomes circular, not chronological; minutes stretch into

hours; some actions don't bear fruit for decades. The gardener is not immune to attrition and loss, but is daily confronted by the ongoing good news of fecundity. A peony returns, alien pink shoots thrusting from bare soil. The fennel self-seeds; there is an abundance of cosmos out of nowhere.

No one wrote better about this paradisiacal aspect of gardening than the plantsman, film-maker, writer and painter Derek Jarman. The last alchemist, his partner Keith Collins called him, magicking an oasis on the desolate beach of Dungeness. He made his famous garden shortly after being diagnosed HIV-positive, tending an abundance of life in the face of death. In between seed catalogues, I spent the beginning of the year writing a new introduction to Jarman's magical, harrowing diary, *Modern Nature*, first published in 1991.

When I finished, I decided to make a pilgrimage to Derek's grave. I didn't want to Google where it was. I wanted to navigate by memory. Was it Lydd? No. Surely Romney? I walked gingerly across damp churchyard grass, scouting under yews. Graves look new for far longer than you might expect. It takes more than a century before the greenery-yallery encrustations of lichen become established.

In the end I succumbed to the iPhone. St Clement's Churchyard, Old Romney. I drove through a liquid landscape, smudging and pooling at the edges like ink on wet paper. The church was very old. There was Derek's grave, just his signature carved into stone. I should have brought flowers, taking my cue from the narrator of his last film *Blue*: 'I place a delphinium, blue, upon your grave.' Hyacinths, or maybe mimosa, Derek's

grandmother's favourite, banishing the dregs of winter with its puffs of cheering yellow.

Before I left, I ducked into the church. It was beautifully unrestored, a hodgepodge of medieval stone carving and Georgian decoration. The tiled floor was wildly uneven, marking the long passage of feet. The ragstone walls were lumpy. But the best thing was the box pews, which had been painted a deliciously unlikely ointment-pink. Here's another kind of art I like: the anonymous, the cobbled together, the hand-me-down, the postscript; collaborations between strangers that marry jubilantly, that don't quite fit. It turned out the pews weren't a rare example of Florentine style in the Kentish marshes. They'd been painted by Disney for the 1963 film *Dr Syn*. The parishioners liked them so much they had decided to keep them, a campy flash of paradise.

It was so exactly the kind of random occurrence Derek seized on in his films. He directed just like he gardened, making hay with the spontaneous and unplanned. Is art resistance? Can you plant a garden to stop a war? It depends how you think about time. It depends what you think a seed does, if it's tossed into fertile soil. But it seems to me that whatever else you do, it's worth tending to paradise, however you define it and wherever it arises.

A History of Violence

June 2018

AT A PARTY in South London a man came up to me. He was big, with close-cropped grey hair and bright blue eyes, a network of broken veins across his face. My dad was Irish, he said, he worked on the building sites. London was built by the Irish. They all died young. No compensation. It was the asbestos, it got into their lungs. He told me about working on a demolition site as a teenager, bringing tea to a man who emerged from a tunnel the width of his body, which ran forty metres beneath the ground. He had a handkerchief over his mouth. Pulled it off, grinning, his whole face pancaked in poisonous white dust.

Everything's seeping to the surface now: the slow or hidden violence of late capitalism, the concealed cruelties of immigration removal centres, the secret acts of racist police, all made inescapably visible by way of the scrying glass of social media. You can be an accidental connoisseur of snuff movies simply by scrolling through Twitter with a breakfast cup of tea. A young woman shot by her ex-boyfriend in a university hall of residence, the video of her final seconds played on a loop on a British newspaper website. A black man looking at his phone in a parking lot dragged from his car and beaten by three white police officers in what looks like riot gear, blow after blow after blow.

'I think it would be indecent these days for writers to talk of anything else but violence,' the French novelist Édouard Louis said in an interview about his new novel, *History of Violence*, a fictionalised account of his rape and attempted murder by a stranger he met on the street. But actually grappling with this material often carries the charge of indecency, as if bringing a horror into view is perversely worse than the act it records. I'm thinking in particular of the Cuban-American artist Ana Mendieta, who in 1973 recreated the recent rape and murder of a woman student at the University of Iowa as a tableau performance in her apartment.

By deploying her own half-naked body, blood dripping from her thighs, she made herself both perpetrator and victim, creating a shock-zone of resistance as well as mourning. A few months later, she poured a bucket of cow blood and animal viscera she got from a butcher onto the sidewalk outside her house, hiding in an unlocked car and filming the reactions of passers-by. No one did a thing. The blood stayed there, seeping from her door, until a caretaker came out and scraped the mess into a cardboard box.

If these works were about making visible a scene of horror, the work that followed was far more concerned with how violence ebbs away. For the *Silueta* series, Mendieta cut female silhouettes into the earth, pressed them into grass, traced them with flowers or burned them with fire. They look like traces of some unspeakable disaster, but at the same time they register a longing for connection, of dissolving or being subsumed into nature.

I find looking at these works weirdly comforting, as if the

violence they attest to has been absorbed by an order of time that dwarfs any human act, no matter how vicious. And yet each time I see the seeping red shape of a woman's body carved into snow I am reminded of a scene from *Eichmann in Jerusalem* by Hannah Arendt, another woman who wasn't afraid to look at indecency and record what she saw.

Eichmann's trial testimony was marked by a constant refrain of looking away. He hadn't seen. He had turned his face from the naked corpses in ditches. He had refused to look through a hole in one of the mobile gas vans that were the precursor to the gas chambers, though he had not been able to tune out the screaming from the people trapped inside. It was all too horrible, he kept saying. What he had seen, and what therefore must stand in for the many things he'd chosen to ignore, was a burial ditch that had been filled with soil. The bodies were no longer visible, but the blood, he said, was shooting out of the earth like a fountain. He didn't want to look, but the blood kept spurting all the same.

Red Thoughts

October 2018

THE DEGAS PAINTING *La Coiffure* or *Combing the Hair* (1896) hangs on a red wall at the National Gallery, next to a marble pillar the rippling colours of aged beef. The staff call it 'Big Red': a tomato-soup interior in which a red-headed woman in a tomato-coloured shift, maybe pregnant, is having the flaming taper of her hair combed out by a maid, also red-headed, in a white apron and pink blouse with leg-of-mutton sleeves. It's a weirdly loose painting, a tonal symphony in which something disquieting, sexy, a little strange is taking place.

At the beginning of October, I went to an event at the National Gallery to hear the painter Chantal Joffe talk about *La Coiffure*. She was describing how the oil paint had been made to look like pastel when someone asked her about voyeurism. Was Degas being voyeuristic, was he watching something forbidden through a keyhole? No, she said, it's not like that. I think he almost wants to *be* a woman.

The previous night, I'd been looking at a different redhead. The trans performance artist La JohnJoseph was reprising their Edinburgh show *A Generous Lover* in a tiny black-box theatre behind Euston station. Eating an emergency packet of Walker's crisps on the pavement outside, I didn't feel like watching

anyone do anything. It was the week of the Kavanaugh hearings, moody autumn, everyone trapped in a psychodrama no less agonising for being grossly out-of-date, a 1980s frat-boy rerun in which we were all dragged in as extras.

Anyway, there was La JJ, in a crumpled violet dress that opened and closed with a complicated network of folds around the neck. The play was a true story about La JJ's lover, here called Orpheus, who was unwillingly detained in a mental hospital during a manic episode. La JJ played all the roles, doctor, patient, visitor; now Katharine Hepburn, now a working-class Scouse wife. In the underworld, everyone was transfigured. The patients had baroque names: The Lobster King, El Infante, Gerry Adams, The Wounded Saint. Their dramas, which were repetitive and hopeless, though not without humour, took place in a landscape of total austerity, an empire of lack. Sinks without taps, toilets without seats, kitchens without forks, nurses watching lolcat videos behind Plexiglas screens.

The play was horrifying and hilarious and defiantly beautiful. A few days after I saw it, still reeling, a writer I was on a panel with said, and I'm paraphrasing here, that it is no longer desirable to write about the lives of other people or experiences one hasn't had. I didn't agree. I think writing about other people, making art about other people, is both dangerous and necessary. There are moral lines. There are limits to the known. But there's a difference between respecting people's right to tell or not tell their own stories and refusing to look at all.

Should Degas have painted those two women? Should he have insinuated or imagined himself into their chamber? Should

La JJ have brought their little red notebook into Ospidale and written down what the men said in their delirium? It depends whether you believe that we exist primarily as categories of people, who cannot communicate across our differences, or whether you think we have a common life, an obligation to regard and learn about each other. Either way, isn't it an impossible line to demarcate? What's autobiography? Was La JJ's play autobiographical, or was it about a communal psychic state, or for that matter a scrupulous accounting of the consequences of Tory cuts? Was Degas painting something that he had seen – verifiable, external – or is *La Coiffure* a mirror in which the painter is caught red-handed, confessing to how he longs to see himself?

On the same panel, another writer spoke about opacity, about how essential it is to allow the people you depict to keep their secrets, their strangeness and their separateness from you. That's a kind of moral code I can get behind. Look again at Degas's scarlet woman. Is she frowning in pain or is she stretching her white neck in ecstasy? It remains opaque. Her body is recorded, and yet she remains unbreached, a private red presence in a public red room.

Between the Acts

November 2018

A WINTER BEACH is a good place for seeing clearly. Last week, I went for a walk at Covehithe in Suffolk with the writer Julia Blackburn, who had just finished her new book, *Time Song*, about Doggerland. Doggerland was the land that once connected England to Continental Europe, before it was lost beneath rising seas around 6500 years BC. It had been right there, under the waves that rose and slapped six feet to our left. People lived there, hunted animals, dropped tools that were sometimes recovered by fishermen or washed up on the tide. Sea levels were rising again, and as the Covehithe cliffs eroded in storms, Mesolithic fossils were exposed once again to the light.

It was a very bright day. The sun was so low that every grain of sand cast a shadow. I pointed at a rust-stained piece of wood. Julia squinted, scooped. What she had in her hands wasn't wood at all, but a fossilised jawbone. Dolphin, she said, maybe whale, probably the oldest thing I've ever touched.

In the era of border walls and Brexit, I find the existence of Doggerland soothing to contemplate: a corrective to triumphalist 'our island story' nationalism. I was sure I'd read about it somewhere before, and eventually I tracked it down as a repeating image in Virginia Woolf's final novel, *Between the Acts*,

which was written at another turning point in history, just as Britain was entering the Second World War.

Woolf had the idea for *Between the Acts* in 1938 and finished writing it in 1940, as bombers flew overhead. She was still working on revisions when she committed suicide in 1941. It's set over twenty-four hours in June 1939, as the uneasy peace threatens to give way to war. The novel is about people talking and the gaps between words, about violent change and abiding continuity. It takes place in a country house where a pageant is being performed, and it's an attempt to situate what Woolf feared might be an end of civilisation itself in a sustained vision of deep time, in which English history and pre-history is constantly rehearsed.

More than one of the characters in *Between the Acts* has been reading about Doggerland. The knowledge undermines the Channel, which has begun to feel like a weak defence anyway now war has entered the air. But it also provides consolations. Time keeps washing on. What is now Piccadilly was once a rhododendron forest, populated 'by elephant-bodied, seal-necked, heaving, surging, slowly writhing, and, she supposed, barking monsters; the iguanodon, the mammoth, and the mastodon; from whom presumably, she thought, jerking the window open, we descend.' Continuation is a comfort; life of some sort is surely assured.

The day after we found the jawbone, I went to see the English National Opera staging of Benjamin Britten's 1962 *War Requiem* at the Coliseum. Britten, a pacifist like Woolf, had lived a few miles down the Suffolk coast from Covehithe, in the fishing village of Aldeburgh. He'd written the *War Requiem* for the

consecration of the new Coventry Cathedral, built to replace the fourteenth-century cathedral destroyed in a bombing raid code-named Operation Mondscheinsonate or Moonlight Sonata, on the night of 14 November 1940. 'Coventry almost destroyed,' Woolf wrote in her diary the morning after the raid, before starting the day's work on *Between the Acts*. 'When I am not writing fiction this fact seeps in.'

This fact seeped in at the Coliseum too. The set was designed by Wolfgang Tillmans. Behind the singers, a giant photograph of Coventry Cathedral. Zoom, broken columns. Zoom, stone. Zoom, moss. Zoom, until the filaments towered over the singers' heads, a sinister forest. Something continues, something grows. Is this comfort or terror, Woolf frets. What consolation can you wring from the lowing cows, the returning flurries of swallows, 'when the whole of Europe – over there – was bristling like . . . He had no command of metaphor. Only the ineffective word "hedgehog" illustrated his vision of Europe, bristling with guns, poised with planes. At any moment guns would rake that land into furrows; planes splinter Bolney Minster into smithereens.'

Woolf finished *Between the Acts* eight days after Coventry Cathedral was bombed. In the same entry in which she noted this fact, she described how a German plane had been shot down in the hills behind her house and how the local people 'stomped' on the heads of the dead airmen. Love, hate, peace, she wrote in *Between the Acts*, the three great elements of human existence. On the screens at the Coliseum more images appeared. Football hooligans, Srebrenica, the deformed face of a soldier, his jaw obliterated.

Under the Influence

March 2019

IT'S 4.46 AM, but my body thinks it's morning, which is why I'm standing in a kitchen in the East Village, eating bran flakes in the dark. It's minus 6 outside and yesterday I walked six miles, what with one thing and another, dropping back into the stations of a semi-discarded life. I went to the Andy Warhol show at the Whitney, which was a revelation even though I sincerely believed I'd seen everything he ever made. What I really liked was the sexy stuff from the 1950s, the not-quite hand drawings he made by way of his blotted-line technique, a home-made, lo-fi version of a printing press and the precursor to the screen prints of the 1960s.

Such swoony drawings, inked onto tracing paper and carefully blotted. Boys like fauns; a dick tied up with a ribbon and embellished with flowers. A bulging crotch in jeans; a pair of high-arched feet, matched adorably with two candlesticks mounted on tiger paws. It was basically fan art, teenaged and unabashed: James Dean with his Cocteau head flung back, next to a tree hung with hearts and a flipped-over car.

This was Warhol before he'd invented Warhol, back when he was a scrawny, pallid, hungry boy. Friendless and hopeless, Truman Capote called him, when he stood underneath the writ-

er's window every day, gazing longingly up. One of the drawings was of Capote's hand, copied from the famous ingénu photograph on the cover of his 1948 novel *Other Voices, Other Rooms*. Cocked but languorous, it beckoned an invitation: do you want this? Yes, Andy did. The show makes a case for Warhol as queer from the very beginning, using art as a way of conjuring the objects of his desire. Inventing what he needed in the paucity of reality, a miner's son willing glamour and beauty his way.

That same night I went to Joe's Pub to see the trans cabaret artist Mx Vivian Bond, of whom I am most unashamedly a fan. To my joy, I'd already seen her on the plane, singing 'Goodnight Ladies' in a cameo in the film *Can You Ever Forgive Me?*. Part of what I love about Vivian's shows is her true genius for digression. No one can make an anecdote wander so far before yanking it home. It's the pleasure of going out on a ledge, taking a leap and landing four-square. That and when she flings her head back and raises her arms, ai-i-i, a high priestess incantating rage and manifesting power.

This show was in honour of the folk singer Judy Collins, who was in the audience in a spectacular blonde wig. 'Describe it', a friend wrote to me urgently the next morning and I typed back, 'like Marie Antoinette going to the scaffold'. *Under the Influence* was comprised of covers of songs by artists Vivian had discovered through Collins's own covers. A pass-the-parcel of attraction: Leonard Cohen, Sandy Shaw, Bob Dylan. Listening, especially with Collins in the room, had the same vertiginous feeling as when you look back through a teenage scrapbook, seeing exactly how you made yourself up, a painstaking patchwork of devotion and desire.

There's not much I like more than one artist appreciating another, turning from diva to fan. Viv went there. She really did. Radiant in a Rachel Comey dress, two layers of gauze and sequins, she described going as a teenager to one of Judy's concerts armed with a giant portrait that she'd drawn. Hang this on your tour bus. When Collins's next record came out, she drew another portrait of her, this time buck naked, and hung it on her bedroom wall, until her mother's expression made her erase the nipples and pencil in a swimsuit instead.

It's called fan art, she said. She closed the show at the piano, the drawing projected above her head. Collins's wide faun's eyes and enormous mane of hair, kin to Warhol's dream boys, a simulacrum of what you want or might become. You could still see where the nipples had been drawn in and rubbed back out. It might be my favourite impulse in art. Fantasy, fetish, making up what you don't yet have, using the loved object to will yourself into life.

FOUR WOMEN

Hilary Mantel

August 2014

IN ENGLAND THE HARVEST is being brought in. Hilary Mantel
is sitting in an armchair in her agent's office in London's Gray's
Inn, where five centuries earlier Thomas Cromwell had his
chambers. She's wearing a cornflower-blue dress scattered with
pink dragonflies. Her hair is the colour of ripe wheat. She has
for most of her adult life been either in pain or fearful of pain's
return but for the last six months she's enjoyed an unprece-
dented spell of health. Her face is no longer swollen from
steroids and the most striking thing about her appearance now
is her enormous, uncannily blue eyes.

The past five years have marked a change in Mantel's for-
tunes. For a long time, she was a writer's writer, producing at
roughly two-yearly intervals odd, ranging novels that defied
categorisation by time or place. These include a paired set of
caustic, deceptively narrow domestic comedies, a vast historical
novel about the French Revolution and a lyrical account of an
Irish giant. Many won prizes, but it wasn't until she published
Wolf Hall, her magically mobile and gripping story of Thomas
Cromwell, that she achieved real fame. In 2009, the story of
the blacksmith's boy who became one of the most powerful
men in Tudor England won the Man Booker. Three years later,

the sequel, *Bring Up the Bodies*, repeated the trick, making her the first woman ever to win the prize twice.

Has it changed her? Yes and no. She was spared the potential paralysis of a new project by already having the last volume of the Cromwell trilogy, *The Mirror and the Light*, well underway. Luckily she isn't precious about working environments either, writing almost as fluently on planes and trains and in hospital beds as she does at her desk at home in Budleigh Salterton, the seaside village where she and her husband Gerald McEwen settled after the years of global roaming necessitated by his work as a geologist. They have known each other since childhood, and have been married twice. 'We share everything,' she says, meaning past as well as future.

What has changed is the external conditions of her life. The prize money liberated her to say no to some of the journalism – essays, reviews, film criticism – that was her bread and butter for decades. She's sixty-two now, alert to the shortness of time. 'I have a stack of books I want to write,' she says in her measured, emphatic voice. 'I have notes for those books. So when? And the answer has got to be now.'

There are multiple projects on the boil. A novel set in Botswana, which she began before *Wolf Hall* and had to set aside, frightened by the darkness of its contents, the way it crept into her dreams. 'It warned me to draw back, that the material was perhaps more powerful than I could handle.' Then there's a non-fiction book about Stanisława Przybyszewska, the Polish playwright who starved herself to death while trying to write the perfect play about Robespierre.

Undaunted by this alarming precedent, she'd like to have a

crack at writing plays herself, inspired by the blissful experience of bringing Thomas Cromwell to the stage, which she describes as 'the most fun I have ever had'. Ben Miles, the actor who plays Thomas Cromwell in the Royal Shakespeare Company production, shares the sentiment, describing working with Mantel as 'the most exciting and rewarding element of the entire project . . . A lesser woman may have sat back on her Man Booker laurels and taken the box office cheques, but not Hilary. She is forever investigating, discovering, pushing further into the lives of these characters.'

No one could say success came too easily to Mantel. It has been the product of work and talent, carried on in the face of appalling physical travails. She suffered ill-health from child-hood: first migraines and then endometriosis, which went undiagnosed for years by a series of negligent and dismissive doctors. In 1977 she and Gerald moved to Botswana. There her pain worsened and she consoled herself by working on an enormously ambitious, intricately researched novel about the French Revolution. *A Place of Greater Safety* was unanimously rejected (finally published in 1992, it promptly won the *Sunday Express* Book of the Year).

It was a black period. Along the way, her marriage came unglued, and at twenty-seven she found herself back in England and very ill. By the time she managed to persuade her doctors that her agonising pain was not all in her head, a product of over-ambition, or to be medicated away with anti-psychotics, it was too late. The disease had spread so conclusively that her womb, ovaries and part of her bowel had to be removed. 'My fertility confiscated, my insides rearranged,' she wrote in her

searing memoir, *Giving Up the Ghost*. And that wasn't all she lost. After the surgery, she and Gerald divorced. Prescribed steroids, her hair fell out, her face swelled up and she began to put on weight, rocketing through dress sizes. The pain continued too, coming and going, inhibiting and constricting, narrowing her world.

After a couple of years apart, Gerald had also returned to England and in the wake of her surgery they tentatively resumed their relationship. 'We go back such a long way,' she says. 'I guess there was more to hold us together than to force us apart.' In 1982 he was offered a job in Saudi Arabia. To go, they had to be married, and so they tied the knot for a second time before moving to the sinister city of Jeddah, a constricting place in itself. He was working for the government and she was mostly alone and still far from well. She coped as she had always coped: by burying herself in work. 'I worked because you had to make choices and that was my choice, but it didn't leave much over. So I feel that large areas of life, I simply haven't had.' Like what? 'Friends, sociability, entertainment: everything else had to come second.'

It would be understandable if she were bitter, but she says she isn't; not for herself, anyway, though she is angry at the culture of misogyny, the way doctors dismiss female pain. 'When you're just struggling to survive – and I did perceive it like that at the time, and I mean survive spiritually – then I think you have to jettison the less useful emotions, and anger and bitterness are not useful. I suppose they can be fuel in some circumstances, but that wasn't the kind of fuel I required. I had to say' – and she says it fiercely now – '*nevertheless* and *despite* and *even so*. Those were my watchwords.'

The battle around health abated only very recently. In fact, the Booker came at something of a crisis point. After *Wolf Hall* was published, Gerald himself became seriously ill: 'a ghastly business, surgical emergency and intensive care and all the rest of it.' Although he recovered, it was apparent that he wouldn't be able to resume his punishingly peripatetic career. Happily, the prize money and increased sales opened up another possibility. He became Mantel's manager. 'My minder,' she says, laughing, although she's quick to point out that he's the creative member of the partnership, not her. 'It isn't quite like people think. They think that Gerald works his way through stacks of paperwork and I sit with my mouth slightly ajar staring at the wall with pink bubbles coming out of my head. And actually I'm the one with the list.'

Mantel was also 'very, very ill' in the period between prizes. Writing with her customarily grim and stoical humour about the experience in the *London Review of Books*, she described her stomach sliced open like a watermelon. 'Yes,' she says, giggling again. 'The wound you could drive a bus through.' The morphine she was given in the hospital brought on florid hallucinations. Alongside visits by the devil and a circus strongman, she encountered a rumpled Irishman in an 'awful jumper' who she immediately recognised as the missing element of a story she'd been trying to finish for twenty years. It's now the title piece of her new collection, *The Assassination of Margaret Thatcher*.

This method of working is characteristic of Mantel. She is a formidable researcher, who will spend decades diligently ferreting through the historical record, assembling meticulous card indexes. She doesn't meddle with the facts, make people appear

where they couldn't, or assign them modern thoughts (so while she is 'absolutely' a feminist, Anne Boleyn is certainly not).

Despite the order, there is an unmistakably uncanny element to what she does; a summoning and speaking with the dead. Though she insists that she has 'a very constrained imagination' and is happiest working within a scaffolding of fact, she is nonetheless adept at the act of mediumship that fiction requires. More than any other historical novelist that I can think of, she has a knack for conveying the slipperiness of time, the way it sloshes back and forward, changing even as you look. 'History and memory is the theme,' she agrees. 'How experience is transmuted into history and how memory goes to work and works it over. It's the impurity, the flawed nature of history, its transience, that's really what fascinates me.'

The novelist Margaret Atwood has described her as 'an exceptionally good writer', while for the literary critic James Wood, 'she seems almost incapable of abstraction or fraudulence; she instinctively grabs for the reachably real . . . In short, this novelist has the maddeningly unteachable gift of being interesting.' Yet despite its sometimes luxuriant trappings, its lavish appeal to the senses, her fictional world is not a comfortable place to inhabit. Whatever era she's working in, her dominant tone is bleakly comic; her dominant subject the oppression of the weak by the strong, the claustrophobia with which circumstance can close around a person. 'There's a pull to the darkness, it's true,' she says. 'You choose to laugh in the face of it, I think. Your best weapon against the devil is ridicule. That's in many ways the weapon of the powerless but it's a case of using what you have.'

*

The need to resist malevolent forces began very early in Mantel's own life. She was born Hilary Thompson in the summer of 1952 in Hadfield, a 'fiercely sectarian' village in Derbyshire, surrounded by the moors. Both her parents' families were Irish Catholics, and she remembers being puzzled as a child by the difference between Catholics and Protestants. 'Like the fact we had a piano and they didn't: was that Catholic?' This sense of schism deepened abruptly when in 1956 her mother's lover Jack came to live in the family home. Divorces were expensive in those days, which was perhaps why her father stayed on in the house, demoted to a lesser bedroom, an increasingly tenuous and uncertain figure.

Everyone knew what was going on. 'It was like putting yourself in the village stocks and then throwing away the key.' At the same time, an oppressive silence reigned. Hilary's mother stopped going out, co-opting a relative to do the shopping. She had two more sons, though it was years before Hilary figured out that they were also her own father's children (Jack, she thinks, may never have realised). Things went on like this until she was eleven, a state of affairs she still finds baffling. 'You would think that any way of sorting their situation out would be preferable to remaining stuck, yet that's what they did, and so it went on and on.'

In the end, her mother left her father, moving the rest of them to a village eight miles away, where they took on Jack's surname, embarking on a new life as the Mantels, though everyone knew exactly who they were. Her mother was ruthless

about the past, excising all records of her former existence, including every photograph of her first husband. Not an easy process, when part of the evidence is your own flesh and blood. 'As I got older,' Mantel says, 'I realised that she'd written her first marriage out of history completely, so that she was pretending to people not only that the boys were Jack's children, but that I was too.'

As a child, Hilary's relationship with her stepfather was toxically uneasy. 'He had considerable capacity for frightening people,' she says. What helped was that she knew that though she only was a dainty wisp of a girl, burdened by a mass of pale hair, she frightened him too. 'You know these angry men, they're used to people shrinking back and over time accommodating their personality around the anger. And I think that Jack felt I was the immovable object. Not that I was in any way oppositional or defiant or talked back to him. But I think he knew he couldn't get to me inside. And of course I was the one who retained all the memories, all the secrets.'

As for her real father, she never saw him again. He died just before *Giving Up the Ghost* was published, but the book did lure some aspects of him back. In the intervening years he'd remarried, and after the memoir came out one of his stepdaughters contacted Hilary. Photographs were handed over, along with her father's army record. Best of all was his travelling chess set, a magical object from her childhood. They used to play the game together, and now here it was, less prepossessing than she'd remembered and faded from burgundy to the pinkish-grey of human skin.

She didn't really grasp the extent of her loss until she was

shown a series of wedding photographs, of unknown girls walking up the aisle on her father's arm. 'I found that a little hard,' she says. 'I didn't know how much I wanted him until I saw those.' It was some consolation to discover that though she'd lost sight of him, he did know what had happened to her. He'd caught sight of her once on television, saying to his stepdaughter, 'That's my daughter. And she looks so like her mother.'

*

Concealed parentage, dissolved marriages, enforced secret-keeping, a powerful figure with a desire to wrestle or rewrite history: Mantel's childhood certainly provided her with an intimate understanding of the dynamics of Henry VIII's court. The other major influence of her youth was the Catholic Church, which left her with the usual reservoir of guilt, but at the same time provided 'a brilliant training for a writer', in that it introduced her to the presence of a second, more powerful reality, co-existent with the seen world.

At the age of eleven she was so devout she might well have become a nun, but then abruptly she lost her faith. She took up with Communism instead and as a teenager considered going into politics herself. Always a first-class student, she went to university to study law, but health and money – a lack of both – got in the way. She wasn't going to be capable of that kind of active, public life. So instead she wrote about politics: politics and power and the ways in which people advance and grapple, scupper or topple themselves.

In the story 'The Assassination of Margaret Thatcher', she

imagines conversing with a man who has broken into her flat in order to murder the prime minister, currently in residence at the hospital across the street. What did she think of Thatcher, a figure who after all has something in common with her beloved Cromwell, that canny outsider among England's ruling classes? Her answer gives a sense of the values by which she steers. 'Mrs Thatcher only recognised communal values in the military sense,' she says. 'She was all for saluting the flag and slaughtering the foe, but she didn't recognise the positive strengths of the community and of the collective. And her struggle to be this lonely being, this superwoman, had practical effects in the real world; it killed people. I see her as an extremely defective human being.'

As well as Thatcher, the new collection encompasses stories about Jeddah, anorexia, adultery, secrets, the inability of the past to stop tangling with the present. Many contain autobiographical elements, combined disquietingly with the paranormal or the grotesque. She doesn't write stories often, and they can take years to assemble, to bring together. 'A short story hangs by a cobweb,' she explains. 'You can't wrestle it into submission. You've got to hold out your hand and it's got to come to you, just come and settle.'

It's a trade, is what it is: a thing you work at, developing your skill, biding your time until you're ready to march out and claim your territory, 'your flags flying and your drums beating'. She got the measure of it young, reading *Jane Eyre* and *Kidnapped* and puzzling out their essential stories: the mad woman in the attic and the boy who leaves home. 'These are still governing me all the time. And then I found Shakespeare, so I found

history. So that was it: my influences. By the time I was eleven, it was all done and dusted.'

Jane Eyre. She sits for a minute, thinking about it, gleefully reconstructing the part where Rochester leaves Jane outside a closed door, unable to make sense of the terrifying shouts and screams coming from within. 'I think,' she says with relish, 'that's one of the most frightening things in English fiction, that she can hear the sound, but she mustn't go beyond the door.' And for a moment she looks away, eyes gleaming, a woman who has spent the best part of a lifetime imaging the things that might be going on in the locked room of the past, the done-with or the never-was, the unmappable region of the interior.

Sarah Lucas

February 2015

DRIVING DOWN THE Essex Road to Sarah Lucas's house in Hackney, it strikes me that the stuff of her sculptures could be gleaned right here, from the ungentrified scattering of greengrocers, newsagents and kebab shops. Lucas has made artwork from Marlboro Light cigarettes, painstakingly gluing them over toilets, garden gnomes and the bodies of wrecked cars. She's stuffed pairs of tights to create the limp, leggy female figures she calls *Bunnies*. But she's best known for the bleakly humorous assemblages she made in the 1990s, partly inspired by reading the radical feminist Andrea Dworkin, and constructed from furniture, fruit and veg, and bits of dried and rotting meat. For 1995's *Bitch*, she stretched a white T-shirt over a table in a simulacrum of a bending body, two melons sagging from where its breasts would be. At the business end, a vacuum-packed kipper dangles from a nail. Melons and fish: a crude synecdoche of a woman reduced to her sexual elements, yes, but also an exercise in minimalism, an experiment in how little you need to ignite the whole grim psychodrama of gender and sexuality.

Lucas graduated from Goldsmiths with a degree in fine art in 1987, part of a tight-knit, predominantly working-class group

of friends that included Gary Hume, the late Angus Fairhurst and Damien Hirst. It was Hirst who organised the seminal group show *Freeze* in a Docklands warehouse in 1988, when he was still a student, showing his first spot painting alongside pieces by Hume and Lucas. This combination of chutzpah and attention-grabbing conceptual work rapidly established them in the public gaze as the Young British Artists or YBAs. Her own career-making piece came four years later with *Two Fried Eggs and a Kebab*, the components of which she fried up each morning right there in the gallery, a tiny temporary space in a Soho shop, before slapping them out on the wooden table: food as genitals, food as face, like a corner-shop version of Magritte's *Rape*. It was bought by the collector Charles Saatchi, who to her shock drove up in a Jaguar one day, just as she was tucking into a jam doughnut.

Back then, Lucas had a reputation for wildness. According to the late writer Gordon Burn, a close friend, she was 'the most unabashedly all-balls-out, rock'n'roll of the YBAs': a fixture at the Groucho Club, out-drinking everyone in her tatty jacket and trainers, refusing to gussy herself up in dresses and heels but instead relying on her gift of the gab, what she describes to me as her 'genius for sarcasm'. This image of toughness, of grungy masculinity, was cemented by her famous self-portraits, in which she looks androgynous, uncompromising, powerful, hard: sprawled unsmiling in a chair with two fried eggs slapped casually over her breasts; crouching on a toilet seat with no knickers on, a cigarette in her right hand.

In person, twenty-five years on, she's warmer than these swaggering images suggest. She's dressed in an oatmeal sweater

and grapefruit-coloured Pumas, her socks tugged up over her jeans, hair unbrushed, a cut on her nose. She says she's ageing, rues the streaks of grey, but what's most noticeable is her face-splitting smile and almost frightening charisma. Unadornment is at the core of her appeal. The gallerist Sadie Coles, who's represented Lucas since 1997, told me that when they first met, at a 'fairly formal' dinner party, Lucas was wearing a T-shirt with rotted armpits. 'She looked amazing. There's no pretension. You're confronted with her straight on.'

She's only just come back to the city, to start work on her commission for the British Pavilion at the 2015 Venice Biennale. Her house is being renovated, the carpets covered in plastic, the air full of dust. We settle upstairs, in a book-lined room filled with packing cases, for a conversation punctuated by the pouring of wine and the click of her cigarette lighter, the passing traffic in the soupy London dark.

The work she is making for Venice will return to the subject of feminism, a preoccupation that dates from the very beginning of her career. She'd never given it a thought until she graduated from Goldsmiths, when of all her art school contemporaries it was the men who she remembers being ushered into success, while she felt herself to be stuck on the sidelines, irritable and resentful. 'It was like all the blokes seemed to be the darling boys of London.' In response, she gave up art altogether, a decision that soon restored her sense of freedom. It wasn't long before she started making things for her own amusement. 'I felt like I was getting interested in myself.'

Her first show, *Penis Nailed To a Board* at City Racing, was, Coles recalls, 'incredibly effective in terms of communicating

ideas through form'. Her next step, at the beginning of 1993, was to set up The Shop with Tracey Emin, an anarchic and short-lived studio-cum-gallery-cum-happening in a former doctor's surgery in Bethnal Green. They sold their own work at bargain-basement prices (home-made T-shirts saying COMPLETE ARSEHOLE; ashtrays with Damien Hirst's face at the bottom) and pursued intoxication with such commitment that she remembered once waking up on top of a mountain of empty bottles. Though the friendship, with its 'almost violent, mad energy', has since waned, the experience 'brought so many people to us that it sort of expanded our world . . . We felt the tremendous power of it.'

Power. The word keeps coming up. Lucas is aware that she possesses it, both as an artist and a person; that she has a knack for making connections with strangers, even 'just standing at a bus stop'. Some objects have it too – like her first self-portrait, the one where she's wearing a leather jacket and biting into a banana. Her face is turned away, but one eye rolls back to gaze unwaveringly at the camera. She looks like Brett Anderson, even James Dean: a self-invented idol, not quite girl or boy.

*

In 2007, Lucas took a deliberate step back from her careering social life, buying a house tucked away in the fields of rural Suffolk, the former home of the composer Benjamin Britten and his partner Peter Pears. It's hard to square this decision with the hyper-verbal figure presiding over the Groucho and the Colony Club, but Lucas is aware that she's composed of two parts, the bantering 'people person' and the more quiet, bookish

self established when she was a very little girl. This inwardness runs deep and is one of the reasons she avoids interviews and exhibitions, those 'looming' commitments. She fell in love with the remoteness of Suffolk, its farms and ancient churches, as if she could grasp the 'tail end of a totally disappearing world'.

The work she's been making there is no less rudely physical, though it has grown weirder and more subtle. For Lent 2008, she and her partner, the artist and composer Julian Simmons, decided 'to give up the outside world', switching off their computers and telephones. It was out of this 'magical' time that she began to make *Penetralia*: plaster casts of phalluses of varying sizes, sometimes emerging from, morphing into or co-existing with natural forms like wands or trunks or flints. While her early works around sexual organs were assumed to be motivated by a desire to shock, these new pieces look more like ritual objects disinterred from the soil, the dick jokes of deep England.

Other recent work recalls the uncanny feminine of Yayoi Kusama and Louise Bourgeois. A chair made of hundreds of breasts, each one formed from stuffed women's tights in shades of pink and brown. Snaking skin-like tubes and coils she calls *nuds*, which are emphatically fleshy without quite resolving into recognisable forms. They look like sausage meat, like mottled legs; you want to fondle them, and also to give them a wide berth. Some have been cast in bronze, a new material that emphasises their spooky shape, like intestines or excretions.

In 2000, Lucas had a show at the Freud Museum, *The Pleasure Principle*. Seeing her work in this context – a Bunny draped on one of Freud's chairs, legs akimbo, ready or perhaps refusing to spill its secrets – begs the question of origins, of

where all this material is rising from. While Lucas's own story
has fairy-tale elements, it's very different from the aspirational
narrative with which the YBAs, Emin and Hirst in particular,
are customarily associated. She grew up on a council estate off
Holloway Road in North London. Her parents were poor but
creative, in a make-do-and-mend kind of way, and, she thinks
now, haunted by their pasts. Her father, a milkman, had fought
in the Second World War and been a prisoner of war in Korea;
she remembers him singing the Chinese national anthem in his
sleep.

Lucas's mother, Irene Violet Gale, came from an impover-
ished family, who all lived in one room above a chip shop on
Chapel Market. Irene's father drank and beat her mother, who
had a history of mental illness. During the war, she was sent as
an evacuee to a Cornish family, who wanted to adopt her; her
decision to return home to her abusive family caused what
Lucas describes as the 'great schism' of her mother's psyche.

Lucas herself didn't speak until she was three, and remained
very quiet as a child – something she suspects was related to her
mother's depression. Some years ago, she dated the psycho-
analyst Darian Leader, who told her that he thought she'd
failed to bond with her mother. She laughs: an unsentimental
smoker's cackle. 'And I think that's true.'

<center>★</center>

Standing casually against a window in the room in which we've
been talking is a urine-yellow resin cast of a toilet – one of a
series she made in 1998 called *The Old In Out*, slang for sex. At
once vulgar and restrained, it's a classic Lucas, speaking of the

most base functions of the body while simultaneously possessing a formal purity, an elegance.

It's what you do with the rude materials that counts: a principle that Lucas has applied to both her art and life. For years, she was troubled by the likelihood that she would be doomed to re-enact her parents' unhappiness. It took her friend and mentor, the curator Clarissa Dalrymple, to convince her that she needn't repeat their lives. 'It was such an extraordinary thought.' She thinks the turning point in her childhood came when in her final year at primary school she got into a fight with a bullying boy who tried to steal her pen. She knew that she didn't want to give in, so she grabbed him by the hair and refused to let go, forcing him to his knees. After that, her tongue was unlocked. A social, sardonic self emerged, bent on freedom.

She left school at sixteen, determined to make her own life and willingly assuming that the price would be poverty. Though a desire for fame and money often seemed to animate the YBA scene, these were not the driving force for her. Nor, unlike many sculptors, is she particularly compelled to make objects themselves, though she acknowledges it as an abiding pleasure as well as a 'cluttering' habit that causes mess. 'Really the point of art for me was that I wanted to carry on talking and thinking with other people,' she says: to create social contexts but also an ongoing, free-moving conversation about ideas.

Over the years, she's experimented with collaboration, from making a gigantic masturbating arm as a prop for her friend Michael Clark's 2001 ballet *Before And After: The Fall* to working with the German collective Gelatin, with whom she had a joint

exhibition inspired by Bosch, *In the Woods*, at Kunsthalle Krems in Austria in 2011. Instead of shipping old works over, they spent the entire budget on making the show from scratch in the museum, a high-wire way of working she's always loved. A group photograph suggests joyous misrule: four people are in horse suits, a bare-chested Simmons has a pair of Lucas's *nuds* draped around his neck, while Lucas herself looks buoyant in a creased sundress and shades, her arms aloft and her feet planted very firmly on the ground.

Most people, she thinks, settle for such boring things: financial security, fame, material possessions. Happiness, I suggest, and she bats the thought away. 'Happiness just comes and goes . . . Whereas I wanted to go somewhere quite mystical I think, but I haven't been able to entirely invent this magical land for myself.' She pauses, her legs curled under her, fiddling with her roll-up. 'So maybe they saw reality for what it was,' she says, 'whereas I thought it was elsewhere.'

Ali Smith

October 2016

THE DOOR IS AJAR. Ali Smith lives in Cambridge, on a half-hidden terrace of tiny Victorian cottages. The gardens are opposite, the fences between them long since removed. It's late September, and Smith's apple tree is still swagged with fruit. Inside, a green sweater slung over her shoulders, she takes me upstairs to her study to catch the last of the sun.

She's only just finished her new novel, *Autumn*, the first in a shape-shifting seasonal quartet about time and history, art and love, and the state the state is in. Its now is right now: turbulent Brexit Britain, where people scan the papers on their phones 'to catch up on the usual huge changes there've been in the last half hour.' Maybe an accelerated news cycle requires accelerated art. A manuscript usually takes a good year to be birthed into the world as a book, but *Autumn* sped through the presses in a matter of weeks. I can't remember reading a novel that felt so firmly footed in the present. The stabbing of MP Jo Cox, children's bodies washing onto beaches: all the nightmarish news of this summer has filtered into a narrative Smith initially planned as a farce about an antique shop.

'All across the country,' she writes of the referendum, riffing on *A Tale of Two Cities*, 'people felt it was the wrong thing. All

across the country, people felt it was the right thing. All across the country, people felt they'd really lost. All across the country, people felt they'd really won . . . All across the country, people felt history at their shoulder. All across the country, people felt history meant nothing.'

But for all its immediacy, *Autumn* also sets the congested present in perspective. Everywhere there are unlikely friendships and enriching, practically Socratic dialogues. People fall in love and conduct bedside vigils. A painter is rediscovered. A young woman in 1940s France refuses internment. Time turns tricks; time flies; a man flings a watch into a canal. The cumulative effect is liberatory, expansive, like stepping out of a foetid room and finding yourself in a field.

I can't pretend total objectivity here. I've known Smith since I was seventeen (her partner is my cousin). In the 1990s we used to write each other letters. Recently I unearthed a blurry photograph she sent me twenty years ago of a cat's tail dangling over a sofa. 'I have a long-term plan to write a novella for each season,' she'd written on the back. 'It seems to me the seasons are so gifted to us that it's a kind of duty, a very nice one.'

Though she jokes now that she sounds like Katherine Mansfield pretending to be charming, this talk of gifts and duties gets to something essential about Smith. She believes in unselfish communal values like altruism and generosity and has an infectious faith in hospitality, be it to new ideas or strangers. In addition to the eight novels and five collections of short stories, she's fought against the mass closure of public libraries ('libraries matter because we're living in an age of disinformation') and the proposed scrapping of the Human Rights Act; is a patron of the

charity Refugee Tales and a staunch advocate for young writers and writers who have fallen out of fashion. She's not, in short, an artist who seeks to wall herself off from the world.

Listening to the radio in the run-up to the referendum, she was appalled by the collapse of dialogue, the creep of lies, the resurgence of a kind of bullying language – 'go home'; 'we're coming after you' – she hadn't heard since she was a schoolgirl back in the 1970s. 'Human beings need to take in all the possibilities of rhetoric, all the varieties and versatilities and here was coming a loggerhead,' she says now.

'The notion of a referendum is in any case a divisory line: you choose one side. Meanwhile, you've got the mass division of sixty-five million people crossing the world from parts of it which are untenable, unliveable and in flames. And what's left of the world deciding whether or not to open the gates or the walls or to build more gates or walls. How could we live in the world and not put our hand across a divide? How can we live with ourselves? It isn't either/or. It's and/and/and. That's what life is.'

The and/and/and of life is what her fiction is so artful at revealing. It's hard to think of another contemporary writer so adept at splicing the ordinary and the marvellous, cracking open possibilities for exuberant invention and transformation in spaces as dismally quotidian as a care-home reception or post-office queue. Words migrate and morph; perspectives slip and skew; things change. 'Language is like poppies,' a character observes in *Autumn*. 'It just takes something to churn the earth round them up, and when it does up come the sleeping words, bright red, fresh, blowing about.'

★

Smith's last novel, the double-jointed *How to be both* (which was shortlisted for the 2014 Man Booker, and won the Baileys Prize for Women's Fiction, the Goldsmiths Prize and the Costa Novel Award), imagined a possible life for a real artist, the Italian Renaissance painter Francesco del Cossa, whose irrepressibly lively frescoes in the city of Ferrara have withstood earthquakes and wars. She's fascinated by the stubbornness of art, its capacity to outlive its creator, to 'float'.

Autumn is likewise concerned with an artist whose work survives despite long odds. Pauline Boty, nicknamed the Wimbledon Bardot, was a heart-stoppingly gorgeous proto-feminist pop art pioneer. She painted the sexy, violent world around her with a sly, wry eye. In a surviving photograph, she lounges naked with an armful of roses against her own painting of Jean-Paul Belmondo, an oozy vaginal flower crowning his hat. ('I'm an intelligent nakedness,' Smith has her say. 'An intellectual body. I'm a bodily intelligence. Art's full of nudes and I'm a thinking, choosing nude.')

Brainy, witty and electrifying, Boty was at the epicentre of Swinging London: dancing on *Ready, Steady, Go!*, making a luminous cameo as a love interest in *Alfie*. In 1965, she became pregnant and was diagnosed with cancer during a routine examination. She refused chemotherapy, worried it would harm the foetus, and died at the age of twenty-eight, a few months after the birth of her daughter. With that, she sank from history until, decades later, some of her riotous canvases were rediscovered, mildewed and covered in cobwebs, in an outhouse on her brother's farm.

Smith was knocked for six when she first saw one. 'There

are people who stand for their times and oh my God, Boty stands for her time.' Her interest quickened when she discovered Boty had been commissioned by an unknown person to paint Christine Keeler, the model at the heart of the Profumo affair (the painting, *Scandal '63*, which can be seen in several photographs, has been missing ever since).

Autumn interleaves the schisms of 2016 with the trial of 1963. Both are key years, Smith thinks, in which a lie in the political sphere had dramatic consequences for society at large. Like Brexit, like the invasion of Iraq, the Profumo affair marked a turning point. 'Meanwhile, the time itself is tearing itself apart because there has been a massive lie and the lie has come from Parliament and dissolved itself right the way through the country and things change. It's a pivotal moment. We were dealing with a kind of mass culture of lies. And it's a question of what happens culturally when something is built on a lie.'

One of the things she loves about Boty's work is that it looks at how governing cultural myths are formed and perpetuated by way of images. She didn't paint people so much as pictures of people already in wide circulation: Marilyn Monroe tottering in furs; the Beatles, Elvis, JFK being shot in a motorcade in Dallas. Like fiction itself, Smith thinks, 'it reminds you to read the world as a construct. And if you can read the world as a construct, you can ask questions of the construct and you can suggest ways to change the construct. You understand that things aren't fixed.'

<div align="center">★</div>

On the wall above Smith's desk is a porcelain branch breaking into leaf, surrounded by dozens of pictures. There are lots of Boty, with her panda eyes and swishing corn-coloured hair, alongside reproductions of her paintings. One of Smith's favourites is of a woman's spectacularly shapely arse, framed by a proscenium arch. Underneath, in huge red letters, Boty has painted the word BUM.

The light is fading. Downstairs, Smith brings us a plate of apples from her tree and two clasp knives. There are great piles of books and records everywhere, paintings propped casually on stacks of art magazines and proofs: an iceberg, a bowl of lemons, a watercolour of a pink lily against a wash of dense black. The lily is by John Berger, another writer sturdy in his faith in art as a force for forging connections, illuminating and resisting what Shakespeare's Thomas More calls 'mountainish inhumanity.'

Where do we end up if we wall ourselves in, Smith wonders. Insist on fortifications, and you create a kind of prison for yourself. In *Autumn* an electric fence appears around a plot of common land, patrolled by the fictive security agency SA4A. It's such an ugly, absurd spectacle: 'Prison for trees. Prison for gorse, for flies, for cabbage whites, for small blues. Oystercatcher detention centre.' Far better to yank them down, to learn how to communicate in a different tongue, to welcome the stranger as a friend.

She knows something of what's coming next in the quartet, though not of course what material the approaching future will fling her way. Winter, she thinks, is a place where you can see really clearly, while summer is the luscious moment when the light kicks in and the leaves are fully spread. But ask her about individual characters and she clams up. I'm particularly keen on

the puckish songwriter Daniel Gluck: a limber one hundred and one, his life spanning the full sweep of a century. Many of Smith's most memorable characters have been disrupters, from *Like*'s Ash and *The Accidental*'s Amber to Miles, the stubborn bedroom squatter of *There but for the*. Daniel, on the other hand, is a repairer: a good person, who makes being good seem sexy and elegant and fun.

In one of the novel's most memorable scenes, he plays a story-telling game with Elisabeth Demand, the precocious, unhappy girl who lives next door. When she insists on a character who wants war, he conjures up a killing field of pantomime characters, from Aladdin to Cinderella, 'a surrealist vision of hell'. And then he lets time get to work on them, grass growing through ribs and eyeholes, costumes nibbled away, until there's nothing left but bones in flower. I don't want to give away the exchange that follows, but I found it at once more stringent and more consoling that anything I've read this year.

Fiction can do that: can make a space for reflecting, for generating novel ways of responding and reacting to lies and guns and walls alike. The mere act of cracking open a book, Smith thinks, is creative in itself, capable of inculcating kindness and agility in the reader. 'Art is one of the prime ways we have of opening ourselves and going beyond ourselves. That's what art is, it's the product of the human being in the world and imagination, all coming together. The irrepressibility of the life in the works, regardless of the times, the histories, the life stories, it's like being given the world, its darks and lights. At which point we can go about the darks and lights with our imagination energised.'

Chantal Joffe

March 2018

EVERY TIME I GO to Chantal's studio we eat cupcakes from Hummingbird Bakery, get hopped up on sugar and talk very fast. We met because she read *The Lonely City* and asked if I'd come and sit for her. I feel like we made friends immediately I walked through the door. She says she's shy, but she's one of the most open, engrossing talkers I know. We both use portraiture as a way of getting at something deeper, and I get a better sense of what that might be by way of our sprawling, rapid-fire conversations.

How do you catch reality, the actual minute? I wanted to see what would happen if I wrote about her while she was painting me, if we could survey each other at the same time, an act of simultaneous witnessing. 27 February 2018, just after one. Chantal's studio is on the second floor of an old industrial building, overlooking a courtyard. There were nine versions of her face leaning against the back wall. She'd been painting one each evening. They looked excoriating to me, but she pointed out their subtle flattery. It isn't easy to really set down what you see. It isn't easy to see at all.

There were people all over the room, looking back at us or turning delicately away. A head of Jay-Z, in an expensive black

overcoat and blue shirt, the planes of his face very quick and sure, caught in a moment of consideration, of intensely private thought. Four versions of a teenaged boy, naked to the waist. In each, he was reticent, careful, folded in on himself. It was a painting of a person, and also of a moment in time, adolescence from the eye-view of the middle-aged, regarding a creature as fresh as a fawn. One of his ears stuck out, pinkly. His mouth was exquisite, a warm smear. The facets of his face fell in lavender shadow. I'm obsessed with Chantal's mouths, the vulnerability of them, the declivities around lips, the dashed depression beneath the nose.

Before we started, I prowled around sockless, getting pastel dust on my soles, itemising the detritus. An orchid, a pair of rubber gloves, a kitchen roll smirched with pink. There were scribbled notes all over the white walls, graffiti I've watched spread month by month. *F. Bacon. Prussian blue. Rimbaud. I am always. My stringbean.* Chantal's palette was covered in fat worms of yellow, ochre, scarlet, black. A painting of a baby was propped against a table leg. It lay on its back, a gender-indeterminate frog. The greenish, aquatic colour of the blanket made it look as if it was floating in amniotic fluid, a snapshot from the womb.

It was snowing. The light kept shifting, one minute a blizzard, the next full sun. There were several huge canvases, primed with pink or green ground. They cast their own light too, glowing weakly like drugstore neon. It was snowing so hard the sky went green. Painting is a high-wire act, especially if you're making portraits from a model. They can't see what you're doing, but they can see you doing it, six brushes in one

hand, leaning in and out, stealing long looks, maybe stalling, maybe running catastrophically aground. It's a negotiation, an exercise in consent. They give themselves up, hoping you'll see them at their best, revealing the beauty they're sure they contain. It's sort of like being a hairdresser, Chantal said. That's what it means to be a painter, you watch the person depart. And then: stop looking! You can't! No!

I recognise the people in Chantal's pictures; sometimes I know them. But a person is not stable. For a start there's such a gap between what people look like and who they are. It isn't easy to catch the essence, what Chantal described Baconishly that afternoon as 'the deadly real of the them'. The first time she painted me I felt like she'd caught something I didn't want to see, a kind of anxiety about being looked at that manifested in muscular tension, a rigidity around the mouth, something masklike and hurt. I could see my own withdrawal, and it was painful to regard.

Later she told me that when she first paints someone she can barely pluck up the courage to look at them, that sometimes she is anyway painting the familiar contours of her own face, or projecting moods into other women's bodies. This conversation fascinated me. It opened up a new door into Chantal's work. It was the sense of slippage between artist and subject I liked, the admission that perfect objective looking is an impossible act. You can't paint reality: you can only paint your own place in it, the view from your eyes, as manifested by your own hands.

A painting betrays fantasies and feelings, it bestows beauty or takes it away; eventually, it supplants the body in history. A

painting is full of desire and love, or greed, or hate. It radiates moods, just like people. That afternoon Chantal told me about painting a friend whose immense beauty was located in her vivacity, her force of presence. The painting she made was accurate, it rendered the features, but the person she'd been looking at had evaded her completely. When she told me that story she was excited. Something had been there, in the room. It hadn't been caught.

Women are always wrestling with their faces. Imagine going through life being so dependent on the arrangement of gristle and eyeballs, cheekbones and pores. It's all sagging and slipping, it's so difficult to inhabit, so dismaying to regard. I know Chantal is besotted by beauty, but what she defines as beautiful isn't the same as the fashion magazines. It's the actual instant, the shifty, wriggling person inside their hapless suit of flesh. I think this is why I love to look at her paintings of women. It's as if she scrapes off some sort of toxic outer layer, a blank plastic. She allows her sitters to possess themselves, to be lovely, idiosyncratic, intelligent, mortal, their eyes wide, wrapped in a daydream or looking boldly back.

She didn't like what she was painting. She got three sheets of paper and took three quick layers off, leaving pallid impressions of my face scattered on the studio floor. We were talking very fast. I had my laptop in my lap. We talked about Alice Neel and Peter Doig, we talked about underpants and bellies. We talked about Francis Bacon throwing paint at his canvases, Chantal said, 'He was trying to get in by a different door.'

We talked about Diane Arbus, Francesca Woodman, Lucian Freud. We talked like fishermen musing over catches, puzzling

over rods and casting techniques. We laid out pictures like silver fish: look at this, yeah but look at this! Over on the other side of the room I could see Jay-Z, his stately face. Chantal got out a catalogue and showed me six or ten Holbeins and Van Dycks. Paint as fur, as velvet, as brocade, as hair. Paint as a way of entering and becoming someone else. Paint as a device for stopping time.

The snow made everything very dreamy. We stopped and ate our cupcakes. The air smelled of burnt dust. I got up and walked around the room. My face was on the easel, a little sugared almond, surrounded by soft white light. My eyes were looking down, I was caught in the act of trying to get her, as she was caught in the act of trying to get me. The sun came out, my phone rang. Something was snagged, a hundredth of an aspect of somebody. It's there, is what I'm trying to say. Already we'd moved on.

STYLES

Two Figures in the Grass

QUEER BRITISH ART

March 2017

YOU MIGHT THINK they were three Hoorays on a spree, caught by a paparazzo's bulb in the fishbowl of a cab. Michael Pitt-Rivers almost seems to be smiling, hair slicked back, collar jacked. Lord Montagu has turned towards him. Only Peter Wildeblood is looking out, jaw jutting forward, some unreadable emotion – fury, maybe defiance, disgust – passing across his face.

The photograph was taken outside Winchester Crown Court on 24 March 1954. The men were on their way to prison, not a party; sentenced for homosexual offences including gross indecency and buggery, after two RAF servicemen with whom they'd spent a larky weekend in a Hampshire beach hut were coerced into turning Queen's evidence against them. Wildeblood and Pitt-Rivers had also been found guilty of 'conspiracy to incite certain male persons to commit serious offences with male persons', the first time that charge had been used in a prosecution since Oscar Wilde was sent to Reading Gaol in 1895.

During the eight-day trial, private love letters between

Wildeblood and one of the airmen were read out loud in court. Exposure, humiliation, shame, the currency of the times. A journalist and diplomatic correspondent for the *Daily Mail* (he was dismissed on conviction), Wildeblood was the only one of the defendants to admit he was homosexual, an act of disclosure that precipitated a sea-change in public opinion, policy and law. 'The right which I claim for myself, and for all those like me,' he wrote in his 1955 memoir, *Against the Law*, 'is the right to choose the person whom I love.'

The Montagu trial was the centrepiece of a vicious post-war witch hunt, the latest sally in a long campaign against same-sex relationships. After coming to power in 1951, the Conservative Home Secretary Sir David Maxwell Fyfe ordered a drive against what he termed 'male vice', promising to 'rid England of this plague'. He drastically increased policing, deploying under-cover officers to pose enticingly in parks, public lavatories and other cruising grounds. ('The prettiest ones,' the film-maker Derek Jarman recalled in *Modern Nature*. 'They had hard-ons but didn't come. Just arrested you.')

Around a thousand gay men were imprisoned each year; often, like the computer scientist Alan Turing, after reporting crimes against themselves. Decades later, Lord Montagu remembered a friend joking bleakly: 'the skies over Chelsea were black with people burning their love letters.' Suicides were legion, blackmail pervasive.

What was it like to live in those stifling years, if your desires were not ordained by the state? And what role did art play? Was it a place of refuge or rebellion; an enclosed arcadia or a way of recording affections and longings that had otherwise to be

ruthlessly concealed? These questions lie at the heart of *Queer British Art* at Tate Britain, a landmark survey of the period between 1861, when the death penalty for sodomy was abolished, and 1967, when consensual sex in private between two men was decriminalised, as long as both participants were over the age of twenty-one.

*

There probably isn't a better figuration of the closet than a painting made by Francis Bacon the year of the Montagu trial. *Two Figures in the Grass* shows a conjoined male couple in agitated embrace: mouth to ear, pink buttocks raised, tawny blades tickling bare legs. But the field in which they lie is somehow also a room, with ribbed black walls and vague white lines that recall an electric fence, or the ropes of a boxing ring. Private gives way to public, the ecstatic meadow becomes a zoo cage or prison cell.

'Caught in the act' is always an appropriate descriptor of Bacon's style, his aptitude and delight at arresting flesh in motion, sliding and sliming between positions. At sixteen, he'd been discovered by his father in his mother's underwear, and thrown out of the family home. When *Two Figures* was shown at the ICA in 1955, the police were called to the gallery on the grounds of obscenity.

These were the impossible conditions queer artists had to navigate. It wasn't just erotic, romantic or domestic lives that had to be repressed and hidden, but also subject matter. In a world where visible transgressions of gender or sexuality were violently policed, making images was a risky business. In 1873,

the Pre-Raphaelite painter Simeon Solomon, known for his milky, androgynous, chastely lounging angels and deities, was arrested for 'attempted buggery', and again the next year for 'indecent touching' in a lavatory. The surrealist photographer Angus McBean, whose magically strange tableaux transformed stage photography, spent 1942 to 1944 in jail for 'criminal acts of homosexuality'. As the painter Keith Vaughan put it: 'It is difficult to bear in mind that with all one's honours, distinctions, success etc. one remains a member of the criminal class.'

The law only applied to men, but that didn't mean same-sex relationships between women were immune to opprobrium. Dorothy Todd was hired as the editor of British *Vogue* in 1922. Under her visionary stewardship, the magazine became a bastion of high modernist style, swapping petticoats and corsets for Picasso, Cocteau, Man Ray and Woolf. Todd lived with her lover, the fashion editor Madge Garland. Sacked in 1926 because of declining circulation, she planned to sue the magazine, but was silenced when the publisher Condé Nast threatened to publically expose her 'morals'.

In such an inimical climate, it's not surprising that art became a zone of both enchantment and resistance. The plenitude of camp aesthetics, the lush excess, the cross-pollination of high and low forms might be conceived as a direct response to the paucity and hostility of the culture at large. From the mannered decadence of Aubrey Beardsley's naughty ink drawings to Cecil Beaton's photographs of Stephen Tennant as a radiant boy prince to the musical-hall high-jinks of Danny La Rue to the wickedly doctored library book covers made by the playwright Joe Orton (a crime for which he received a jail

sentence), camp offered a way of remaking the world, cutting it down to size and reassembling it in richly strange and strangely rich new forms.

★

When making an arrest, police would customarily search gay men for lipstick and rouge, confirmatory evidence of the pervert or deviant. Don't think for a moment that the current visibility of transgender people implies a recent emergence. Gender transgression and transcendence is not new. Angus McBean met the young Quentin Crisp in the blackout. In a series of portraits made in 1941, he immortalised Crisp's youthful, ambiguous beauty, all velvety lashes and Joan Crawford brows. The novelist Radclyffe Hall, painted in 1918, is the picture of an Edwardian gentleman, complete with stand-up collar and dove-grey cravat, Eton crop and sallow, sorrowing face, the self-declared 'congenital invert', who preferred to go by the name John.

Hall was by no means the only artist to stray across gender thresholds, or to claim a new name. The painter born in 1895 as Hannah Gluckstein refashioned herself as Gluck, 'no prefix, suffix, or quotes'. She dressed in an elegant masculine style; in her most famous self-portrait she juts her chin at the viewer, looking coolly back, not giving ground. As for the Victorian poets and lovers Edith Cooper and Katherine Bradley, they created a joint identity as Michael Field, at once a pen-name and a way of declaring the conjoining, unifying effect of their love. Unlike Gluck, they mostly used male pronouns. The reputation of the Field poems might have declined after their

friend Robert Browning revealed their identities, but their passionate collaborative marriage lasted a lifetime.

While it was not impossible to establish these small, imperilled utopias – one might think also of Bloomsbury, or the socialist, sexually experimental circle that grew up around the gay writer and campaigner Edward Carpenter – it was certainly safer to dream them up on canvas, though even pictures could be punished. In 1911, Duncan Grant painted his muscular, erotic panorama *Bathing* for the dining room at Borough Polytechnic. A fantasia of rippling flesh and water, in which every stroke is figured as a kind of entry, it was denounced in the press as having a potentially 'degenerative' effect on students.

Keith Vaughan too used paint as a way of capturing and commemorating something fugitive or fleeting. Keeping faith with the figure long after it had fallen out of fashion, his images are populated by austere pairs and groupings encountered in the back alleys and swimming pools of London. A powerful mood of sadness rises from these tense, coolly configured nudes, passing through transitory embraces, with their palette of damp sand and twilight blue. 'I ask myself', he wrote in his journal in 1953, 'which of my pictures would I be willing to stand beside in public, say Piccadilly Circus, for all to see. The least personal ones, I suppose, abstract landscapes. The continual use of the male figure . . . retains always the stain of a homosexual conception . . . "K.V. paints nude young men". Perfectly true, but I feel I must hide my head in shame. Inescapable, I suppose – social guilt of the invert.'

Despite this, he published his explicit, burningly honest

Journals in 1966, the year before partial decriminalisation was achieved. The decade's abrupt influx of light can likewise be tracked through David Hockney's paintings from the 1960s, from the meaty darkness of his student work, where the word QUEER ghosts in tentative letters, to the saturated jubilance of 1966's *Peter Getting Out of Nick's Pool*, bare buttocks centre stage.

It was a mood exemplified by the playwright Joe Orton, posing naked astride an Arne Jacobsen chair in knowing tribute to the famous photograph of Christine Keeler (the same photographer, Lewis Morley, was responsible for both images). In his plays, Orton gleefully yanked the blinds on England's small-minded pieties and prurience, exposing hypocrisy and greed. And yet in a way it was the closet that got him too: murdered in 1967 by his lover Kenneth Halliwell in a hammer-blow of shame and panic, a legacy of all those years in the shadows.

★

If there's an avatar of all this, a single figure who captures the rebellions and refusals of queer aesthetics, it's Claude Cahun, the French surrealist photographer and writer, who was making art out of gender refusal back in the 1930s. It feels as if we're only just catching up to the alien figure of Cahun, who translated writing on the third sex by Havelock Ellis and who wrote in her autobiography, *Aveux non Avenus* (*Disavowed Confessions*): 'Masculine? Feminine? It depends on the situation. Neuter is the only gender that always suits me.' 2017 is certainly her year. In addition to the Tate exhibition, she's the subject of a new biography, *Exist Otherwise* by Jennifer Shaw. Her work is currently on show at the National Portrait Gallery in tandem with

the photographer Gillian Wearing, who shares her interest in self-image and bodily transformations.

Cahun took self-portraits of surpassing strangeness. Now a little blonde boy; now a kiss-curled weightlifter; now walking blindfolded in jodhpurs along a sea wall, led by a cat on a leash, she sites herself as a protean creature, slipping between genders or abdicating the whole performance altogether. She frequently collaborated with her lover and stepsister Marcel Moore, born Suzanne Malherbe. They moved from Paris to Jersey in 1937, and after the German occupation dedicated themselves to a campaign of creative resistance.

Always adept at disguise, Cahun and Moore would dress up as German soldiers, infiltrating marches and giving out subversive handwritten translations of British news reports, which they'd sign 'The soldier without a name'. In 1944, both were arrested and sentenced to death. Liberation came just before the sentence was imposed, but Cahun's time in prison haunted her. It was maiming, to come up against authority like that, to have her own ability to freely move, identify and love inhibited, to be harmed by an occupying enemy who saw the sheer fact of her existence as a threat.

It's the story of queer art in a nutshell. The work is what's left, both record and dream; the lovely fruit of bitterly constrained lives, as Keith Vaughan well knew. Diagnosed with inoperable cancer, lonely, isolated and full of despair, he took an overdose on 4 November 1977. Then he picked up his diary and wrote a final entry, his pen wavering as consciousness faded. 'The capsules have been taken with some whiskey,' he wrote. 'It wasn't a complete failure I did some good w . . . '

Free if you want it

BRITISH CONCEPTUAL ART

April 2016

IN AUGUST 1966, a part-time tutor at St Martin's School of Art withdrew a book from the college library. His name was John Latham and the book in question was *Art and Culture*, an essay collection by the doyen of modernism, Clement Greenberg. But Latham didn't read the book. Instead, he invited friends, students and fellow artists to his house for what he called a *Still and Chew* event. Participants were asked to select a page, chew it to a pulp, and then spit the resultant 'distillation' into a flask. Latham added acid, sodium bicarbonate and yeast ('an Alien Culture'), and left the fertile brew to bubble gently.

There it remained until the following May, when the library requested the book's return, because, as Latham put it, a student of painting was 'in urgent need of Art and Culture'. What he delivered instead was a small, stoppered phial, neatly labelled 'Art and Culture/Clement Greenberg/Distillation 1966.' The library was not amused. On 14 June, Latham was informed that his temporary contract would not be renewed. The Vice-Principal suggested that he smooth things over by apologising for his 'bad joke', but Latham cheerfully refused, observing that

he considered such 'eventstructures' a crucial part of his teaching practice, and more useful to his students than theory.

Latham's distillation was one of the first acts of British conceptual art, and it serves to encapsulate its early mood and mores, the way it turned deconstruction, even destructiveness, into a creative force. But what was Latham actually doing? Was he being prankish, playfully pricking establishment balloons, or was he making a serious point? What does language like 'eventstructures' even mean? And what enmities were being expressed? Why Clement Greenberg, and why St Martin's?

The British conceptual movement of the 1960s and '70s so fundamentally changed the face of modern art that it's hard now to reimagine the conditions that precipitated its appearance. Conceptual art was rebellious to its core, a banger in the face of what it saw as stuffy, elitist modernism. This is why Greenberg was a target, though it might also be observed that he had recently described Latham's book reliefs as 'patly cubist'. What the early conceptual artists wanted to do was expand the definition of art, to blow the bloody doors off the venerable white cube of the gallery. Impure and fluid, worldly and engaged, in many ways conceptual art was a philosophical quest: a search for a vanishing point, for the outer limits of what might constitute a work of art.

In the old days, art had meant things; objects to which the viewer pays solemn homage. But what if art could also be ideas, expressed by way of acts, events in time that left minimal traces in the world? Maybe a person could be a work of art. Maybe you didn't need a gallery at all. Maybe art could take place in the street, or in a field. Maybe it only came into being with the

viewer's presence, and maybe it didn't require witnesses at all.

Conceptual art didn't come from nowhere. It had an ancestor in the phlegmatic form of the surrealist Marcel Duchamp, whose readymades shattered conventional notions of art as a result of craft or skill. But it was also a product of philosophy, the restless questioning of Wittgenstein brought to bear on the arena of the visual. It sprang up spontaneously in the febrile atmosphere of the 1960s, sending up tendrils in London and Coventry, in New York, Berlin, Milan and Rome. In America, minimalists like Ad Reinhardt and Donald Judd were exploding traditional categories of painting and sculpture. In Italy, artists associated with Arte Povera were experimenting with materials, rejecting bronze and oil in favour of dirt and ash.

An interest in ordinary and unclassifiable things also engaged the British contingent, who brought to conceptual art an anti-establishment edge and a deprecating wit. It was never a unified movement, but instead took place in pockets and seams across the country, from the Art & Language movement in Coventry to the defiant experimentation that came out of St Martin's School of Art in the late 1960s.

*

The work the British artists made was at once intellectual and playful, risking charges of pretentiousness in order to challenge received notions of value and meaning. In 1967's *Soul City (Pyramid of Oranges)*, Roelof Louw stacked 5,800 oranges in a pyramid in the London Arts Lab, a hotbed for countercultural hijinks. Over a fortnight, the work gradually shrank as visitors were encouraged to consume the fruit. As Louw put it: 'By

taking an orange each person changes the molecular form of the stack of oranges and participates in "consuming" its presence. (The full implications of this action are left to the imagination.)' What he'd done was pass control over the sculpture's form from artist to viewer; a radical step.

As for the immaculately besuited duo of Gilbert and George, they decided to destroy the gulf between artist and creation altogether, by converting themselves into a lifelong, evolving work of art. In *A Message from The Sculptors*, 1969, they declared themselves living sculpture, who could perform in a variety of ways, including 'interview sculpture, dancing sculpture, meal sculpture, walking sculpture'. Like Midas, everything they touched was transmogrified, including samples of their hair, their shirts and their breakfast. As they put it firmly: 'Nothing can touch us or take us out of ourselves.'

This interest in dissolving or dismantling barriers was a common impulse of the period. For the then-British based Braco Dimitrijević, it meant hanging huge photographs and banners of random passers-by in museums, while for Bruce McLean it involved rejecting the gallery in favour of the street, satirising the pretensions of the art world by displaying rubbish on plinths, and using his own body to mock the poses of serious sculpture.

When he was given a retrospective at the Tate in 1972, at the youthful age of twenty-seven, McLean held a one-day show, *King for a Day*, notable for not including any work whatsoever. Instead, he exhibited a neat grid of 1000 exhibition catalogues, typed in one sitting and comprising a satirical list of 1000 ideas for imaginary artworks, among them:

403 Earthworks piece, mixed media.

978 Henry Moore revisited for the 10th time piece

Not everyone was so gentle in their approach. One of John Latham's more disturbing works was his *Skoob Towers*, in which he assembled vast piles of dictionaries, encyclopaedias and textbooks in the streets of London, before setting them alight. They were designed to challenge received ideas about what the sculptural object meant, but they were also disquieting occurrences, with unpleasant historical echoes. Their malevolent energy clearly unsettled the writer A. S. Byatt. Smoke from burning *Skoob Towers* drifts through her 1996 novel *Babel Tower*, conveying the destructive energy of the 1960s.

At the decade's turn, the mood began to change. In the 1970s, conceptual art became increasingly political, and far less easily co-opted by galleries and institutions. This was the era of the Women's Liberation Workshop and the Artists' Union; the age of social engagement and collective action; a period in which the Royal College of Art organised a conference for artists, activists and trade unionists, asking among other burning questions whether the artist could ever be a member of the proletariat.

If the language was sometimes humourless or rotely Marxist, the effort to make art matter in the world could produce incandescent results. It was in the 1970s that women began to engage more powerfully with conceptual art, wrestling it from the hands of art-school boys and using it as a force to convey more urgent concerns. As Susan Hiller remarked, 'you have no subject matter other than what's already in language – and what

was already in language, for my generation of women, was not what we wanted to say. We wanted to say other things, not necessarily feminist political things, but other kinds of things, and you couldn't do that without inventing other ways of going about the whole procedure of making art.'

One of the most stimulating of these works is Mary Kelly's monumental *Post-Partum Document 1973–9*, a six-part series in which she formally investigated the mother–child dyad by way of her own relationship with her infant son. Inflected by feminism and psychoanalysis, the work caused tabloid outrage when it was first exhibited at the ICA, because it included stained nappies (you couldn't have Tracey Emin without Mary Kelly). At once tender and intellectually provocative, a sustained investigation into care-giving and women's labour, *Post-Partum Document* is among the most significant political artworks of the decade.

<p style="text-align:center">*</p>

As a movement, conceptual art was peculiarly preoccupied with non-existence, haunted by disappearances and vanishing acts of all kinds. This is particularly true of the artist and photographer Keith Arnatt, one of the greatest British conceptual artists. Arnatt's witty, curious art was invested in retraction and omission. He liked to make works that left no trace of themselves, burying boxes in the earth and filling pits with turf and mirrors, so that they were invisible until revealed by the passage of his own shadow.

One of his most memorable pieces is *Self-Burial (Television Interference Project)*, which exists as a grid of nine sequential

photographs made in 1969. They show a bearded man in jeans standing on a hillside, being slowly swallowed by the earth. In the third photograph, he is buried to his knees; in the eighth, to his eyes. In the ninth, he has disappeared altogether, replaced by a circle of freshly turned soil.

Arnatt was unusual in that he regarded the photographic evidence of his strange acts as crucial, the point itself rather than a necessary but tedious by-product. By the 1970s, he'd moved away from conceptual art altogether, turning his attention to pure photography (he possessed an unusual facility for finding art historical echoes in the most unprepossessing of circumstances, including photographs of rotting rubbish that look like Turner sunsets).

For others, like the land artists Hamish Fulton and Richard Long, the eventstructure was what counted. They turned walking into an art form, travelling across the country and engaging in subtle, often undocumented interventions with the landscape. The excursions were the real act, though both brought small, humble items back to the gallery – diary entries, photos, stones; compressed aide-memoires of their voyages out.

Conceptual art is often accused of being pretentious, or misunderstood as trying to claim a sack of rubbish has the equivalent status of a Vermeer. There's no doubt that it spawned all manner of vacuity, and yet much of the early work retains its questing power, its unsettling occupation of the boundary between thing and no thing, between object and idea.

At its best, it is improbably generous and inclusive, resistant to the capitalist wiles of the art world. An art of vanishing, an art that exists nowhere save in the afterlife of the mind. Want

to participate? Then think of Richard Long, setting off from Waterloo in 1967, on a blazing June day. He travelled southwest by train until he reached open countryside, and then he got off at a random station and walked until he found a field. There he paced back and forth in a straight line until the grass was worn flat beneath his feet.

The black and white photograph he took that afternoon is beautiful in its own right: a transient shining line. But that is simply a document. The work of art itself was made out of nothing more than effort and intent, and it returned to nothing, vanishing within hours of its creation. It isn't possessable. You can't buy it; it doesn't exist. All the same, it's free if you want it. You simply have to conceive of it, to let the idea occupy your imagination.

ESSAYS

Feral

May 2011

WHEN I WAS a very small child I was obsessed with a picture book called *The Green Man*, in which a rich young man who goes swimming in a forest pool has his clothes stolen from him and is forced to live in the wild. I can't remember much of anything about it now, except the hold it had over me and a colour plate of the man in a green suit he'd stitched from leaves, almost indiscernible against oak trees. I've periodically wanted to vanish into nature too, and at the age of twenty I almost managed it.

I'd been worried about the planet ever since I was a schoolgirl, sitting anxiously through geography lessons on greenhouse gases, drawing pencil diagrams of the ragged ozone layer. Later, as a teenager, I became fascinated by New Age travellers and especially the environmental protest movement, a counter-culture that was spectacularly lively before the 1994 Criminal Justice and Public Order Act criminalised its many forms of gathering and protest. First I combed *i-D* and *The Face*, magazines that were similarly fixated on the scene, for photographs of horse-drawn wagons and dreadlocked dancers at outdoor raves, and then I joined in for myself.

I turned down a place at Cambridge in favour of Sussex and

its radical curriculum, moving to Brighton, the urban epicentre of the protest scene. It was an era characterised by the temporary autonomous zone. Reclaim the Streets parties on motorways or in Trafalgar Square, a bouncy castle to block traffic, thousands of people dancing to an illegal sound system housed in a tank or run from a bicycle-powered generator. Demos against the arms trade and McDonald's. Squatted community centres in empty houses, shouting Section 6 of the Criminal Law Act through the letterbox at the police: 'TAKE NOTICE that any entry or attempt to enter into this PROPERTY without our permission is a criminal OFFENCE.'

But all of these activities were ancillary to road protests. In the early 1990s, people in the UK had begun using non-violent direct action to prevent the government's then-extensive programme of road building, protesting against both the destruction of wild places, among them numerous sites of special scientific interest, and the polluting, climate-destroying effects of cars. Starting with Twyford Down in 1992, they occupied land that was in the line of road-building projects, using direct action techniques to delay and prevent work – lying in front of bulldozers, chaining themselves to machinery, occupying tunnels dug perilously into the earth. Over time, the camps became arboreal, with protestors living full-time in threatened trees to protect them. Evictions were pitched battles; their cost so prohibitive and the risks of injury so high that many road projects were abandoned.

I'd been hanging around the fringes of road protests since my late teens, bunking off my English degree to steal stray weeks at Newbury and Fairmile. I loved arriving after dark and

seeing the lumpy silhouettes of tree houses, a chorus of yips and whistles echoing from the branches. The passport to entry was a climbing harness. Mine was blue, with a pink and green striped cowstail. I learned to abseil and prusik, laboriously dragging my own weight up a free line to the treetops. Once aloft, we moved around by walkways: two lines of blue polypropylene that ran from tree to tree, thirty feet above the ground. You clipped onto the top line with your cowstail, and walked along the bottom, heart in mouth, restored to the perilous vantage of a hairless ape.

The summer that I was twenty I moved to a tiny protest camp in Dorset, established by locals to protect a strip of much-loved woodland from being bulldozed for a relief road. Teddy Bear Woods was a beech hanger, falling steeply to a meadow. There was a net slung in the canopy, built as a defence for when the bailiffs came. Lying up there among the leaves, you could see the glittering blue ribbon of the sea a mile south. What did we do all day? We made endless trips to gather wood and water, sawed wood, chopped wood, prepped food, washed up. Without electricity, the most basic tasks took hours.

At the end of that summer I dropped out of university altogether. Living outdoors, under the stars, the world had come to seem at once infinitely lovely and infinitely at risk. Teddy Bear Woods had been saved, but Newbury and Fairmile were gone, the ancient oaks chainsawed down, the undergrowth grubbed up by diggers. When Fairmile was evicted, I'd wept in shame, that we were doing such an appalling job at stewarding the planet, that a place so beautiful had been destroyed for a dual carriageway that might cut journey times by a few

minutes. I didn't want to be a part of it any more. I wanted to find a way of living that did no harm, and so I retreated, ending up at twenty living alone and off-grid in a way that seems in retrospect more like an animal than a human being.

Some friends had plans to start an organic market garden on an abandoned pig farm in the Wealden countryside north of Brighton. We went out that winter in Alan's black Dodge 50 to take a look. Priestfield was at the end of a long track lined with blackthorn and scraggy elder. There was a rusty gate and beyond it a hardstanding, an empty mobile home and two or three dank barns stuffed with generations of Brighton hippies' rubbish. We left the van there and walked on, past the wreckage of former pigsties and into a sloping field edged with ash and oak. In the distance the Downs rose up in their whaleback curves. The air smelt of wet grass and mould. 'I'm going to live here,' I said, and when nobody presented any objections, I gathered up my possessions and began the process of building a house. The market garden didn't materialise until a long time later, and though there were visitors I lived at Priestfield entirely alone.

I wanted to build a bender, once the traditional summer dwelling of Romany Gypsies and a structure loved by travellers and eco-activists for being both low-impact and warm. Benders are like rustic tents, made of bent poles of coppiced hazel covered with canvas or tarpaulin. I stole my hazel from a wood up the road, sneaking in with a pruning saw and taking perhaps forty whippy fifteen-foot poles, cut at an angle so that the trees wouldn't rot. I persuaded a wood yard to give me six unwanted pallets, bought two green tarpaulins from an army surplus store, and was given a little pot-bellied stove by my mother, with old

washing-machine ducting found in a skip to serve as a chimney. These were the skills I'd learned from my years on protests: how to climb, how to build my own house, to tie knots and lash beams, to light a fire, to scavenge useful things from other people's rubbish (much of what we'd catcn on site came from making nightly raids on the giant bins behind the local Co-op, before they started dousing the contents in bleach).

By the time everything was assembled it was February. One still, cool day my friend Jim came up to help. I'd chosen a spot at the top of the field, nestled in against a double hedge of stripling oaks. We laid the pallets on the lumpy grass, covered them with carpet and planted the poles around this rudimentary floor, binding them into interlocking arches with lengths of twine. Soon it resembled the ribcage of a dinosaur, and then a giant upturned baskct. Within a few hours the frame was finished. We hauled the tarps on top, rolling them back around a wooden window I'd found on the street. Then I dragged my things in: a sofa, an old bookcase, two foam mattresses for a bed. I tucked throws and quilts behind the frame, hanging trinkets from the twigs.

I lived that spring in a way that has few parallels in the urbanised world, and as such it's difficult to integrate it into the more conventional life that followed. I washed in a bucket of water, cooked my vegan stew over a fire, used a compost loo and slept in all the clothes I owned. I had a pager – if mobile phones had been invented then, nobody I knew owned one yet – and when I wanted to speak to someone I'd walk two miles along the river to a red phone box that stood dusty and untended on a country lane.

I barely spoke, and my quietness allowed the world to emerge. It was a time of strange, almost dreamlike encounters with the wild. At dawn and dusk, deer would sometimes graze a yard from where I sat. At night, I squatted by the fire and watched the stars turn their slow wheels over Wolstonbury Hill and Devil's Dyke. One day I walked past the heaps of broken concrete and bindweed and disturbed an adder that rose up on its tail and hissed into my face. It was the sort of experience I'd longed for, but still I slept with an axe under my pillow, though in reality the only enemy I had were the mice that ate everything I owned and woke me at night by running through my hair. I was frightened all the time. I felt more exposed than I ever have since, almost unravelled by it, paranoid that I was being watched by the inhabitants of the scattered houses whose lights I could see winking through the fields at night.

The pleasure of being there was about escaping and effacing myself, and though it had ecstatic elements, in retrospect I wonder if there was also an element of punishment, if I was serving a sentence of solitary for the communal crime of environmental despoliation. The environment then was the sole province of cranks and hippies. Roads, pesticides, plastic, petrol: these were regarded as the scaffolds of civilisation, to be used infinitely, without consequence. I thought all the time of the future, a world without water, animals, trees. Civilisation seemed the thinnest of veneers. Even though the camp at Teddy Bear Woods had been successful and the trees were safe, like many ex-protestors I'd begun to buckle under the strain of trying to avert – trying even to articulate – an oncoming catastrophe.

I left the bender in June. Protest culture was tribal and nomadic, almost medieval in its calendar. People lived scattered in small communities on camps, traveller sites and in London squats, wintering in canal boats, trucks and benders and coming together each summer at festivals and raves. I went to Cornwall, living with a street theatre company who travelled horse-drawn from village to village. I'd planned to go back to the field in September, but out in the world again I'd realised I wanted to be more useful, and much less isolated. I missed people, and was no longer so sure that the best thing I could do for the planet was to efface myself or live according to such austere, punitive standards.

That autumn I moved, half reluctantly and half with relief, into a housing co-op on the outskirts of Brighton. The garden backed onto the Downs and the landlord let me install my old wood burner in my bedroom, but the house also had central heating, a bath and an indoor loo, all the luxuries I'd done without. My feral spring was over, though even now if I catch the smell of wood smoke I tumble back through time.

Thirteen years after I left the field, I saw the film *Into the Wild*. It's based on the life of a young man, Christopher McCandless, who in 1990 destroyed his credit cards, gave away his possessions and went to live in the wilderness, moving further and further away from people until he ended up living in an abandoned bus in the Denali National Park in Alaska, with minimal equipment. After three months, he realised, as I had done, that isolation can eat away at you, and that living with other people is a source of sustaining happiness as well as conflict and stress. McCandless had walked in over the Teklanika

River, then a stream, but by the time he decided to make his way home to his family, it was in spate and no longer fordable. He was trapped, though if he'd owned a map he would have known that there was a bridge less than a mile away from his bus. He ran out of food, and tried to live off the land, gathering wild plants and hunting game, until he starved to death.

Watching the film, I felt an uneasy thrill of recognition. Though the field I'd lived in was by no means a wilderness, for a time I'd contrived to pitch right through the trappings of civilisation, reaching a ground zero most people don't even know exists. I don't just mean physically. Like McCandless, my motivation was at least in part a kind of undoing of the self. I didn't want to be a person back then. I was sick with guilt about how human behaviour was damaging the planet. I wanted to live in a way that did no harm but I also wanted to lose myself, to be reabsorbed into the wild, to disappear beneath a canopy of leaves.

Drink, drink, drink

WOMEN WRITERS AND ALCOHOL

June 2014

IF YOU WRITE a book about alcohol and male writers, as I did, the one question you'll be asked more than any other is *What about the women?* Are there any alcoholic women writers? And are their stories the same, or different? The first question is easier to answer. Yes, of course there are, among them such brilliant, restless figures as Jean Rhys, Jean Stafford, Marguerite Duras, Patricia Highsmith, Elizabeth Bishop, Jane Bowles, Anne Sexton, Carson McCullers, Dorothy Parker and Shirley Jackson.

Alcoholism is more prevalent in men than women (in 2013, the NHS calculated that 9% of men and 4% of women are alcohol dependent). Still, there's no shortage of female drinkers, no lack of falling-down afternoons and binges that stretch sweatily into days. Women writers haven't been immune to the lure of the bottle, nor to getting into the kinds of trouble – the fights and arrests, the humiliating escapades, the slow poisoning of friendships and familial relations – that have dogged their male colleagues. Jean Rhys was briefly in Holloway Prison for assault; Elizabeth Bishop more than once drank eau de cologne,

having exhausted the possibilities of the liquor cabinet. But are their reasons for drinking different? And how about society's responses, particularly in the lubricated, tipsy twentieth century: the golden age, if one can call it that, of alcohol and the writer?

In her book *Practicalities,* the French novelist and film-maker Marguerite Duras says many shocking things about what it means to be a woman and a writer. One of her most striking statements is about the difference between male and female drinking, or rather the difference in how the two are perceived. 'When a woman drinks,' she writes, 'it's as if an animal were drinking, or a child. Alcoholism is scandalous in a woman, and a female alcoholic is rare, a serious matter. It's a slur on the divine in our nature.' Ruefully, she adds a personal coda: 'I realized the scandal I was creating around me.'

She'd been an alcoholic, she figured, from the moment of her first drink. Sometimes she managed to stop for years at a time, but during her bingeing periods she'd go all out: start as soon as she woke up, pausing to vomit the first two glasses, then polishing off as much as eight litres of Bordeaux before passing out in a stupor. 'I drank because I was an alcoholic,' she told the *New York Times* in 1991. 'I was a real one – like a writer. I'm a real writer, I was a real alcoholic. I drank red wine to fall asleep. Afterwards, cognac in the night. Every hour a glass of wine and in the morning cognac after coffee, and afterwards I wrote. What is astonishing when I look back is how I managed to write.'

What is also astonishing is how much she managed to write, and how fine most of it is, rising coolly above the sometimes

dire conditions of production. Duras wrote dozens of novels, among them *The Sea Wall*, *Moderato Cantabile* and *The Ravishing of Lol Stein*. Her work is elegant, experimental, impassioned, incantatory; almost hallucinatory in its appeal to the senses, its rhythmic force. A forerunner of the nouveau roman, she dispensed with the conventions of character and plot, the heavy furniture of the realist novel, at the same time retaining an almost classical austerity, a clarity of style that resulted from obsessive redrafting.

Duras's childhood was marked by fear, violence and shame: a common enough concatenation in the early life of the addict. She was born Marguerite Donnadieu (Duras is a pen name) in 1914 in Ho Chi Minh City to French parents, both of whom were teachers. When she was seven, her father died, leaving the family in abject poverty. Her mother saved for years to buy a farm, but was cheated on the price, buying land that was often inundated by the sea. Both Marguerite's mother and her elder brother beat her, calling her *crab louse* and, later, *whore*. She remembered hunting for birds in the jungle to cook and eat, remembered swimming in a river that would fill periodically with the corpses of miscellaneous creatures that had drowned upstream. At school, she had a sexual relationship – seemingly encouraged by her family for financial reasons – with a much older Chinese man. Later, in France, she married, had a son with someone else, made films, lived and wrote with a single-minded intensity. Her drinking worsened as the decades passed, stopping and starting, gaining traction, until at the age of sixty-eight she was diagnosed with cirrhosis and forced to dry out, a terrifying experience, at the American Hospital in Paris.

Not many writers manage to get sober and those who do often suffer a decline in output: testament not so much to the power of alcohol as a creative stimulant as to its role in destroying brain function, obliterating memory and playing havoc with the ability to formulate and express thought. But Duras wrote one of her very best and certainly most famous novels two years after she stopped drinking. *The Lover* tells the story of a young French girl in Indochina who has an erotic relationship with – yes – a much older Chinese man. Much of it was drawn from Duras's own life, from the secret core of violence and degradation out of which she'd emerged.

As later published versions make clear, she was capable of returning over and over to this primal scene of childhood, redrawing it in an almost infinite variety of colours: sometimes erotic or romantic, sometimes brutal and grotesque. Retelling the same stories; going back repeatedly to the substance that she knew was destroying her: these repetitive acts, some generative and some decreative, made the critic Edmund White wonder if Duras was not in the grips of what Freud had called the repetition compulsion. 'I'm acquainted with it, the desire to be killed. I know it exists,' she once told an interviewer, and it is this intensity, this absolute and uncompromising vision, that sets her work apart. At the same time, this statement seems to shine a light on how she used alcohol: as a way of giving in to her own masochism, her suicidal ideation, while simultaneously anaesthetising herself from the savagery she saw at work everywhere, filling the world.

★

Duras's nightmarish childhood raises the question of origins, of what causes alcohol addiction and whether it is different for men and women. Alcoholism is roughly 50% hereditable, a matter of genetic predisposition, which is to say that environmental factors such as early life experience and societal pressure play a considerable role. Picking through the biographies of alcoholic women writers, one finds again and again the same dismal family histories, the same hand-me-down genes and hard-luck stories that are present in the lives of their male counterparts, from Hemingway to Fitzgerald, Tennessee Williams to John Cheever.

Elizabeth Bishop is a good example. Many members of her family were alcoholics, including her father, who died when she was a baby. Bishop's life was additionally marred by the kind of loss and physical insecurity often present in the family histories of addicts. When she was five her mother was institutionalised. They never saw each other again. Instead, Elizabeth was parcelled between aunts, an anxious child who at university at Smith gratefully discovered the use of alcohol as a social lubricant, not realising until too late that it was also a potent source of shame, isolating in its own right. In the poem 'A Drunkard', Bishop uses incidents from her own life to create an ironic portrait of an alcoholic, keen to explain their abnormal thirst. 'I had begun/to drink, & drink – I can't get enough,' the narrator confesses, a line that recalls John Berryman's frank *Dream Song* statement: 'Hunger was constitutional with him,/ wine, cigarettes, liquor, need need need.'

Shame was one of the central drivers in Bishop's drinking: first the internalised shame she carried from her childhood, and

later the shame that followed on from her own appalling binges. Then too there was the matter of sexual identity. A lesbian at a period in which homosexuality was by no means socially sanctioned or accepted, Bishop found her greatest freedom in Brazil, where she lived with her female partner, the architect Lota de Macedo Soares. She spent her most peaceful and productive years there, though even these were interleaved with drunkenness, followed by the inevitable fights and confusions, the frightening declines in physical health.

Shame is also a factor in the life of Patricia Highsmith, who was born Mary Patricia Plangman in 1921, her surname an unwelcome memento of the man her mother had divorced nine days before she was born. She wasn't exactly welcome herself. Her mother had drunk turpentine at four months, hoping to abort the baby. 'It's funny you adore the smell of turpentine, Pat,' she later said. This grisly joke recalls John Cheever, whose parents also used to kid about having tried to abort him. Like Cheever, Highsmith had complex feelings about her mother, and like Cheever she had a pervasive sense of being fraudulent, empty, somehow a fake. Unlike Cheever, however, she was courageous in facing up to the direction of her sexual desires, though she did have a sometimes pleasurable, sometimes troubling sense of deviance, of running counter to society's grain.

She was an anxious, guilty, tearful child – *lugubrious*, in her own words. By eight she was fantasising about murdering her stepfather Stanley and at twelve was disturbed by violent rows between him and her mother. That autumn, Patricia's mother took her to Texas, saying that she was going to get divorced

and live in the South with Pat and her grandmother. But after a few weeks of this all-female utopia, Mrs Highsmith returned to New York, abandoning her daughter without explanation. Left high and dry for a whole miserable year, Patricia never got over the sense of betrayal, the belief that she had been personally rejected.

Her drinking began as a student at Barnard. In a diary entry from the 1940s, she wrote of her belief that drink was essential for the artist because it made him 'see the truth, the simplicity, and the primitive emotions once more'. Ten years on, she was describing days in which she went to bed at four in the afternoon with a bottle of gin before putting away seven Martinis and two glasses of wine. By the 1960s, she needed booze to keep going, needed an eye-opener in the morning, lied about her drinking and lied too about all kinds of large and small details – about what a good cook and gardener she was, though her garden at the time was dried-up grass and she often lived off cereal and fried eggs.

Much of how she felt and behaved went into her work, passing fluidly into her most famous character. Tom Ripley is not always a heavy drinker but he shares with the full-blown alcoholic his paranoia, his guilt and self-hatred; his need to obliterate or escape his painfully empty, flimsy self. He's forever splitting or slithering into other, more comfortable identities, though this in itself is shameful and often serves as the impetus for his casual and dreadful murders. In fact, Ripley's entire career as a killer mimics alcoholism in that it is driven by a need to repeat an activity in order to snuff out the trouble the activity has caused. Then too there's the atmosphere of the books,

the looming sense of anxiety and doom, instantly familiar from any number of alcoholic works. Look, for example, at this passage from *The Talented Mr Ripley*, in which Tom is in Rome, trying to convince himself he won't be caught for Dickie's murder:

> Tom did not know who would attack him, if he were attacked. He did not imagine police, necessarily. He was afraid of nameless, formless things that haunted his brain like the Furies. He could go through San Spiridione comfortably only when a few cocktails had knocked out his fear. Then he walked through swaggering and whistling.

Cut the name, and it could be lifted directly from Charles Jackson's *The Lost Weekend* or almost any page of Tennessee Williams's drink-besotted diaries.

*

There's no doubt that personal unhappiness is part of why both men and women develop the habit of drinking, but these intimate stories leave out something larger, something less easy for any individual to challenge or address. What lives were like for women in the West for the majority of the twentieth century is angrily summed up by Elizabeth Young in her introduction to *Plain Pleasures*, the collected stories of Jane Bowles. 'Up until the 1970s women were discounted and despised,' she writes. 'They were, *en masse*, classed with children in terms of capability but, unlike children, were the butt of virtually every joke in the comedian's repertoire. They were considered trite, gossipy,

vain, slow and useless. Older women were hags, battle-axes, mothers-in-law, spinsters. Women were visible in the real world, the world of men, only while they were sexually desirable. Afterwards they vanished completely, buried alive by the creepy combination of contempt, disgust and sentimentality with which they were regarded.'

By way of illustration, she relays a story about the writer who Truman Capote, William Burroughs and Gore Vidal all considered among the greatest of her age: a giant of modernism, despite the minute proportions of her output. After having an alcohol-induced stroke in middle age, Jane Bowles was sent to see a British neurologist, who patronisingly told her: 'You're not coping, my dear Mrs Bowles. Go back to your pots and pans and try to cope.'

This intense disregard for women, this inability to comprehend their talents or inner lives, was hardly a one-off. Similar scenarios can be found in the lives of almost any twentieth-century woman writer of note. Jean Stafford, for example, who these days is more likely to be remembered for her marriage to Robert Lowell than for her Pulitzer Prize-winning stories or her savage novel *The Mountain Lion*. This latter work was published in 1947, while she was drying out at Payne Whitney, a mental hospital in upstate New York. There her psychiatrist was less interested in her reviews than in insisting she improve her grooming, switching her habitual baggy sweater and slacks for a blouse and skirt, with pearls for dinner, like, Stafford said dryly, 'a Smith College girl'.

I can think of no writer who better expresses these pressures and hypocrisies than the novelist Jean Rhys, who can hardly be

described as a feminist and yet who wrote so bitterly and so bleakly about the lot of women that her work is disturbing even now. Rhys was born Gwen Williams on the island of Dominica in 1890, to a British father and Creole mother. Like F. Scott Fitzgerald, she was a replacement child, conceived nine months after the death of her sister. Like Fitzgerald, she had a pervasive sense of standing outside, of not being quite real or legitimately loveable. She came to London at sixteen, a pretty and hopelessly ignorant girl. Her expectations of a new and glamorous life were dashed by the porridgey, puddingy greyness, the bitter cold, the casually cruel and competent people. Her father died while she was at drama school, but instead of going home she slipped away, joining a chorus and changing her name to Ella Gray.

Ella Gray, Ella Lenglet, Jean Rhys, Mrs Hamer: whatever name she was travelling under, Rhys was always on the verge of drowning, always frantic to find a man who'd scoop her up and lift her into the kind of warm, luxurious world she craved. Unused to love, she picked badly or perhaps was just unlucky, choosing men who left her or who were somehow incapable of providing the sort of financial and emotional security she needed. She had an abortion, married, had a baby who died and a daughter, Maryvonne (who spent most of her childhood being cared for not only by someone else but in a different country to her mother), married for a second and then a third time, and was throughout these misadventures always at the brink of destitution, the very outer edge.

Alcohol quickly became a way of dealing with this endless trouble and confusion, of blotting out the darker elements,

temporarily filling an unbearable black hole of need. As her excellent biographer Carole Angier puts it: 'Her past tormented her so that she had to write about it, and then writing tormented her: she had to drink to write, and she had to drink to live.'

But what emerged from the muddle and mess was a series of lucid novels: strange, slippery texts about alienated rootless women adrift among the demi-monde of London and Paris. These books – *Quartet, After Leaving Mr. Mackenzie, Voyage in the Dark* and *Good Morning, Midnight* – show the world as it appears from the vantage of the dispossessed. They're about depression and loneliness, but they're also about money: money and class and snobbery and what it means if you can't afford to eat or your shoes are wearing out and you can no longer keep up the little genteel illusions, the ways of getting by, of being accepted in society. Rhys is brutal in her depiction of a world in which there is no safety net for a woman alone and getting older, running short on the only reliable currency she has.

In the unstable *Good Morning, Midnight* she makes a case for why such a woman might turn to drink, given limited options for work or love. At the same time, and like her near-contemporary Fitzgerald, she uses drunkenness as a technique of modernism. The novel is written in a flexible first person, slip-sliding through Sasha's shifting moods. 'I've had enough of these streets that sweat a cold, yellow slime, of hostile people, of crying myself to sleep every night. I've had enough of thinking, enough of remembering. Now whisky, rum, gin, sherry, vermouth, wine with the bottles labelled "Dum vivimus, vivamus . . ." Drink, drink, drink . . . As soon as I sober up I

start again. I have to force it down sometimes. You'd think I'd get delirium tremens or something.'

During the war, Rhys vanished yet again from public view, re-emerging in 1956 after the BBC ran an advert looking for information on the author it believed to be dead. She spent the 1960s shipwrecked in the aptly named Landboat Bungalows in Devon, living with her third husband, the nervy Max Hamer, who had been in prison for fraud and was now invalided after a stroke. In this dismal period, Rhys was tormented by extremes of poverty and depression and also by her neighbours, who believed she was a witch. She was put in a mental hospital after attacking one of them with a pair of scissors. The drinking continued unabated, worse than before. And yet at the same time she was working away on a new novel, *The Wide Sargasso Sea*: a prequel to *Jane Eyre* that drew on her childhood in the Caribbean, her feelings of being an outsider, left out in the cold by the icy, inscrutable English.

'No one,' Diana Athill writes in *Stet*, 'who has read Jean Rhys's first four novels can suppose that she was very good at life; but no one who never met her could know how very bad at it she was.' Athill became Rhys's editor around this time, befriending her along with Sonia Orwell and Francis Wyndham, who were the protectors and guardians of her renaissance, the success that came too late and after too much hardship to make a real difference to Rhys's ravaged internal world.

In her writing about Rhys, Athill puzzles over what might be the central question of the alcoholic writer, which is how someone so very bad at living, so incapable of facing up to trouble and taking responsibility for their own mess, might be

so very good at writing about it, peering into what were in their own personal life total blind spots. 'Her creed – so simple to state, so difficult to follow – was that she must tell the truth: must get things down *as they really were* . . . this fierce endeavour enabled her to write her way through to understanding her own damaged nature.'

This fierceness is everywhere in Rhys's work, flipping self-pity into pitiless critique. She shows how power works and how cruel people can be to those who are beneath them, revealing too how poverty and social mores pinion women, limiting their options until a Holloway cell and a Parisian hotel room come to seem pretty much indistinguishable. It's not a triumphant kind of feminism, an assertion of independence and equality, but a savage, haunted account of stacked cards and loaded dice, which might drive even the sanest woman to drink and drink and drink.

The Future of Loneliness

March 2015

A GIGANTIC BILLBOARD advertising Android, Google's operating system, appeared over Times Square at the end of last winter. In lower-case lettering, corporate code for friendly, it declared: *be together. not the same.* This erratically punctuated mantra sums up the web's most magical proposition: its existence as a space in which no one need ever suffer the pang of loneliness, in which friendship, sex and love are never more than a click away, and difference is a source of glamour and not of shame.

Like the city itself, the promise of the internet is contact. It seems to offer an antidote to loneliness, trumping even the most utopian urban environment by enabling strangers to develop relationships along shared lines of interest, no matter how shy or isolated they might be in their own physical lives. But proximity, as city dwellers know, does not necessarily mean intimacy. Access to other people is not by itself enough to dispel the weight of internal isolation. Loneliness can be most acute in a crowd.

In 1942, the painter Edward Hopper produced the signature image of urban loneliness. *Nighthawks* shows four people in a diner at night, cut off from the street outside by a curving glass

window: a disquieting scene of disconnection and estrangement. In his art, Hopper was centrally concerned with how humans were handling the environment of the electric city, the way it herded people together while enclosing them in small and exposing cells. His paintings establish an architecture of loneliness, reproducing the confining units of office blocks and studio apartments, in which unwitting exhibitionists reveal their private lives in cinematic stills, framed in pens of glass.

More than seventy years have passed since *Nighthawks* was painted, but its anxieties about connection have lost none of their relevance, though unease about the physical city has been superseded by fears regarding our new virtual public space, the internet. In the intervening years, we have entered into a world of screens that extends far beyond Hopper's unsettled vision.

Loneliness centres around the act of being seen. When a person is lonely, they long to be witnessed, accepted, desired, at the same time as becoming intensely wary of exposure. According to research carried out over the past decade at the University of Chicago, the feeling of loneliness triggers what psychologists term hypervigilance for social threat. In this state, which is entered into unknowingly, the individual becomes hyperalert to rejection, becoming inclined to perceive their social interactions as tinged with hostility or scorn. The result of this shift in perception is a vicious circle of withdrawal, in which the lonely person becomes increasingly suspicious, intensifying their sense of isolation.

This is where online engagement seems to exercise its special charm. Hidden behind a computer screen, the lonely

person has control. They can search for company without the danger of being revealed or found wanting. They can reach out or they can hide; they can lurk and they can show themselves, safe from the humiliation of face-to-face rejection. The screen acts as a kind of protective membrane, a scrim that permits invisibility and also transformation. You can filter your image, concealing unattractive elements, and you can emerge enhanced: an online avatar designed to attract likes. But now a problem arises, for the contact this produces is not quite the same thing as intimacy. Curating a perfected self might win followers or Facebook friends, but it will not necessarily cure loneliness, since the cure for loneliness is not being looked at, but being seen and accepted as a whole person: ugly, unhappy and awkward as well as radiant and selfie-ready.

This aspect of digital existence is among the concerns of the MIT professor Sherry Turkle, who's been writing about human–technology interactions for the past three decades and who has become increasingly wary of the capacity of online spaces to fulfil us in the ways we seem to want it to. According to Turkle, part of the problem with the internet is that it encourages self-invention. 'At the screen,' she writes in 2011's *Alone Together*, 'you have a chance to write yourself into the person you want to be and to imagine others as you wish them to be, constructing them for your purposes. It's a seductive but dangerous habit of mind.'

But there are other dangers, too. My own peak use of social media arose during a period of painful isolation. It was the autumn of 2011, and I was living in New York, recently heartbroken and thousands of miles from my family and friends. In

many ways, the internet made me feel safe. I liked the contact I got from it: the conversations, the jokes, the accumulation of positive regard, the favouriting on Twitter and Facebook likes, the little devices designed for boosting egos. Most of the time, it seemed like the exchange, the gifting back and forth of information and attention, was working well, especially on Twitter, with its knack for prompting conversation between strangers. It felt like a community, a joyful place; a lifeline, in fact, considering how cut-off I otherwise was. But as the years went by – 1,000 tweets, 2,000 tweets, 17,400 tweets – I had the growing sense that the rules were changing, that it was becoming harder to achieve real connection, though as a source of information, it remained unparalleled.

This period coincided with what felt like a profound shift in internet mores. In the past few years, two things have happened: a drastic rise in online hostility and a growing awareness that the lovely sense of privacy engendered by communicating via a computer is a catastrophic illusion. The pressure to appear perfect is greater than ever, while the once-protective screen no longer reliably separates the domains of the real and the virtual. Increasingly, participants in online spaces have become aware that the unknown audience might at any moment turn on their real self in a frenzy of shaming and scapegoating.

These are the digital witch trials whose consequences have been so alarmingly documented by Jon Ronson in *So You've Been Publicly Shamed*. One of his most disturbing stories concerns Lindsey Stone, who put a flippant photograph of herself on what she thought was her private Facebook page, raising her middle finger at Arlington military cemetery in front of a sign

reading 'Silence and Respect', part of a series of pictures she and her friend were taking in which they defied the advice of signs. Four weeks later the picture went viral. Stone received multiple rape and death threats and was fired from her job, entering a period of depression that kept her almost house-bound for a year.

The dissolution of the barrier between the public and the private, the sense of being surveilled and punished, extends far beyond our human observers. We are also being watched by the very devices on which we make our broadcasts. As the artist and geographer Trevor Paglen recently observed in *frieze*: 'We are at the point (actually, probably long past) where the major-ity of the world's images are made by-machines-for-machines.' In this environment of enforced transparency, the psychic equivalent of the *Nighthawks* diner, almost everything we do, from shopping in a supermarket to posting a photo on Facebook, is mapped, the gathered data used to predict, monetise, encour-age or inhibit our future actions.

This growing entanglement of the corporate and social, this creeping sense of being tracked by invisible eyes, demands an increasing sophistication about what is said and where. The possibility of virulent judgement and rejection induces pre-cisely the kind of hypervigilance and withdrawal which increases loneliness. With this has come the slow-dawning realisation that our digital traces will long outlive us.

Back in 1999, the critic Bruce Benderson published a land-mark essay, 'Sex and Isolation', in which he observed: 'We are very much alone. Nothing leaves a mark. Today's texts and images may look like real carvings – but in the end they are

erasable, only a temporary blockage of all-invasive light. No matter how long the words and pictures stay on our screens, there will be no encrustation; all will be reversible.'

Benderson thought the transience of the internet was the reason that it felt so lonely, but to me, the fact that everything we do there is permanent is far more alarming. No doubt it was impossible, two years before 9/11, and fourteen years before Edward Snowden, Julian Assange and Chelsea Manning exposed the intrusive surveillance it had set in motion, to imagine the grim permanence of the web to come, where data has consequences and nothing is ever lost – not arrest logs, not embarrassing photos, not Google searches of porn or embarrassing illnesses, not the torture records of entire nations.

Faced with the knowledge that nothing we say, no matter how trivial or silly, will ever be completely erased, we find it hard to take the risks that togetherness entails. But perhaps I am being too negative, too paranoid, as lonely people often are. Perhaps we are capable of adapting, of finding intimacy in this landscape of unprecedented exposure. What I want to know is where we're headed. What is this sense of perpetual scrutiny doing to our ability to connect?

*

The future does not come from nowhere. Every new technology generates a surge of anxious energy, since each one changes the rules of communication, rearranging the social order. Take the telephone, that miraculous device for dissolving distance. From the moment in April 1877 that the first line linked phones No. 1 and 2 in the Bell Telephone Company, it was

perceived as an almost uncanny instrument, because it separated the voice from the body.

The phone swiftly came to be regarded as a lifeline, an antidote to loneliness, particularly for rural women, stuck in farmhouses miles from family and friends. But fears around anonymity clung to the device. By opening a channel between the outside world and the domestic sphere, the telephone facilitated bad behaviour. From the very beginning, obscene callers targeted both strangers and the so-called 'hello girls' who worked the switchboards. People worried that germs might be transmitted down the lines, carried on human breath, and they also worried about who might be lurking, invisibly eavesdropping on private conversations. The germs were a fantasy, but the listeners were real enough, be they operators or neighbours on shared or party lines.

Anxiety also collected around the possibility for misunderstanding. In 1930, Jean Cocteau wrote his haunting monologue *The Human Voice*, a play intimately concerned with the black holes that technologically-mediated failures of communication produce. It consists of nothing more than a woman speaking on a bad party line to the lover who has jilted her and who is imminently to marry another woman. Her terrible grief is exacerbated by the constant danger of being drowned out by other voices, or disconnected. 'But I *am* speaking loud . . . can you hear me? . . . Oh, I can hear you now. Yes it was terrible, it was like being dead. You're here and you can't make yourself heard.' The final shot of the television film starring Ingrid Bergman leaves no doubt as to the culprit, lingering grimly on the shining black handset, still emitting the dead end of a dial tone as the credits roll.

The broken, bitty dialogue of *The Human Voice* underscores the way that a device designed for talking might in fact make talking more difficult. If the telephone is a machine for sharing words, then the internet is a machine for constructing and sharing identities. In the internet era, Cocteau's anxieties about how technology has affected our ability to speak intimately to one another accelerate into terror about whether the boundaries between people have been destroyed altogether.

I-Be Area, a chaotic and alarming film made in 2007, turns on these questions of identity and its dissolution. Its central character is engaged in an identity war with his clone, and his clone's online avatar. Making lavish use of jump cuts, face paint and cheap digital effects, the film captures the manic possibilities and perils of digital existence. All the cast, starting with the children in the first frame, making hyper-cute adoption videos for themselves, are in search of a desirable persona, performing for an audience that may at any moment dissolve or turn aggressive, a situation that stimulates them into increasingly creative and bizarre transformations. Often seemingly imprisoned in teenage bedrooms, everyone is talking all the time: a tidal wave of rapid, high-pitched, Valley Girl-inflected internetese, the spiel of YouTube bedroom celebrities mashed with corporate catchphrases and the broken English of bots and programming lingo. Everyone is promoting, no one is listening.

The creator of this hilarious and disorientating film is Ryan Trecartin, a baby-faced thirty-four-year-old described by the *New Yorker's* art critic, Peter Schjeldahl, as 'the most consequential artist to have emerged since the nineteen-eighties'. Trecartin's movies are made with a band of friends. They

possess a campy DIY aesthetic that often recalls the avant-garde genius of the 1960s film-maker Jack Smith, the character morphing of Cindy Sherman, the physical mayhem of *Jackass* and the idiotic confessional candour of reality TV.

These films take the experiences of contemporary digital culture – the sickening, thrilling feeling of being overwhelmed by a surge of possibilities, not least of who you could become – and speed them up. Trecartin's work is often ecstatically enjoyable to watch, though as the writer Maggie Nelson wryly observes, 'viewers who look to Trecartin as the idiot savant emissary from the next generation who has come to answer the question *Are we going to be alright?* are not likely to feel reassured.'

Watching the precisely crafted chaos, one has the disquieting sensation that it is one's own life that is under the lens. Trecartin's characters (though I doubt he'd sanction such a term, with its vanished, twentieth-century confidence in a solid knowable self) understand that they can be owned or branded, discarded or redesigned. In response to pressure, their identities warp and melt. What's exciting about Trecartin's work is the pleasure generated by these transformations. It's tempting to suggest that this might even be a futuristic solution to loneliness: dissolving identity, erasing the burdensome, boundaried individual altogether. But there remain fairly thick currents of unease, not least around the question of who is watching.

*

For the past two years, Trecartin has been working with the curator Lauren Cornell to put together the 2015 Triennial at New York's New Museum, which opened at the end of

February. The show brings together fifty-one participants whose work reflects on post-internet existence. The title, *Surround Audience*, expresses the sinister as well as blissful possibilities for contact that have opened up. Artist as witness, or maybe artist imprisoned in an experiment none of us can escape.

Over the course of a freezing week in New York in February, I went to see *Surround Audience* four times, wanting to gauge current thinking about loneliness and intimacy. The most confrontationally dystopic piece was Josh Kline's *Freedom*, an installation that recreated the architecture of Zucotti Park, the privately owned public space in Manhattan that Occupy Wall Street took over. Kline had populated his replica with five life-sized Teletubbies dressed in the uniforms of riot police, with thigh holsters, nine-hole boots and bullet-proof vests. Their bellies housed televisions playing footage of off-duty cops flatly intoning the social media feeds of activists. Kline's work makes tangible the growing complication of the spaces we inhabit, and the easy misappropriation of our words.

What's it like to be watched like this? Many of the pieces suggest that it feels like being in prison – or perhaps in the quarantine bunkers designed by Hong Kong artist Nadim Abbas. These tiny cells, no larger than a single bed, had been furnished, Apartment Therapy-style, with potted plants, striped throws and abstract prints, an atmosphere of modish domesticity at odds with the implicit violence of the space. As in Hopper's *Nighthawks* diner, there's no way in or out; simply a pane of glass that facilitates voyeurism while making contact impossible. Touch can only be achieved by way of two sets of

black rubber gauntlets, one pair permitting someone – a guard, maybe, or a nurse or warden – to reach in and the other allowing the incumbent to reach out. It's hard to think of a lonelier space.

But *Surround Audience* also includes work that testifies to the internet's ability to dissolve isolation or to reinvent. *Juliana*, Frank Benson's sculpture of the twenty-six-year-old artist and DJ Juliana Huxtable, is a triumphant icon of self-creation. Huxtable is transgender, and the sculpture, a life-sized 3D print, displays her naked body with both breasts and penis, those supposedly defining characteristics of gender identity. She reclines on a plinth, braids spilling down her back, her extended left hand fixed in a gesture of elegant command: a queenly figure, her shimmering skin spray-painted an unearthly metallic blue-green.

You could read *Juliana* as a three-dimensional argument for how the trans community is reshaping concepts of realness and authenticity. It's not a coincidence that the trans rights movement has surged in an era in which both identity creation and community building are facilitated by technology. Turkle's talk of danger misses the importance, especially for people whose sexuality or race or sense of gender is considered marginal or transgressive, of being able to construct and manifest an identity that is often off-limits or forbidden in the physical world.

<p style="text-align:center">★</p>

The future does not announce its arrival. In Jennifer Egan's Pulitzer Prize-winning novel *A Visit from the Goon Squad*, published in 2010, there is a scene set in the near future that

involves a business meeting between a young woman and an older man. After talking for a while, the girl becomes agitated by the demands of speech and asks the man if she can 'T' him instead, though they are sitting side by side. As information silently flushes between their two handsets, she looks 'almost sleepy with relief', describing the exchange as *pure*. Reading it, I distinctly remember thinking that it was appalling, shocking, wonderfully far-fetched. Within a matter of months it seemed instead merely plausible, a little gauche, but entirely under-standable as an urge. Now it's just what we do: texting in company, emailing colleagues at the same desk, avoiding encounters, DMing instead.

While I was in New York, I met with Trecartin to discuss *Surround Audience* and what it has to say about the future we've fallen into. He was clutching a coffee and dressed in a red hoodie emblazoned with the word HUNT, a leftover prop from a shoot. He spoke much more slowly than the logorrheic char-acters he plays in films, pausing frequently to locate the exact word. He too felt that we have entered almost unknowingly into a new era; long heralded and abruptly arrived. 'We don't necessarily look different yet, but we're very different,' he said.

This space, the future now, is characterised, he believes, by a blurring between individuals and networks. 'Your existence is shared and maintained and you don't have control over all of it.' But Trecartin feels broadly positive about where our embrace of technology might take us. 'It's obvious,' he said, 'that none of this stuff can be controlled, so all we can do is steer and help encourage compassionate usage and hope things accumulate in ways that are good for people and not awful . . . Maybe I'm

being naive about this but all of these things feel natural. It's like the way we already work. We're making things that are already in us.'

The key word here is compassion, but I was also struck by his use of the word natural. Critiques of the technological society often seem possessed by a fear that what is happening is unnatural, that we are becoming post-human, entering what Sherry Turkle has called 'the robotic moment'. But *Surround Audience* felt human; an intensely life-affirming combination of curiosity, hopefulness and fear, full of richly creative strategies for engagement and subversion.

Over the week, I kept being drawn back by one piece in particular, an untitled six-minute film by the Austrian artist Oliver Laric, whose work is often about the tension between copies and originals. Laric had redrawn and animated scenes of physical transformation from dozens of cartoons, anchored by an odd, unsettlingly melancholy loop of music. Nothing was staying constant. Forms continually migrated, a panther turning into a beautiful girl, Pinocchio into a donkey, an old woman deliquescing into mud. What was striking was not so much the transformations themselves as the characters' expressions as they changed: a painful, even heart-rending combination of resignation and alarm.

The film captured something of a core anxiety about the relationship between internal and external self, which doesn't so much arise from the internet as fuel our use of it. Am I desirable? Do I need to be tweaked or improved? Why can't I change? Why am I changing so fast? This sense of being out of control, subject to external and sinister forces, is part of what

it has always meant to be human, to be trapped in temporal existence, with the inevitable upheavals and losses that entails. What could be more sci-fi, after all, than the everyday horror show of ageing, sickness, death?

Somehow, the vulnerability expressed by Laric's film gave me a sense of hope. Talking to Trecartin, who is only three years younger than me, had felt like encountering someone from a different generation. My own understanding of loneliness relied on a belief in solid, separate selves that he saw as hopelessly outmoded. In his world view, everyone was perpetually slipping into each other, passing through perpetual cycles of transformation; no longer separate, but interspersed. Perhaps he was right. We aren't as solid as we once thought. We're embodied but we're also networks, expanding out into empty space, living on inside machines and in other people's heads, memories and data streams as well as flesh. We're being watched and we do not have control. We long for contact and it makes us afraid. But as long as we're still capable of feeling and expressing vulnerability, intimacy stands a chance.

The Abandoned Person's Tale

June 2016

Some 24,000 migrants are detained in Immigration Removal Centres in the UK each year. Around half are asylum-seekers. Unlike other European countries, the UK has no upper limit on how long a person can be detained.

'The Abandoned Person's Tale' was written for Refugee Tales, an outreach project of Gatwick Detainees Welfare Group. Refugee Tales pairs writers with refugees, to tell and share their stories. Every July, Refugee Tales organise a five-day walk in solidarity with refugees, asylum-seekers and detainees. Each night, two refugee tales are told. Through that sharing of other people's stories the project gathers and communicates experiences of migration, aiming to show what indefinite detention really means. In 2016, I was paired with a man trapped in Britain's indefinite detention system for eleven years. This is his story.

<div align="center">★</div>

You are not much more than a boy when it starts. You are a student at a university in the capital city of your country. Let's call that country X. X is a corrupt country, and you are involved in student protests about the elections, which are rigged. A boy running in the streets, a boy high on the notion of freedom.

The student protestors are rounded up, they are arrested, they are taken to the police station. You are very young. The booking policeman is struck by your name, which is the same name as someone powerful in your country. Are you related? he asks. Yes, you say. Leaning close, he tells you what will happen next. He tells you you'll be transferred to a secret prison, an underground prison, and if you go there, you will never come out alive. *He means you are dead*, you tell me.

This man says he will help you. You wait a day in the prison. Unbearable. You wait two days in the prison, unbearable. That night they come in black jeeps, and load you in. You are alone in your car, you are the only one who is alone. Your jeep swerves away from the convoy, you are taken to a hotel, your relative is there, he takes your photograph. You wait. The next day you are taken to the airport. You are given a new passport. I am not sending you to France, your relative says. *I'm going to send you to a country where they have human rights.*

You arrive at Heathrow at eight in the morning. You don't know what to say, so you put your hand in the air. You don't speak English. The border staff are kind. They give you hot food. They find a translator. Within a week you are living in a flat in London. You are given money by the government. You start a college course. You are the oldest person on the course, it is embarrassing, but you stick with it, you get an A-level, you go on to university, you do a degree. *This is the 1990s*, you say, *these things happened*.

The conversation we are having is taking place in London. We have just met, and you are telling me your life story. I hate asking you to tell me this story, because I know you have told

it and told it and told it, that you have recited this repertoire of facts, that in some way you have vanished behind them. You are wearing a baseball cap. So far, what you are saying is what I expected to hear. I expected you to tell me about a violent, repressive country, about escape. I expected you to tell me about coming to England, my home. I am pleased about the hot meal, the flat, the education. Yes, I think, you did well to come here, to a country with human rights.

And then your story changes direction. It starts with a mistake, a stupid error of judgement. You buy a plasma television from an acquaintance. It is very cheap, but you don't think too much about that. The next thing you know, the police are at your door. You are arrested, you are sentenced for receiving stolen goods. You go to prison, far away, in a part of the country you don't know. Well then. Head down, you serve your time. You are released. *Oh my dear*, you say to me sadly, *that's the beginning of disaster now.*

Outside the prison, the border guards are waiting for you. They are holding a big photograph of you, you can't escape it. While you were inside, the law changed. If you are sentenced for more than a year, you are automatically a subject for deportation. You served nine months, but your sentence was for eighteen. You are a subject for deportation.

Now the nightmare starts. Every month a report is written. It says bad things about you. What? I ask, and you say, *You will be considered more than the devil, the devil even is good.*

Then the detention centre is burned down. They have to put you somewhere, so they put you back in prison. *I am not a prisoner, I'm only a detainee*, you tell them, but it takes four

months before they release you. The first condition of your liberty is that you must be tagged. The second condition is that you have a curfew. The third condition is that you must report to the border authority three times a week. The fourth condition is that you cannot work. A return ticket to the place where you have to report is £24. You have to report three times a week. You cannot work. *Miss, life is hard*, you tell me. *Life is hard*.

They want to force you to go back? I ask. *To frustrate you*, you say. *To damage you. To finish your life.*

After a year of this, you ask if you can sign at your local police station. No, you are told. That is absolutely not possible. *OK, if this is the case, I will stop signing because I can't, I can't*, you tell them. *The day you arrest me is up to you guys.* Another year goes by. Then one day you are on a bus. You are reading the *Metro*. Three boys get on the bus and they steal your phone. You ask the driver to stop the bus. *Driver, please, it's my only contact*, you say. The police come. They get your phone back, but then, *bango*, they realise you are wanted by immigration, that you have absconded. The superintendent himself comes out to tell you that the Home Office will pick you up in the morning.

You go back to a detention centre. This time, you are made an orderly. You are paid £25 a week to look after the new detainees. You are allowed to work in here, an irony that doesn't escape you.

Three years go by. Here is what you say about those years. You are crying and there are long silences between words. *I see people, nine month, they are trying to hang themself, nine month, but me three years. It was not easy. It was not easy, miss. I try my best to*

be a man. The suffering that I endure psychologically, miss, if I give it to you, you commit suicide – you cannot take it. No human people can take it. Even your dog cannot take it. But I took it. Do you know how many people, they wanted to commit suicide in this detention centre? Detention is not good. Detention give birth to hatred.

Your case goes to trial seventeen times. On the eighteenth time, the judge is kind. He tells you to pack your bag. He says you are being released.

You are released, but you still aren't at liberty. You cannot sleep. You do not like to be around people, you feel afraid of them. Sometimes you hear voices that tell you to kill yourself. Sometimes you talk out loud. You are depressed. You think maybe you are dreaming, that nothing is very real. You still can't work, you still have to report in every week, you still don't have indefinite leave to remain.

Soon, in a few days, that might change. *Almost there*, I say, and you say bitterly, *It's not about almost there, it's half of my age. Two decades and a half.*

I don't know when I have ever felt so ashamed. I think of you as a boy, running in the street, high on the notion that you can change your country, can make it better. You have not had a life. Your life has been wasted, thrown away. What has happened to you has happened here, on British soil. *I'm sorry*, I say, but no words can help.

What I would like to give you is time: 1303 weeks, 9121 days, 219000 hours, a quarter century stolen from you. That is what detention is: a thief of talent, of energy, of time. For weeks I think of your uncle, standing at the airport, saying, *I am sending you to a country with human rights.*

What has been done to you cannot be undone, what has been taken from you cannot be returned. But we could become that country. We could as a nation stop being so lethally afraid of strangers, so dangerous in our self-protection.

You are a Christian and I am not, but we both agree on this: kindness is what counts. So imagine a country founded on kindness, a country that treats desperate strangers with respect. And now we come to the question that haunts me. What could you have become in that good, imagined place? What would you have done with your beautiful life?

Lamentations

July 2017

I WAS A CONVENT GIRL, which meant growing up amidst images of pain and grief, the body in all its variegated states of distress. The grounds were large and among the rose beds, tennis courts and conker trees were statues of the Virgin and the saints. A print of Dali's crucifixion hung in the sick bay: Jesus as spaceman, ascending vertiginously through the night sky. Once I fainted in chapel, toppling before the alarmed priest. The body was a host, a relic, a false refuge; you ate the flesh of Christ and disdained your own.

Dali's aerialist is notable for lacking any marks of the ordeal through which he's passed. There are no nails in his palms, no chaplet of thorns. The lamentation I'm looking at now is a different matter. Painted at the end of the fifteenth century by an unknown Spanish artist, it emphatically displays a corpse. Christ lies across his mother's lap, naked save for a loin cloth. Someone has had the foresight to spread a clean white sheet beneath him. Already, it's stained with blood. His body is a litany of small wounds, lacerations from a scourge or flail, dabbed here and there with scarlet beads. His eyes roll whitely upwards. His ribcage has been split open. It gapes, obscenely like a lipsticked mouth.

This ghastly body is flanked by a grieving semicircle of mourners, bent and interlaced like reeds in a breeze. I'm pole-axed by their faces. All six have the same long Byzantine noses and hooded, sorrowful eyes. They are looking and looking, these veiled, haloed figures, gauging the extent of the damage, keening over every mark. Antecedents of the Madres de Plaza de Mayo, claiming back their tortured boy.

How are you meant to respond to an image like this? Why contemplate such an unstinting account of violence? The traditional purpose of a lamentation was to show Christ's sacrifice. *He died*, as we'd sing in assembly in wavering voices, *to save us all*. Then too there is the memento mori aspect, the reminder that flesh is temporary and all too soon a feast for worms, and as such one should seek sanctuary in the eternal kingdom, whose doors stand open to the pure of heart.

I've long since shrugged off my Catholicism, but its sense of the body as an imperfect refuge continues to haunt me. You don't have to believe in heaven to be moved by a depiction of the body's vulnerability, its provisional, fugacious nature, its susceptibility to hurt. The revelation of impermanence awaits us all. In the early eighteenth century, the Spanish sculptor Juan Alonso Villabrille y Ron made a terracotta figurine of St Paul in his palm-frond corset, gazing into a skull. I recognize the horror in his face, a panic so visceral the cords of muscle in his neck have gone into spasm. There's the bad news of what will come, and then there's the sweetness of the living form, with dainty pink cheeks and a tanned bald crown.

Most replications of the saints don't possess such intact, healthful bodies. They're more often portrayed at the moment

of martyrdom, undergoing the varied torments that one person can inflict upon another. On occasion, it's tempting to suspect this grim subject matter provided a stealthy way of portraying a body in a state of ecstasy. An ivory statuette made by Jacobus Agnesius around 1638 shows the youthful St Sebastian snared perpetually in the act of falling forward, wrists bound, an arrow piercing his upper arm. The subtle pleasures of eyeing or fingering his cool white flesh return magnified in Derek Jarman's 1976 queer fantasia, *Sebastiane*. Here, martyrdom is reconfigured as a sado-masochistic rite, the covert metaphors of submission and penetration made explicit.

Other images are more determined in their desire to convey harm. In fifteenth-century France, an unknown artist painted an extraordinary rendition of the death of St Quentin. The patron of porters, tailors and locksmiths stands at the centre of an eerily static crowd of men in red-toned clothes: red caps and leggings, red jerkins, red belts, red boots, the colour conveying the blood to come. They all have the same blank faces, as they apply to his small, bare body instruments of torture.

That kind of specific damage won't befall many of us, but the revelation of bodily vulnerability holds fast. In the summer of 1966, the poet and curator Frank O'Hara was hit by a jeep after a party on Fire Island. He died a few days later, at the age of forty: a gay man, a lapsed Catholic, once an altar boy. At his funeral, the painter Larry Rivers attended with fascinated horror to his best friend's body in a speech that has something of the same grievous intensity as the Spanish lamentation, the anguished detailing of a medieval martyrdom.

This extraordinary man lay without a pillow in a bed that looked like a large crib . . . He was purple wherever his skin showed through the white hospital gown. He was a quarter larger than usual. Every few inches there was some sewing composed of dark blue thread. Some stitching was straight and three or four inches long, others were longer and semicircular. The lids of both eyes were bluish black. It was hard to see his beautiful blue eyes which receded a little into his head. He breathed with quick gasps. His whole body quivered. There was a tube in one of his nostrils down to his stomach. On paper he was improving. In the crib he looked like a shaped wound, an innocent victim of someone else's war.

When Rivers read these words at O'Hara's funeral, people cried out for him to stop, but I think the act of bearing witness is an act of love. There's no need for heaven: the pearly gates, the cherubim and seraphim, the light beyond the sun. It is the protean body, come and gone, that's the abiding miracle.

Party Going

July 2017

LIKE FREUD SAYS, everything in Rome is reused, repurposed. Last night I had dinner next to three gossipy Irish priests in the Piazza Farnese. In the middle of the square there were two fountains in vast marble bathtubs, taken by the Farnese family from the ancient baths at Caracalla. The priests were from Donegal. I bet I know at least one of them, John texted from New York.

In another square, by another fountain, I watched a kind of hooded crow with a cape of pale feathers eviscerating a dead pigeon, flipping it to get purchase, tearing morsels of flesh, lordly as the diners at Ar Galetto. I noticed it mostly because I was reading *Party Going* by Henry Green, a 1939 novel in which a group of aristocratic English people on their way to a holiday in Europe are trapped in Victoria station by thick fog. In the first sentence a dead pigeon falls from the sky. Miss Fellowes picks it up, takes it into the lavatory and washes it. Later she wraps it in brown paper and gives the parcel to a man to put in a bin; later still she retrieves it.

Hovering on the brink of Europe, trapped in a fog, unable to enter or retreat, the bloody old British. I see them here and wince: hesitant or bullying, overconfident, uncertain of their place.

Today, I am taking the train to Trieste. Rome's civic buildings give way to apartment blocks, peach and vanilla, rubble by the tracks. Europe is a boneyard, a dead land, stronger than ever, united, in tatters, at the end of its rope. Flying in from London, the dry summer landscape was scattered with chips of jade that grew bluer as we came down over Rome. The biggest was next to a field of ash. Tiny people sporting in the turquoise water.

Hard Brexit versus la dolce vita. This time last summer I was in Paris, sitting on my bed, watching the news unfold on Twitter. Drunk English football fans in Lille, chucking coins at refugee children. Pictures of Nigel Farage with his sad beery smile, posing next to a truck displaying a photograph of young men in hoods and hats, walking across a damp green landscape. BREAKING POINT, the caption said. And then an incident in the North. An MP was shot and stabbed. The details were unclear. The man shouted something. The man shouted: 'Britain First.'

It was Bloomsday. We were staying at Shakespeare and Company, where for the past few years they've been conducting a Bloomsday reading of *Ulysses*, working their way line by line through that rapturous voyage. I read after a flushed Irishman in a linen jacket. Leopold Bloom, the cosmopolitan, the wandering Jew. Funny how words have regained their malignant 1930s power, their covert racism, their false populist appeal. *Elite, metropolitan, liberal, enemy of the people.* At the end of that horrible summer, Theresa May said: 'If you believe you're a citizen of the world, you're a citizen of nowhere.'

We didn't have to show our passports in Rome. Though we didn't belong to the Schengen zone, we had the luxury of free

passage. I'd never been before but the architecture of the city was familiar to me from York, from Bath. We were always on the move; people of many turnings, like the original Ulysses.

Outside the train, it has begun to rain. Little silver darts of water fly past the window and vanish abruptly. I like it when we're different from each other. I feel safer, I feel richer. The illusion of national purity leads to trains across Europe packed with people who have been stripped of their possessions, clothes, children, teeth, humanity. Take back control: against what? People who want hospitals and schools, libraries, fresh bread, an evening at the cinema.

While I was in Paris I took a screenshot of the Farage photo and saved it on my laptop. Looking at it again now, my eye is caught by a small boy. The crowd of walkers is ten deep, it snakes out of shot. I suppose you are meant to think that these men are coming for your wives, your daughters, that they are Muslims who will feast on Europe's plenty and then destroy it. This boy, this small Telemachus, has been caught in a posture familiar to anyone who has taken a long walk with a child: head thrown back, eyes closed, done in, over it, absolutely knackered. *We must break free of the*, the white text says, and then on the other side of Farage's shoulders, *back control of our borders*. I want to go home, Telemachus replies. I miss my mother, I miss my dog.

In *Party Going*, the fog stops all the trains from leaving. The group shelter in a hotel, which soon locks its doors against the gathering hordes of travellers. Occasionally, one person or another wanders to the window to look out at the tired, jostling masses below. It is so comfortable to look down on a

crowd, and then to shiver and return to one's tea. In the photograph Farage's shoes are very shiny. He trades in the same queasy fantasy of British exceptionalism and deserved privilege that Green is satirising. Outside, the crowd keeps growing. They can't disperse. They have no choice but to wait there, on the brink of Europe.

It's nearly noon. I'm approaching my station. On the platform at Orvieto there's a monument carved with the words: *In memoria di tutti i ferrovieri caduti sul lavoro.* Travel exacts a toll and yet there will never be a day when we don't need to move, for love or water, away from bombs, looking for places of greater safety or abundance. Wouldn't it be more civilised, more cosmopolitan to say yes, to unlock the doors, to pool the resources? *Yes I said yes*, the closing lines of *Ulysses*, and then the exile's small prayer: *Trieste–Zurich–Paris.*

Skin Bags

September 2017

I'M WORRIED ABOUT MY SKIN. I'm in a hotel in Virginia, I got married six weeks ago, this is the first time I've been alone with my body in months. In the mirror, under tube lights, my thighs are pocked and striated with veins. I'm forty, on the downhill run. I used to scorn moisturiser but the horror show of ageing has caught me up.

My Google search history from that afternoon: Myths and Facts about Cellulite, Cellulite: Top 10 Facts, Can you get rid of cellulite with exercise. Then I notice some bumps that didn't used to be there. Why the Skin on Your Arms is Bumpy. Treating 'Chicken Skin' Bumps: Keratosis Pilaris. It's the implacability of the body that frightens me, not just the ugliness of the manifestation, but the sense of invisible processes, malign or lethal, going on beneath the skin.

A long time ago, in the early 1990s, I worked as a life model. I was seventeen when I started, mid-twenties when I stopped. It paid ten pounds an hour, better than bar work. I borrowed a green silk dressing gown from my boyfriend's mother and travelled from art school to sixth-form college to adult educa-tion centre by bus, crossing my legs and twisting my torso in front of an electric heater. Once, in a class in a Portsmouth loft,

I felt abruptly dizzy and came round to find an anxious crowd of pensioners clustered about my naked body.

When I prowled the easels in the break, what I saw was always the same: outline, skin bag, the more or less improbable architecture of the human form. Legs, fingers, nose. It was what my body looked like, sure, but not anything like how it felt to live inside it. There are two bodies, aren't there? The one you see in magazines, the one that is available to strangers' eyes, and the one you inhabit, the leaky vessel, permeable and expulsive, prone to rents and fractures; a factory, slippery and bilious, its secret compartments stained rose madder and Chinese red.

I feel like I've been searching for images of that other body all my life. The closest I've come, 1: a photograph of a drawer swimming with body parts in formaldehyde, by Joel-Peter Witkin, which I glimpsed in a magazine as a teenager. The closest I've come, 2: Holbein's *Dead Christ*, body as transitional object, hands and feet livid, suffused with purple. The closest I've come, 3: *Under the Skin*, that sleek, slick body-horror flick.

In it, Scarlett Johansson plays an alien fallen to earth, garbed in woman-skin, cruising the streets of Glasgow in her white transit, her cheap black wig. She chokes on cake, she can't swallow. In bed with a man she abruptly rears back, grabs a lamp and examines the aperture between her legs. Pussy shot as crisis, it reframes teen sexting as existential anxiety. Am I all there? Does this anatomy suit me?

The best bit – or maybe the worst, depending on your taste – was what happened to the men that Johansson's alien collected. She walked with them into a black room, undressing as she went. The floor under her feet was solid, but the men sank

into viscid liquid. Down they went, into the black pool. Submerged, they swelled and wrinkled, time's advance ratcheted to the max. One bloated body burst, with a noise like a starter's pistol, leaving a wrinkled skin suit in the water. A time-lapse nature doc of what's in store, the uneasiness, the insanity of setting up house in a transient vessel.

I had sex for the first time the same year I began working as a model. We were in a room in Southsea, listening to Pink Floyd, the record with an ear photographed underwater on the sleeve. I took my earrings out, and then, feeling that this was a significant act, somehow sexual in its own right, I put them back in and took them out more slowly, where my lover could see me. It isn't easy to inhabit the body, is what I'm trying to say; it isn't easy to stop being a picture, pretty as or trying to be.

It's funny that sexiness is so associated with images of physical perfection. When we talk about the pornification of everyday life, part of what we mean is an impossible amplification of visual attainment, a two-gender world, each unambiguous sex honed and plucked and pumped and sheened. Bodies being penetrated or displayed, showered with effluent, in extremis, but God forbid you see a bloodied Tampax string or zit.

Personally, I prefer the sex you get in a Bacon painting, where bodies turn into apes or dissolve into sand, into corpuscles, into red mist. It's the edges I'm chasing, the point of exchange. Someone told me recently about looking up through a skylight in Italy, late at night, and seeing a group of wolverines writhing and tumbling over the glass. Maybe they were

having sex, she said, or maybe they were fighting, anyway it was disgusting. Yes, I said, but what I really meant was I wish I'd seen it, the Muybridge transitions inside the wooden frame, like Bacon's wrestling, copulating bodies in their invisible cages.

'This image,' Bacon once said of his portraits, to the critic David Sylvester, 'is a kind of tightrope walk between what is called figurative painting and abstraction. It will go right out from abstraction, but will really have nothing to do with it. It's an attempt to bring the figurative thing up on to the nervous system more violently and more poignantly.' It was a practice composed of deliberate stabs in the dark, as he put it in the same interview, 'one continuous accident mounting on another'.

This spring, I modelled for the first time in decades, for my friend Chantal. She used to paint pallid angular girls in fashion poses, but over the years her brush has become more concerned with the actuality of flesh. Hulking white backs, flowery pants, the canvas as the mirror in which you apprehend the onset of ruin, the actuality of decline, the translation of skin into long unsteady licks of flake white and chromium yellow.

Chantal worked fast. We were done in two sessions. I wasn't allowed to look until the end. My nose was like a banana, I looked anxious, my dress jarred with the red blanket. I think I'm in love with ugliness, Chantal said, and if my vanity was upset – for who doesn't want to be an etiolated green plant, pliant and nubile, legs and elbows and slanting eyes – I loved the way she articulated the smart of being there at all, an animal with its eyes open, not quite gelling with the room. There I was, the figurative thing, one continuous accident: a bag of old skin, tired, frightened, electrically alive.

READING

Gentrification of the Mind

BY SARAH SCHULMAN

February 2013

BETWEEN 1981 AND 1996, over 80,000 people died of Aids in New York City, in conditions of horrifying ignorance and fear. Patients were left for days to die on gurneys in hospital corridors. Politicians and public figures called for people with Aids to be tattooed with their infection status, or to be quarantined on islands. At the time, the Plague, as Schulman sometimes calls it, seemed like the beginning of the end of the world. And yet somehow, as treatment improved and the death rate declined, a seeming normality was restored.

According to conventional wisdom, that *somehow* was a natural process, a slow shift from prejudice towards justice and effective care. When the lesbian novelist, playwright and activist Sarah Schulman realised this was becoming the official history of Aids in America, she was appalled. A long-standing member of ACT UP, the direct-action group formed to end the crisis, she knew what was being elided: fifteen years of struggle by people who were profoundly disenfranchised – by queers, drug addicts and sex workers, many of them now dead.

This process of banalisation, this insidious forgetfulness,

seemed furthermore to reflect a larger cultural trend that has taken place in the wake of Aids: the ongoing creep of gentrification, the physical reconstitution of cities such as New York from diverse and vibrant to homogenised and bland; exclusive compounds for wealthy whites. In the post-Aids world, this tendency has spread like bindweed, suffocating diversity and bringing with it conservatism, disempowerment and passivity. Are the two linked? Schulman wonders. And if so, why does it matter, and what can be done about it?

Gentrification is never the result of single factors. In New York, it was facilitated by tax incentives for developers and moratoriums on city-sponsored low-income housing. The role of Aids in all this was both coincidental and expedient. Because of rent control, properties couldn't be moved to market rate unless the leaseholder either moved out or died. Aids accelerated turnover, changing the constitution and character of neighbourhoods far more rapidly than would otherwise have been permitted. In Schulman's own East Village, 'the process of replacement was so mechanical I could literally sit on my stoop and watch it unfurl'. The new residents, for the most part the clean-cut citizenry of corporate America, were largely ignorant of the people they'd displaced. In short order, an entire community of 'risk-taking individuals living in oppositional subcultures, creating new ideas about sexuality, art, and social justice' had almost disappeared from record.

It's hard to imagine, for those who have not lived through it, what it might be like to lose one's entire community, one's social circle, one's peers and friends and lovers. Harder still to gauge what it might be like to have such a loss publicly

unacknowledged or erased. Schulman hauls old enemies to account, among them Ronald Reagan and New York's late mayor Ed Koch, who by their homophobia, indifference and indecision permitted the disease to spread. 'There has been no government inquiry into the fifteen years of official neglect that permitted Aids to become a world-wide disaster,' she writes. 'Where is our permanent memorial? Not the Aids quilt, now locked up in storage somewhere, but the government-sponsored invitation to mourn and understand'. It's understandable that she might feel bitter at the institutional opulence of the 9/11 memorial to 'the acceptable dead', noting: 'in this way, 9/11 is the gentrification of Aids.'

A self-declared old school avant-guardian, there's nothing homogenised about her counter-attack. *Gentrification of the Mind* is best understood as a polemic, a passionate, provocative, scattergun account of disappearance, forgetfulness and untimely death. To her mind, the undigested, unacknowledged trauma of Aids has brought about a kind of cultural gentrification, a return to conservatism and conformity evident in everything from the decline of small presses to the shift of focus in the gay-rights movement towards marriage equality (the Gay Fifties, she observes scathingly).

The sorry thing about this is that the true message of the Aids years should have been that a small group of people, ill and at the very margins of society, succeeded in forcing their nation to change its treatment of them, 'thereby saving each other's lives'. The memory of this lost moment of accountability and empowerment drives Schulman's final, stirring call for degentrification, her dream of a time in which people realise

not only that it's healthier to live in complex, dynamic, mixed communities than uniform ones, but that happiness which depends on privilege and oppression cannot by any civilised terms be described as happiness at all.

New York School Painters & Poets: Neon in Daylight

BY JENNI QUILTER

November 2014

THE NEW YORK SCHOOL refers to a sociable coterie of painters and poets at work and play in downtown Manhattan around the midpoint of the twentieth century. Used first to describe the abstract expressionists of the 1940s (Jackson Pollock, Willem de Kooning, Philip Guston and so on), the term subsequently became identified with a younger generation of more figuratively inclined colleagues, among them Jasper Johns, Fairfield Porter, Grace Hartigan, Alex Katz and Robert Rauschenberg, as well as poet friends like John Ashbery, Frank O'Hara, Barbara Guest and Kenneth Koch. In the 1960s, the term expanded again to encompass a third generation springing up around the St Marks Poetry Project, including though by no means limited to Ron Padgett, Anne Waldman, Ted Berrigan, Bill Berkson and Joe Brainard.

Uniforms were never a requirement at this charismatic establishment, which was anyway hardly established or formalised. What the New York School poets and painters held in common, aside from shared zip codes, was a kind of convivial

interest in each other's company, conversation and intentions, the latter of which might retrospectively be described as taking European modernism, especially abstraction, and reinventing it in a decidedly American lingo and palette.

Gossipy, curious and assured, this atmosphere of sociable convergence nourished co-production. Artists painted portraits of poets. Poets wrote profiles of painters. Poems were jointly or communally authored (often on napkins at the artists' favourite, the Cedar Tavern, while the painters swigged beers and got into fights, their rowdy voices leaking into the verses like static). Small magazines sprang up to publish these outpourings. Some – *Folder*, *Locus Solus* – were works of art in themselves, while others, like the later *Fuck You/a magazine of the arts*, were more disreputable and scruffy.

Maybe the most interesting of these collaborative ventures are the hybrid works, fusing the singular domains of word and paint by way of what Norman Bluhm described as 'a conversation' between disciplines. Pairings include Joan Mitchell's luminous pastels and James Schuyler's dreamy lines, and Philip Guston's cartoonish scrawl with stark Clark Coolidge. Bearing in mind that a mood of generosity and playfulness underpinned even solo pieces, it's canny of Jenni Quilter to make collaboration the focus of her lavish compendium, which captures the essential spirit of the New York School, its valuing of what people do together as well as alone.

Neon in daylight: the subtitle is lifted from Frank O'Hara's 'A Step Away From Them', one of his most famous Lunch Poems. O'Hara is undoubtedly the lynchpin here, his distinctive grin, hooked nose and widow's peak surfacing repeatedly

from photographs, sculptures and paintings, as befits the man Larry Rivers described as 'the central switchboard' of the scene (in return, O'Hara called Rivers 'a demented telephone'). From the moment of his arrival in the city in August 1951, O'Hara took root in New York's art world. His first job was on the information desk of the Museum of Modern Art and aside from a brief break he remained at this august institution until the end of his short life, rising to the position of Associate Curator in the Department of Painting and Sculpture. He organised some of the most important exhibitions of the period, acting as a passionate advocate for the work he loved, much of it made by his own circle.

This makes him sound parochial, which he wasn't, and partisan, which he was. One of the most noticeable things about this prodigiously talented man is the sheer intensity of his involvement in other people's lives. He was forever cajoling, provoking and pummelling those around him into producing work. As Larry Rivers put it in his eulogy for O'Hara, who was killed by a jeep on Fire Island at the age of forty: 'There were at least sixty people in New York who thought Frank O'Hara was their best friend . . . At one time or another he was everyone's greatest and most loyal audience.' 'The frightening amount of energy he invested in our art and our lives often made me feel like a miser,' the painter Alex Katz added, while the poet and dance critic Edwin Denby described him as 'everybody's catalyst'.

In the midst of this packed programme he managed, apparently effortlessly, to produce some seven hundred poems of his own that remain as original and lovely as anything of the century.

O'Hara's work is deceptively casual. *Lunch Poems* catches him in the act of loitering in the city, speaking himself onto the page while drinking chocolate malteds and buying magazines. His writing, as Kenneth Koch has elsewhere observed, is stuffed with quotidian objects, among them 'jujubes, aspirin tablets, Good Teeth buttons, and water pistols, most of which had not appeared in poetry before'.

This desire to extend boundaries, to let the air out of pompous and sentimental notions about what constitutes art or authenticity, is a common impulse here. Many of the works are deliberately light, designed for private parties and audiences of amused friends. They must have cackled over a jaunty collaborative painting by George Schneeman and Ron Padgett from the 1970s of a man riding a giant cockerel, embellished with the words SHIT ON YOU. Exquisitely coloured (Schneeman emerges from these pages a tonal virtuoso) and crude, it risks, as Quilter points out, 'being dismissed as scatological absurdity', though it also keeps things from getting too stuffy.

Even the weightier works have an atmosphere of zero gravity. One of the masterpieces is Fairfield Porter's 1957–58 portrait of the poets John Ashbery and James Schuyler, perched on a floral sofa against an indeterminate creamy background. Porter, that strange, abrupt, observant man, had a knack for keeping the objects in his paintings separate. Jimmy and John maintain a courteous, unsettled distance from one another. Though they're both unequivocally present in the light-filled room, they aren't in anything like the sweaty contact of normality. Schuyler appears to be floating an inch or two above the cushions, his legs sticking into the air like those of a blow-up doll,

a world away from the man whose tense and unhappy form is superimposed over his left foot.

This disjunction between things, this art of objects and the spaces between them, is key to the New York School aesthetic. It's there in Jasper Johns' assemblages and Larry Rivers's insistently inchoate paintings, with their marshy palettes. Disjunction is at the heart of O'Hara and Ashbery's surreal wordplay, their shearing away of the humble zips and buttons of language. It's central too to Alex Katz's hyperreal, disassociated portraits, his flat slabs of pastel colour brushed with light, and to Joe Brainard's joyful collages and cut-ups.

Brainard, whose congeniality and lack of arrogance made him both a natural collaborator and less well known than his work deserves, appears here as an unmistakable star. His collages often riff around found objects or popular art, especially comics; despite their low origins, they're almost painfully delicate and coherent. A black and white photograph from 1975 shows him islanded in his loft on Greene Street, the floor covered in hundreds of drawings. A writer as well as artist, whose quasi-autobiography *I Remember* is one of the most engaging books of twentieth-century poetics, he died of Aids-related pneumonia at the age of fifty-two. By that time he'd already retreated from art-making, though not from the collaborative friendships he'd maintained since boyhood.

If there's a single quibble to be made, particularly from a researcher's point of view, it's the absence of an index, which makes navigating in search of a single name somewhat laborious, despite the congenial surrounds. Though the sleek production values suggest a coffee-table volume, the material

inside has lost none of its spontaneity or mess. 'Collaborative art makes art, in general, seem more possible,' Quilter observes in her conclusion, and it's possibility that crackles from these pages, a sense of abundance, a feeling of yes.

The Argonauts

BY MAGGIE NELSON

April 2015

LET'S START WITH an introduction. Maggie Nelson is one of the most electrifying writers at work in America today, among the sharpest and most supple thinkers of her generation. Born in 1973, she has so far this century produced nine books, four of poetry and five of non-fiction, knitting together what might in heavier hands be abstruse theory and humid confession to create an exhilarating new language for considering both the messiness of life and the meanings of art. If you haven't heard of her, it's because she's yet to be published in the UK, from which one might conclude that British publishing is becoming too timid for its own good.

Her writing defies easy definition. Previous works include a philosophical survey of heartbreak and the colour blue (*Bluets*), two volumes about the abduction and murder of her aunt (*Jane: A Murder* and *The Red Parts*), and the ranging and invigorating *The Art of Cruelty*, a study of avant-garde art that turns by degrees into an unflinching investigation into the nature of violence itself. These books never quite settle into a fixed form. They float across categories, now memoir, now poetry, now

philosophy, now criticism, too fleet and subtle to be pinned down.

The Argonauts is likewise resistant to summary, though describing it as a love story might come closest. It is, after all, about love and its fruits: both the falling in and the maintaining of affection, devotion. It's about love and marriage, mother-hood, pregnancy, birth and family-making, and because it is a book by Maggie Nelson, it turns every one of these benighted concepts on its head.

The words *I love you* come in the very first paragraph, a confession uttered by Nelson to her debonair lover, the artist Harry Dodge. She falls for Dodge's brilliance, decency and immense sexual charisma, but during the early days of their courtship, she is not at all certain of which pronoun her lover prefers to go by. Dodge is transgender, and not in accordance with the insistent media narrative of a man locked in a woman's body, but rather as someone who does not wish to traffic in binaries at all (*'I'm not on my way anywhere*, Harry sometimes tells inquirers').

They marry in a rush in the final hours before Prop 8 passes (the ruling that temporarily eliminated same-sex marriage in the state of California), their sole witness a drag queen doing triple-duty as the Hollywood Chapel's greeter and bouncer. 'Poor marriage! Off we went to kill it (unforgivable). Or re-inforce it (unforgivable).' In the years that follow, they undergo dynamic shifts in their own bodies. Nelson passes through gruelling rounds of IVF and then becomes pregnant; Dodge starts injecting testosterone and has top surgery, liberating him from years of painful chest-binding. His three-year-old son

moves in with them part-time, and then their own baby, Iggy, joins the family.

The Argonauts is about these small, miraculous domestic dramas, and the acts of readjustment and care that they require, but it is also a reconsideration of what the institutions established around sexuality and reproduction mean if you come at them slant, if you disrupt them by the very fact of your being. Evictions and exclusions keep occurring. Friendly encounters with male waiters or service personnel are regularly unsettled when Dodge hands over his credit card with its female name, an act freighted with the threat of violence. During a Q&A, Nelson is asked by a well-known playwright how she managed to write a book about cruelty while pregnant. 'Leave it to the old patrician white guy to call the lady speaker back to her body, so that no one misses the spectacle of that wild oxymoron, *the pregnant woman who thinks*. Which is really just a pumped-up version of that more general oxymoron, *a woman who thinks*.'

These narratives are interesting in and of themselves, but Nelson isn't just airing her feelings out. She's bent on using these experiences as ways of prying the culture open, of investigating what it is that's being so avidly defended and policed. Binaries, mostly: the overwhelming need, to which the left is no more immune than the right, for categories to remain pure and unpolluted. Gay people marrying or becoming pregnant, individuals migrating from one gender to another, let alone refusing to commit to either, occasions immense turbulence in thought systems that depend upon orderly separation and partition, which is part of the reason that the trans-rights movement

has proved so depressingly threatening to certain quarters of feminist thought.

Real people are the objects of this boundary-policing, and Nelson is at pains to make them visible, to show both the cost and virtue of their freedom. It is because she presents herself and Dodge so nakedly on the page that she is able to make light work of the thinkers, radical and conservative alike, who traffic in casually cruel abstracts and prohibitions. Of Baudrillard's claim that assisted reproduction heralds the suicide of the species by eliminating the mortal, sexed being, she observes tartly: 'Honestly, I find it more embarrassing than enraging to read Baudrillard, Žižek, Badiou and other revered philosophers of the day pontificating on how we might save ourselves from the humanity-annihilating threat of the turkey-baster.'

The kind of thinking Nelson does value is subtle, capable of ambiguity and arising out of close observation, which is why it's not surprising that the British paediatrician and psychoanalyst D. W. Winnicott should emerge as something of a hero here. Winnicott is responsible for the concept of the good enough mother, and his refusal to insist upon perfection makes him an ideal participant in Nelson's project of celebrating ordinary maternal devotion while castigating the toxic canonisation of the mother that society uses to punish and shame women.

In the largest sense, this is a book about dependence, about the way that life requires interpenetrations and boundary-crossings of all kinds, beginning with the in-utero experience of being housed within another's body, that 'most mysterious and gory of apartments', and continuing through acts of

extension that include both sex and reading, those journeys into the recesses of other minds and anatomies.

Nelson is keen on both; positively evangelical on the subject of ass-fucking, but also lucid and generous when it comes to acknowledging the thinkers who have shaped and schooled her. Her list of 'the many-gendered mothers of my heart' ranges from the late and much missed Eve Kosofsky Sedgwick, the fat, freckled queen of queer theory, to the porn star and performance artist Annie Sprinkle. What draws her are people who, as the critic Roland Barthes explains in his theory of the neutral, 'in the face of dogmatism, the menacing pressure to take sides, offer novel responses: to flee, to escape, to demur, to shift or refuse terms, to disengage, to turn away.'

This interest in dependence and ambiguity is reflected stylistically, too. The Nelsonian unit of thought is not the chapter but the paragraph, a mode that allows for swerves and juxtapositions, for the interspersing of anecdote and analysis. If the danger of being elliptical is that one sometimes sounds dotty, the reward is an ability to dodge enclosure, to achieve by way of judicious layering a complexity that is otherwise elusive. This is bolstered by Nelson's habit of lacing her text with italicised statements by other writers, the sources logged in the margins. The effect is musical, polyphonic, a conversation between multiple participants rather than a narcissistic aria for one.

In the final pages, Nelson tells the story of Iggy's birth, mixing it with Dodge's own account of his mother's death. Earlier, Nelson described the way a foetus creates space in the body where there was none, and it is precisely this gift that her

own writing possesses: a facility for making room, for offering up possibilities beyond the either/or, the this and that. This is a book that belongs on the shelves of anyone who desires, especially if what they desire is nothing short of freedom itself.

I Love Dick

BY CHRIS KRAUS

November 2015

DICK IS SUCH A DICK. He won't reply to Chris's letters, even
though she's written dozens, maybe even hundreds – a cache
of words she describes as 'a timebomb, a cesspool or a manu-
script'. To be fair, at this point he's only met her once, on 3
December 1994. She and her husband, the cultural critic Sylvère
Lotringer, had dinner with him in a sushi bar in Pasadena, and
then spent a tipsy night at his place in Antelope Valley, out in
the Californian desert (Dick has cowboy pretensions). Chris
was sure he was giving her smouldering glances, but in the
morning he had vanished, a rejection that somehow triggered
a ferocious, life-engulfing crush.

Sex has long been absent from her marriage, but now she
and Sylvère find a tentative new intimacy by collaborating on
a seduction campaign, bombarding Dick with letters, voicemail
and faxes (it is the 1990s, after all). Aware they're morphing into
stalkers, they couch their epistolary assault as art, inviting Dick
to collaborate with them on a video project about romantic
obsession and signing themselves Charles and Emma Bovary.

'Madame Bovary, c'est moi,' Flaubert famously remarked,

but why go to the trouble of inventing a character when you can make economic use of the juicy fruits of your own life? *I Love Dick* is a novel in memoir's clothing, populated by real people in real situations, which are conveyed by way of (maybe real, maybe not) letters, diary entries and sections of exegesis, in which the performers are considered in a dignified third person. It was first published in America in 1997, to an initially frosty reception (who was this harpy, turning the tables on Serious Men?). In the intervening years it's gained cult status, especially among women, developing a passionate readership thrilled by the way Kraus flips abjection into power. Amazingly, this is its first publication in the UK.

If you don't dally in the precincts of the avant garde, you could be forgiven for not having encountered Kraus, who at the time of writing was a thoroughly obscure film-maker (she has since published several books, among them *Torpor*, *Aliens and Anorexia* and *Summer of Hate*). Her then-husband, Sylvère Lotringer, is a French intellectual and founder of the publishing house Semiotext(e) (Kraus herself ran the Native Agents wing, which brought such counterculture luminaries as Cookie Mueller and Eileen Myles into print). As for Dick, an English critic who works on subculture and style, his identity can be rapidly discovered by way of Google.

Chris loves Dick. Dick does not love Chris. Chris writes to Dick, at length and in a multitude of moods and tones, from lust-struck to bitter, melancholy to enraged. But though the minute by minute account of infatuation is gripping, it slowly becomes clear that the Dick Thing is only bait, a smokescreen for something much more subversive and sophisticated.

You think you're reading about love and lust ('my hand was wet from holding the telephone so tightly') and then, sentence by deceptively casual sentence, you find you're deep into an essay on political prisoners in Nicaragua, or a disquisition on the nature of evil, or an analysis of the career and reception of the feminist artist Hannah Wilke, who repeatedly photographed herself naked and covered in tiny vaginas made of chewing gum. 'Why does everybody think that women are debasing themselves,' Kraus asks of both her own and Wilke's work, 'when we expose the conditions of our own debasement?'

This is the scalding core of her enquiry. What does it mean to be an intelligent, ambitious woman in a world of men, 'the host culture', particularly a woman who wishes both to have her work taken seriously and to be regarded as an object of desire? What does it mean to be ugly or unwanted, or to make work that no one sees? What does it mean to be without power, and furthermore to find that by drawing attention to this state of affairs one makes oneself sexually undesirable, even repulsive? 'You keep looking for rejection,' Sylvère shouts at Chris, who counters dryly: 'But I believe this problem's bigger, and more cultural.'

Though grounded in what are apparently not just real but devastatingly painful events, *I Love Dick* is not so much a roman-à-clef as a formidable novel of ideas: a novel that pretends not to be a novel, that keeps breaking apart or shifting into other forms, in part because it is built explicitly to grapple with the question of how inherited forms warp and limit women's lives. The master's tools will never dismantle the master's house, Audre Lorde wrote, and in Kraus's hands the

classical form of the novel continually destroys itself, enacting structurally the same refusal of constriction that Chris begins to insist upon in her own life.

A novel that breaks the novel; a memoir that refuses to accept its duty is to provide a purely personal narrative: hardly any wonder *I Love Dick* has proved so wildly influential. Among its recent heirs are Sheila Heti's *How Should a Person Be*, Jenny Offil's *Dept. of Speculation* and Maggie Nelson's *The Argonauts*, all of which are engaged in fusing memoir and fiction for more or less political purposes. It's less easy to think of precedents to Kraus's self-described 'Lonely Girl Phenomenology', though Virginia Woolf, Alice Notley, William Burroughs, Doris Lessing and Jane Bowles all spring to mind.

Like Woolf, Kraus is bent on discovering an encompassing and porous form. Chris often sounds purely telephonic, looping chattily between descriptions of home repairs in upstate towns, reminiscences of old boyfriends in New Zealand, bad dinners with disliked neighbours. But the signature move of the speaking voice is the non-sequitur, the jump cut, and it is by deploying these leaps that Kraus builds her argument, steadily making legible the hidden relationship between the personal and political.

The effects are frequently sublime, as in this dreamy paragraph: 'It was April, the season of blood oranges, emotion running like the stream behind my house upstate, turbulent and thawing. I thought about how fragile people get when they withdraw from anything, how they become like bloody yolks protected only by the thinnest shells.'

In one of her many digressions, Kraus tells the story of the

nineteenth-century French writer Louise Colet, a mistress of Flaubert. When he broke her heart, Colet wrote a poem about it, and in return Flaubert replied: 'You have made art an outlet for the passions, a kind of chamber pot to catch the overflow of I don't know what. It doesn't smell good! It smells of hate.'

Similar things have been said of *I Love Dick*: that it is insincere, ironic, cruel, a knowing, narcissistic, post-modern game. Wrong. It is an assault on power, especially the dick-swinging, oblivious, obliterating kind, but even more importantly it is a defence of vulnerability, which is after all the necessary condition of love. The chamber pot becomes compost for something else, something new. 'If we want reality to change then why not change it?' Kraus asks. 'Oh Dick, deep down I feel that you're utopian too.'

Future Sex: A New Kind of Free Love

BY EMILY WITT

November 2016

FOR THE PAST FEW YEARS, Emily Witt has been dispatching gripping, keenly strange field reports from the frontiers of contemporary desire. A curious, if cautious participant-observer, she's attended orgies, inhaled nitrous oxide with polyamorists and watched college students in the Midwest broadcast their fantasies via webcams, painstakingly assembling a luminous, flickering portrait of human (hetero)sexuality in the age of the internet.

Witt's desire to chart new species of sexual behaviour followed hard on the heels of a breakup, an alarming rupture in what she'd previously conceived to be a natural, seamless progression from monogamous dating to the permanent station of marriage. Abruptly and unhappily single at the age of thirty, she was forced to confront the troubling possibility that love is not something you can ordain or engineer; worse, that it might not be attainable at all.

What if the interim behaviours in which she and her peers had been engaging – the hook-ups with friends, the undating, the ghosting, the casual, carefully meaningless encounters –

were not the aperitif, but the main event? 'We were souls,' she says, 'flitting through limbo, piling up against one another like dried leaves, awaiting the brass trumpets and wedding bells of the eschaton.' Perhaps the future wasn't coming; perhaps coming in the present could be its own reward.

There are many reasons why a straight woman approaching middle age might shy from promiscuous sexual experiment, not least the chlamydia clinic in which Witt finds herself after a nocturnal dalliance produces unwanted consequences. The zipless fuck, as Erica Jong dubbed it in her 1973 novel *Fear of Flying*, was made plausible by the invention of the contraceptive pill, yet remains perennially hampered by fears of pregnancy, violence and disease, as well as more subtle cultural inhibitors.

Witt herself is beset by a kind of magical thinking that finds an inverse relationship between number of partners and likelihood of finding love, a nagging puritanism that supposes pleasure will be punished, abstinence rewarded. Elizabeth, her polyamorous interlocutor, had to consciously resist knowing her sex life affected the way she was viewed in her professional life. 'Monogamy was assimilated into notions of leadership and competence; other sexual choices came with loss of authority. The fear of falling on the wrong side resulted in a general performance of consensus about what constituted a responsible life, when in fact there was, perhaps, no centre at all.'

Little wonder we've become so dependent on computers for organising and enabling our erotic lives, with their promise of anonymity, their marvellous ability to mediate between bodies, displaying, connecting and transmitting at will. The internet is a frictionless utopia for the polymorphously perverse,

routing desires of every possible heft and size. Witt became single in 2011, a few months before she purchased her first smartphone and a year before Tinder was invented. There was no better place that year for assessing how technology was facilitating new models of sexual behaviour than San Francisco, where the healthy, wealthy young employees of Google and Facebook were daily sculpting the future into being. 'The city just happened to be a synecdoche,' Witt observes of her temporary home, 'where the post-1960s combination of computers and sexual diversity were especially concentrated.'

The problem with internet dating, as she swiftly clocks, is that even the most sophisticated algorithms are hopeless at assessing physical attraction. Women are supposed to be put off by frankly sexual content, preferring instead the 'clean well-lighted room' approach purveyed by the bougie marriage markets of OK Cupid and Match.com. But what if you decline the moral obligation of love; what if you want something wilder, darker or less inclined to permanence? Among the alternatives that Witt explores is the website Chaturbate, where anyone with access to the internet can play both exhibitionist and voyeur, like the pallid Edith, who strips while reading R. D. Laing and claims to be 'internet sexual' and wholly celibate in her non-cyber life.

A stronger stomach might be required when Witt attends the filming of an orgy for the BDSM website Public Disgrace, during which a young performer named Penny Pax is stripped, whipped, shocked, fucked and fisted in front of an audience of rowdy extras. Were there any moments of genuine pleasure? an incredulous Witt asks post-game Penny as they huddle in a

stairwell. 'She looked at me like I was crazy. "Yeah. Like the whole thing! The whole thing." '

There are feminists, from Andrea Dworkin on, who would allege this to be false consciousness, a Stockholm syndrome assimilation of a violently misogynist culture, and there are feminists (Annie Sprinkle, say) who would applaud its honest acceptance of sexual diversity, the grand mystery of specific human arousal. Or, pleasingly, is Witt's byword. She perpetually interrogates her own received ideas, more interested in auditing than legislating possibilities.

Meanwhile, in the Google canteen, a new breed of free-love advocates were diligently hashing out the rules of their poly-amorous adventures. Witt is an unusually immersive journalist, and her account of the shifting fortunes of a three-way relation-ship is alert to irony and affection. Whatever you might think of polyamory, it's hard not to admire the sheer labour – the shared Google docs, book groups and endless, wrangling con-versations – that sexual liberation entails.

This is, of course, Free Love 2.0. The original Free Love movement, which reached its zenith in the 1960s, fed by think-ers like Wilhelm Reich, believed that in going beyond religious strictures a new kind of humanity would emerge: more peace-ful, healthy and content thanks to their potent orgasms. Perhaps sexual experiment also birthed a new documentary form. The New Journalism, a movement to which Witt owes a significant stylistic debt, emerged at around the same time, energised by and quick to skewer the eccentricities, hypocrisies and bleak fallout of the Free Love era.

The New Journalists, a loose cohort that included Tom

Wolfe, Joan Didion and Gay Talese, brought the exuberant techniques of the novel to bear on the non-fiction world. Like the affectless Didion in particular, Witt possesses a knack for capturing the aesthetics of the present moment: 'leathery-tan nudists twinkling at passers-by in the Castro, stone fruit season at Bi-Rite. Somewhere down in Palo Alto Steve Jobs was on his deathbed, the white aura of battery light pulsing ever more faint. San Francisco, 2011: the Summer of Emotional Involvement.'

The problem with the future is that it turns so quickly into the past. It's beginning to seem as if the sexually liberal era here envisaged as permanently secured might already be under siege; that the sex of the Obama years could prove as vulnerable to the rise of the ultra-conservative right as Obamacare. In Britain, certainly, the curious reader will soon no longer be able to summon up the whipping posts of Public Disgrace and its ilk. The Digital Economy Bill, currently passing through the House of Lords, will force internet service providers in the UK to block sites showing images or videos of 'non-conventional sex acts', applying the same regulations as are currently applicable to DVDs. Never mind whether they involve mutually consenting adults: fisting, female ejaculation and menstrual blood must be banished, our communal erotic repository censored, just as the old fleshpots of Soho and Times Square were cleaned up and colonised by well-lighted Starbucks cafés.

But it isn't only governments that threaten the freedom of the imagination, the liberty of the sexual body. 'There was no industry of dresses and gift registries for the sexuality that interested me in those years,' Witt writes towards the end of her

adventures, 'and some part of the reason I wanted to document what free love might look like was to reveal shared experiences of the lives we were living that fell outside a happiness that could be bought or sold.'

Sex, and especially sex that doesn't take culturally sanctioned forms, is here conceived as a way to escape the consumerist imperatives of late capitalism, to experience a kind of wildness and emotional connection that can't immediately be repurposed by ads, even if it's grubby or depressing or actively risky. I know exactly what she means, and I want it too. Amazing the price you have to pay for free love.

After Kathy Acker

BY CHRIS KRAUS

August 2017

THE MUDD CLUB, New York City, Valentine's Day, 1980. A young woman is on stage. She looks a real picture: tight leather skirt, white skin, red lips, heavily kohled raccoon eyes. Then she starts to read the wicked letters from her novel-in-progress, *Great Expectations*. 'Dear Susan Sontag, Would you please read my books and make me famous . . . Dear Susan Sontag, will you teach me how to speak English? For free.'

Stars aren't born but created; they don't arise out of nowhere, but you can date the moment they first appear. Of the fourteen Kathy Acker books I've got in front of me, eight have her pugnacious waif's face on the cover, while *Young Lust* shows her bare muscular back, with its distinctive self-penetrating rose tattoo. She's the acme of the self-invented, self-mythologising counterculture superstar, a foul-mouthed Beat biker and bodybuilder dressed in Comme des Garçons, the love child of the Marquis de Sade and Wild Bill Burroughs.

The source of much of the Acker legend was Acker herself. She lied constantly, obfuscating her origins, sharpening and distorting the raw elements: the mother of twins, a stripper, an

heiress, dirt-poor. 'But then again,' Chris Kraus observes, 'didn't she do what all writers must do? Create a position from which to write?' Later, she adds smartly: 'Acker worked and reworked her memories until, like the sex she described, they became conduits to something a-personal, until they became myth. This was the strength, and also the weakness, of her writing.'

The bones at least check out. Acker did come from money, and also neglect. Her real father ditched her mother when she was three months pregnant with Kathy; though she knew his identity and received a small bequest, Acker never met him. As for her mother, Claire was the epitome of the poor little rich girl. She killed herself on Christmas Eve 1978, checking into the Hilton near her apartment on the Upper East Side and overdosing on barbiturates. After years of estrangement, mother and daughter had recently been rebuilding their relationship. Abandonment, loss, fury: this was Acker's inheritance, her native territory.

Pretty much the only job she ever had was in 1971, performing a live sex show at Fun City in Times Square with her then-boyfriend. They had a Santa Claus routine. The things she saw provided material and a certain degenerate, sinister atmosphere for the books to come. Despite agonising pelvic inflammatory disease, she started writing seriously that year, inaugurating a routine she'd stick to lifelong, though it took a move to California for her to embark on her first novel.

The Childlike Life of the Black Tarantula began life as six episodic pamphlets mailed to a list of receptive art-world types. It was composed of stolen fragments from other books, wrenched out of context and put in the first person, where they took on

a dreamlike, unsteady new life. Appropriation suited Kathy; it became her trademark. She mixed bits of Dickens and Bataille, pulp fiction, porn, historical romance, *The Story of O* with extracts from her own impassioned letters and diaries. Never mind finding her voice: what she wanted was a vehicle for conveying the fluid, fragmentary nature of identity, the shattered world with its abysmal imbalances of power. Abortions, STDs, lust, disgust were her lived experience, and so she found a way to force them into the hallowed house of fiction.

Kraus is intent on dismantling the tired myth of the romantic genius, the artist working in a void, so keen to cop to shared production that she repeatedly names her own research assistants in the text. She situates Acker amid an avant-garde of comparable experiment, tracing the use of appropriation back to Burroughs's cut-ups, of course, but also to the poet David Antin, whose seminars Acker attended in the late 1960s at UC San Diego. Antin didn't want confessional material from his students, so instead he proposed they steal something from the library, reworking it in the first person. No doubt it helped liberate Kleptomaniac Kathy, but none of those other students wrote *Blood and Guts in High School*.

'History,' as Acker's first husband observes, 'is hard to do!' In many ways Kraus is Acker's ideal biographer. But given her interest in making hidden structures visible it's surprising that she doesn't acknowledge her own relationship to her subject. Acker was the previous girlfriend of Kraus's now ex-husband, Sylvère Lotringer, like Kraus an editor at the publisher Semiotext(e) and a frequent interlocutor here. Is it crass to point this out? It certainly complicates any objective perspective,

and maybe it would have been better to state it plainly, especially since it's logged in *I Love Dick*, the roman-à-clef that made Kraus famous. That said, Kraus reconstitutes Acker's wanderings with real wit and beauty, understanding without pandering to the painfully high stakes of her identity games.

Acker always led a peripatetic life. In London in the early 1980s, she became a full-blown star, helped by a *South Bank Show* documentary. She was working on *Don Quixote*, trying to abandon her old dependence on the cut-up, telling a lover 'quick virtuosity teenage passion is no longer useful or interesting'. She was also lonely. By 1986, she'd fallen deep into an S&M relationship with a man she called the Germ, short for German. The fusion of sex and pain mesmerised her, promising intellectual and emotional revelation and lending her late works a tone of obsessive, exultant desolation (it would be illuminating to consider Acker alongside Foucault, who likewise spent the final years of his life conducting experiments in the limits of freedom in the S&M clubs of San Francisco).

Willed humiliation is very different from inadvertent shaming. Acker's London life fell apart in 1989, when she was accused of plagiarising the popular novelist Harold Robbins. She was forced by her publishers, Pandora, to publicly apologise (or so she said; Kraus's London researcher failed to find a trace of this apology, which was apparently placed in numerous literary magazines).

The last years weren't so hot. She took an adjunct teaching job in San Francisco without tenure or benefits, and travelled frequently, 'a motorcycle in every port'. And then in April 1996 she was diagnosed with breast cancer. She chose a double

mastectomy and refused all other treatment, putting her faith in a retinue of alternative healers, two of whom would later be indicted for medical fraud.

Once again, she was inhabiting a fabular world, partly out of fear and partly because her job didn't include medical expenses and 'chemotherapy begins at $20,000' (though as Kraus points out, she still had a trust fund). She told many people she'd been poisoned, after drinking from a bottle of Evian that had fallen into Regent's Canal. 'I affirm,' she wrote in her notebook, 'that every day is a day of wonder.'

She was fifty, she was dying, she was still on tour. In September she checked into a San Francisco B&B, where the few friends she was still speaking to convinced her to go to hospital. The cancer was everywhere, but she insisted on leaving. In the end, she spent her final month in an alternative clinic in Tijuana, Mexico. Her friend and former agent Ira Silverberg set up a fund to pay for her medical expenses, which were clocking in at $7,000 a week. By the time she died it had raised $2,440.

Her books remain: radical and uncanny, entirely inimitable, a smash and grab on the history of literature. Maybe she summed it up best herself, the warp and scale of what she was doing. As she put it in the essay 'Dead Doll Humility', language was her material, and what she liked to do was play with it: 'build up slums and mansions, demolish banks and half-rotten buildings, even buildings which she herself had constructed, into never-before-seen, even unseeable jewels.'

The Cost of Living

BY DEBORAH LEVY

February 2018

IT'S AN EXPENSIVE BUSINESS, being alive. It takes a toll on hearts and pockets alike. And it's especially costly if you're compelled to live outside conventional structures. Freedom, as the novelist, playwright and essayist Deborah Levy observes, 'is never free. Anyone who has struggled to be free knows how much it costs.'

In 2013, Levy published a slim, incendiary book. Titled *Things I Don't Want to Know*, it was a response to Orwell's 1946 essay 'Why I Write'. In it she grappled with her own biography, attempting to figure out in particular what it means to write from the 'the suburb of femininity', and how to reconcile the demands of motherhood with making art.

This is the sequel, the second in three planned volumes about the intertwining consequences of being a woman and a writer (also a mother, a daughter, a childhood exile from South Africa, none of which are simple roles). Now in her mid-fifties, we re-encounter Levy in the aftermath of a divorce, the exhausted, exhilarated survivor of a catastrophic shipwreck. 'Now that I was no longer married to society,' she writes, 'I was transitioning into something or someone else. What and who

would that be?' This is a story, then, about gender and age, how the two can constrict and limit possibilities, and how it might be possible to construct a different kind of account.

Getting divorced means abandoning socially sanctioned structures – the scaffold of the marriage, the sanctuary of the family home – and entering strange, potentially perilous waters. Levy relinquishes her Victorian house and moves with her two teenaged daughters into a decaying apartment block on the top of a hill in North London. It's very cold; the heating doesn't work. The building is in the midst of an eternally delayed project of regeneration. The communal hallway carpets are covered in grey industrial plastic for three years. Levy nicknames them the Corridors of Love, and invests in halogen heaters.

She's the most delicious narrator. The post-divorce landscape is well trodden by memoirists, and what makes Levy remarkable, beyond the endless pleasures of her sentences, is her resourcefulness and wit. She's ingenious, practical and dryly amused, somehow outside herself enough to find the grim, telling humour in almost any situation. Her experience is interesting to her largely for what it reveals about society, rather than the other way round.

The plumbing breaks. Fine. Dressed in a black silk nightie, a French postman's jacket and a pair of fur slippers, she sets to work with the Master Plunger, a gender-defiant shaman presiding over the city's blocked pipes. A supermarket chicken falls off the back of her bike and is run over by a car in the pouring rain, hours after a catastrophic meeting. No problem. Roast it with rosemary (not for remembrance) and fill the house with women of all ages for a raucous, festive dinner.

Generosity begets generosity. As in a fairy tale, helpers emerge. Levy needs somewhere to write. Enter Celia, a fierce former bookseller and the widow of the poet Adrian Mitchell, who offers up an unglamorous garden shed, complete with a freezer containing twenty plastic tubs of quartered apples. Levy lugs in a few books and immediately sets about writing *Hot Milk* (later shortlisted for the 2016 Booker Prize).

Not everyone is so benevolent. There is something alarming about a single woman, especially over a certain age. She's so suspicious and so deviant that she requires perpetual diminishment. The enforcers of the patriarchy aren't always men. For weeks, Levy is accosted by Jean, a sweet-voiced elderly woman whose mission is to prevent her new neighbour from leaving her e-bike (a fairy-tale steed in its own right) in front of the flat for the few minutes it takes to unload her groceries. 'It was as if she felt ashamed to be living alone and was transmitting a portion of that shame onto me.'

Levy has always been skilled at the symbolic, attentive to how we declare our deepest selves in our most casual actions and phrases. Perhaps it's a legacy of her years as a playwright, but she knows how small items — a parakeet, a stray bee, a bubble-gum lolly — generate an atmosphere, making a Freudian weather of their own. This see-sawing, two-things-at-once capacity of objects to open up reservoirs of memory is part of what makes her writing so distinctive.

A natural surrealist, she always provides slightly less information than you might expect, the enigmatic opposite of an overshare. It's amazing the deft use to which she puts *um* and *yes*; the anti-sentimentalising impact of a cannily placed *etc.* Her

style is basically parataxis, things lodged next to things, the junctions missing or cut out. It makes everything a little bit jerky and fragile, and it is a particularly good mode with which to regard the shattering or assembling of the self, which has been among Levy's chief subjects since her novels of the late 1980s and early 1990s, like *Beautiful Mutants* and *Swallowing Geography*.

Shattering is a universal experience, but it also exposes power structures. You realise who is protected and who is marginal, who is listened to and who cannot be seen. Levy keeps encountering men who won't look at their wives or speak their names; men who ask women they've never met before to do tasks for them, men who tell women they talk too much, who cannot believe they're minor characters in someone else's story.

It takes work to insist on being a major character, even in one's own existence. Levy draws repeatedly on Simone de Beauvoir and James Baldwin, allies in the dissident act of making yourself heard, of choosing a mode of living that doesn't require you to participate in your own diminishment. 'When a woman has to find a new way of living and breaks from the societal story that erases her name, she is expected to be viciously self-hating, crazed with suffering, tearful with remorse. These are the jewels reserved for her in the patriarchy's crown, always there for the taking.'

There are better ways of being free. Levy presents it as a puzzle: not easy, not effortless, but full of joy. Cycling to a party twenty miles across London on her liberatory e-bike, her dress streaming behind her, an electronic screwdriver in her

bag, she evokes the pleasure of slipping away from old roles, the glamour of self-sufficiency, of mutual aid. This is a manifesto for a risky kind of life, out of your depth but swimming all the same.

Normal People

BY SALLY ROONEY

May 2018

ARE CONNELL AND MARIANNE normal people? Marianne certainly isn't. At school in Carricklea she's the weird girl, ostracised and excluded, too clever and uppity for her own good. She doesn't look right, she does gross things; even speaking to her might somehow pass on the taint of unpopularity.

Connell's the opposite. The handsome son of a single mother, he's adored by everyone. It's not that he's friends with Marianne, exactly. Like all his mates he blanks her in school. But his mother cleans her house, and their brief, halting conversations in the kitchen swiftly give way to an intense mutual attraction, part sexual, part intellectual, that will become the centre point of both their lives.

Their shared cleverness is a bond, a bridge over the inadmissible gulf in social status. Marianne encourages Connell to apply to Trinity College Dublin to read English. But by the time they get there their brief, electrifying affair has ended, and their statuses have reversed. Now Marianne is a beauty, at home among the privileged surrounds. Suddenly it's Connell who's unpopular and alienated, an unworldly loser with a thick Sligo

288

accent, a 'milk-drinking culchie' who only slowly realises the students speaking so confidently about books in his classes haven't actually bothered to read them.

In some ways, Sally Rooney's magnificent, painful second novel, the follow-up to her acclaimed debut *Conversations with Friends*, is a meditation on power and its shifts: the way that beauty, intelligence, class are all currencies that fluctuate as unpredictably as pounds and dollars. Then again, it's also about love and violence, about how damage is accrued and perhaps repaired.

Time, too. *Normal People* hurdles forward in increments of months and weeks, passing back and forth between Connell's and Marianne's not always convergent perspectives. Each chapter is given a time signature: 'three months later', 'two weeks later' and so on. Within these chapters are fluidly accomplished flashbacks, swift movements back and forth between past and present, always natural and easy to follow and yet virtuosic in their intricacy, showing how rapidly conditions change in the country of youth. At points of crisis – a broken nose; a fight over champagne glasses; a season of depression – time dilates, slowing unbearably.

Connell worries about money; Marianne struggles with an abusive family. On they go, navigating the difficult terrain of young adulthood together. Anxiety attacks, bereavement, a bitchy friend, break-ups and holiday jobs. For the most part it's familiar ground. What's remarkable is the pitch of Rooney's writing, the way it shimmers and quivers with intelligence. Each sentence is measured and unobtrusive, and yet the cumulative effect is a near-unbearable attentiveness to the emotional dimension of human lives, the quick uneasy weather.

All the descriptions stem precisely from a character's mood. After a disturbing sexual encounter, Marianne registers snowfall 'like a ceaseless repetition of the same infinitesimally small mistake.' When Connell travels to Europe, after a scholarship gives him financial licence for the first time, there is a luxurious deepening of detail, an intensification of sensuality. 'Cherries hang on the dark-green trees like earrings', 'the air is light with scent, green with chlorophyll'.

Sex dominates the book, though it's by no means graphic. The ongoing, apparently unquenchable attraction between Connell and Marianne holds them in orbit despite multiple tensions and misunderstandings. Rooney's skill at writing about sex is especially marked when she describes Marianne's desires, and the states her desires send her to. It's hard to think of another novelist who is so fluent at communicating this secret, internal aspect of sex: the way that a craving for certain acts is also a shortcut to a particular kind of emotional landscape. More than that: how a history of violence creates a need for self-harm, how this can be outgrown, how growth itself requires and is sustained by love, which can be conveyed by way of bodily acts.

A visiting writer, encountering Connell at a reading and guessing at his literary aspirations (themselves veiled in layers of shame), observes beadily that not fitting in at Trinity 'mightn't be a bad thing. You could get a first collection out of it.' This is Rooney's second book set at Trinity, where she herself studied, but it doesn't feel as if she's running short on material. Instead, it seems that in this small campus she's found an equivalent to Henry James's closed communities, where outsiders

must sink or swim on swelling, deforming tides of wealth and privilege.

If this is a love story (it is), then it's a notably mature vision of love, ethical + erotic, valuing kindness over possession, while wise to the impossibility of ever existing in complete independence, without the care and influence of other people. Contemplating her relationship with Connell, Marianne thinks that they 'have been two plants sharing the same plot of soil, growing around one another, contorting to make room, taking certain unlikely positions'.

This is very Jamesian, too: the understanding that we exist not as individuals, but as a complex network of relationships, some sustaining and others deleterious and undermining. It's a thing worth saying, and this is a hell of a way to say it. Rooney is miraculously astute about human relations, the best young novelist – indeed one of the best novelists – I've read in years.

LOVE LETTERS

David Bowie

1947–2016

January 2016

ART, DAVID BOWIE once told the *New York Times*, 'has always been for me a stable nourishment.' You don't think of stability with the Thin White Duke, locked in a room in Los Angeles or Berlin, the blinds pulled down, living off cocaine and frightening himself half to death with forays into black magic. But art permeated everything he ever did, a source of succour and reliable inspiration, one of the few constants in his restless life.

The only O-level he got was art, and like many glam rockers and proto punks he did the obligatory stint at art school too. He didn't stick around, abandoning Croydon College in the early 1960s in favour of making stabs at rock stardom. When that didn't seem to work he backed away from music altogether, spending a couple of years studying and performing with his lover, the visionary mime artist Lindsay Kemp. It was Kemp who introduced him to some of his most lasting influences, including kabuki theatre, and who helped him develop a captivatingly visual, physical dimension to his songs, bringing high art to bear on the disposable medium of pop.

After the release of *Hunky Dory* in the summer of 1971, he

went to visit another hero: Andy Warhol, the consummate magician of the twentieth century. Among the things Bowie got from Warhol were his permissive, prodigal mixing of high and low culture and his thrifty willingness to snatch inspiration from anywhere. Bowie turned up at the Factory in white Oxford bags and Mary Janes, a slouchy bibbety-bobbity hat pulled low over his long blonde hair. He sang his homage 'Andy Warhol' to the master ('Tie him up when he's fast asleep, Send him on a pleasant cruise'), who was reportedly not wholly flattered. Then he performed an earnest mime for a nonplussed Andy, in which he opened up his heart and let his guts spill on the floor, the antithesis of affectless Factory style.

It was prophetic, perhaps, of what was to come: the annihilating effects of serious, cult-level fame; the sense of being haunted by his own creations, of careering with them into places inimical to physical and mental health. Bowie was always willing to risk ridicule and failure, to expose himself, to go further out than anyone else might have thought possible or wise. Album after album wore its influences on its sleeve, the avant-garde German expressionism of *Heroes* or *Low*, the Chatterton-meets-Beau Brummell lushness of *The Man Who Sold the World*.

Like many rock stars, he started collecting art, including a pair of Tintorettos, a Rubens and a Frank Auerbach. But at some point in the 1980s he began making it too. He'd got himself stuck creatively, and as a way of edging out of the doldrums he switched mediums, using painting as a way of swimming back to himself. At first it was a private business, a

respite and release from music, and then a fertile way of solving problems and nudging around blocks.

Always courageous in his reinventions, he made this aspect of his life public in 1994, when he first exhibited his expressionistic, interestingly static and melancholy paintings at the Flowers East Gallery in London for his friend and collaborator Brian Eno's charity War Child. By this time, he was already part of the art establishment. He was on the board of the magazine *Modern Painters*, where at an early meeting he'd shyly suggested that he might interview the painter Balthus, then a neighbour in Switzerland. This was followed by serious, knowledgeable interviews with other contemporary artists, among them Tracey Emin, Roy Lichtenstein and Julian Schnabel. In 1997 he played Warhol in Julian Schnabel's film *Basquiat*. Much is made of Bowie's inability to act, but there's something almost eerie about how well he embodies Andy, with his weird spacy intonation and awkward grace. It's a loving homage, circling him back to his own youthful ambitions.

He never stopped collaborating, never stopped travelling between mediums. One of his last great songs was 'Where Are We Now?', a plaintive hymn to ageing, to abiding loss and abiding love. The video, made by Tony Oursler, is set in an artist's studio, that site of rigorous and messy transformation, Bowie's psychic home throughout the years. 'As long as there's me,' he sings, his face lined and sorrowful, still dignified though it is projected ridiculously onto a puppet. 'As long as there's you.'

I've kept a picture of him on my desktop for years, a screenshot of two frames from Nicholas Roeg's 1976 film *The Man*

Who Fell to Earth. It was the quintessential Bowie story, the one he kept telling: an alien traveller, trapped on earth or lost in space, the only one of his kind, lonely and magnetic. In the first frame he's lying on a bed, head propped on one skinny arm, a strand of auburn hair falling across his bony, feline face. 'What do you do?' the subtitle asks. 'For a living, I mean.' In the second frame his head is down, pillowed on his arm, and he is smiling to himself. Oh, I'm just visiting.

Vanished into Music

ARTHUR RUSSELL

July 2016

THERE'S A MAN on the ferry. He's wearing jeans and a baseball jacket, and standing at the stern, his handsome face pitted with acne scars. Everyone else is looking at Manhattan. It's 1986: the Twin Towers dominate the view. But this man isn't looking at the buildings. He's staring at the swirling water, the confluence of tides, the East River and the Hudson coming together in the harbour of the city.

Out here, everything is expansive. Out here, everything falls away. He has his Walkman in his pocket, his headphones around his ears. The music he's listening to is a mix he finished late last night. When he was done – though nothing he does is ever done, exactly – he took the cassette and left the studio. Full moon, of course. He has been recording this album every full moon for three years now. Sometimes he curls up in the studio for a nap, waking in the small hours with a new idea, an unprecedented sound bubbling through his mind.

His name is Arthur Russell. He's thirty-five. He's a gay man, a Buddhist, a cellist, a country singer, an avant-garde composer, a disco queen; he is the greatest musician you've never heard

of. The music he's been making doesn't sound like any music that's ever been made before. It's like music from the bottom of the ocean, it's like music they play in nightclubs on the moon. The album he's working on, his first, is called *World of Echo*. Just his voice and his cello, in a studio in the deserted financial district, surrounded by empty, glowing offices. One man pushing music to its limits, finding the breaking points, making the most beautiful songs imaginable and then teasing them apart like taffy, amplifying and distorting until they dissolve into lakes of sound.

In the booth, he listens tensely, moving his shoulders a little, dancing on the spot. Which is best? How does the cello sound when it's distorted, feeding back like an electric guitar? How subtly can he bow, making gauzy veils of sound? Is it better when you can hear the words he's singing, or when there's no intelligible language at all, just a polysyllabic babble, the music pouring through him?

At two or three or four in the morning he stops and slots in the night's tape, listening to it repeatedly as he prowls the sleeping city. Sometimes he'll walk for hours, wandering the streets of Soho or following the river north. Maybe he'll stop at Gem Spa and buy an egg cream; maybe he'll call in at Paradise Lounge or the Garage, where the beautiful boys dance, black and white together, in an ecstatic sweaty fusion.

<p style="text-align:center">★</p>

Lately, though, Arthur has been losing his taste for the nightlife; lately he's been feeling dog tired. So tonight he finds himself on the ferry at dawn, gazing out at the water, loving

how the music sounds over the low drone of the ferry's engine.

He doesn't come from here. He's a farm boy, a refugee from the cornfields of Iowa, seeking his fortune in the big city. He never felt like he fitted in in Oskaloosa and at eighteen he ran away from home. He washed up in a Buddhist commune in San Francisco, where he was forbidden to play his cello and so hid in a tiny closet to practise for hours. In 1973, at the age of twenty-two, he made the move to Manhattan, finding an apartment in The Poets Building, a tatty East Village walk-up, home to the poet and counterculture legend Allen Ginsberg, who encouraged him to come out as a gay man.

The wake of the boat is white. Arthur leans on the rail, dreaming of his future. What he wants is to be a pop star, though he is hampered by his shyness, his lack of money, his perfectionism and his refusal to compromise on any aspect of his vision. Most musicians stick to a single scene but Arthur has always been a rover. He's a restless soul, sticking his nose into all the different places in the city where music is made. Boundaries and borders mean nothing to him; he hurdles them with ease.

Within a year of his arrival in New York, he was appointed musical director of The Kitchen, the venue at the heart of the city's experimental music and performance scene. He collaborated with minimalist composers like Philip Glass and Steve Reich, and at the same time he played dirty downtown rock and roll, running out to CBGB to play cello with the Talking Heads. Any music could be experimental music; any music could be pushed to its limits.

And then he discovered the hedonistic, libidinal world of disco. All across downtown, nightclubs were proliferating: wild spaces where you could sweat with a thousand strangers, relinquishing inhibitions in a nocturnal world of rhythm. Quickly, he began to release dance records, under multiple pseudonyms. Dinosaur L, Loose Joints, named for the constant cry from the dealers in the park by his house. Indian Ocean, Killer Whale: names for alternate selves, each with their own alternate vision. You could dance to these records, sure, but they were also experimental adventures in minimalism in their own right: spacey, dubby, weirdly unstructured grooves, shifting in mood from high-octane, fist-pumping ecstasy to a more childlike, innocent sensuality.

Listening to *World of Echo* over the sound of the water, he thinks it is the most complete thing he's ever done. But it's never easy to put something new into the world. The album is released later that year and though the early reviews are positive the sales are appalling. There is no market for the music of the future, not yet.

<p style="text-align:center">★</p>

One of the most magical things about Arthur Russell's music is the way it conveys feelings, especially feelings that are not easily translated into words. For him, music is a place of refuge, a haven: an infinite realm into which he can voyage, even vanish. He hopes it might bring him fame, heightened visibility, but he also loves the way he can swim out into it, temporarily disappearing from the world.

Aids accelerates this tendency, turning it malignant. His

natural spaciness becomes confusion, while his capacity for wandering gives way to a dangerous tendency to get lost. The virus lays waste to him, eroding his immune system. The end comes fast: 4 April 1992, in a hospital bed high above New York.

How do you define success? Arthur Russell was only forty when he died, flat broke, a few obscure singles and one album to his name. But he left behind thousands of hours of unpublished music, hundreds upon hundreds of songs. In his absence, it has slowly been released into the world, to growing appreciation and acclaim. Listening to it now, it becomes apparent that the quiet man on the ferry, dancing silently to sounds that only he could hear, might have been one of the best and strangest talents of twentieth-century composition, a nomad with an absolute commitment to freedom, whose natural element was music itself.

'That's us,' Arthur once sang, 'before we got there'. He's telling a story about being a kid, driving to the lake before dawn to swim. Then the beat kicks in, and now it's love he's singing about, or maybe just how it feels to be awake in the world on a summer morning. It's a wild combination all right, and so was he: a firework on the 4th of July, everything all at once, in a flash, and gone before you could grasp what you'd seen.

John Berger

1926–2017

January 2017

I ONLY SAW John Berger speak once, at the end of 2015. He was in conversation at the British Library about *Portraits*, his collected essays on artists. He clambered onto the stage, short, stocky, shy, his hewn face topped with snowy curls. After each question he paused for a long time, tugging on his hair and writhing in his seat, physically wrestling with the demands of speech. It struck me then how rare it is to see a writer on stage actually thinking, and how glib and polished most speakers are. For Berger, thought was work, as taxing and rewarding as physical labour, a bringing of something real into the world. You have to strive and sweat; the act is urgent but might also fail.

He talked that evening about hospitality. It was such a Bergerish notion. Hospitality: the friendly and generous reception and entertainment of guests, visitors or strangers, a word that shares its origin with hospital, a place to treat sick or injured people. This impetus towards kindness and care for the sick and strange, the vulnerable and dispossessed is everywhere in Berger's work, the sprawling orchard of words he planted and tended over the decades.

In 1972 he won the Booker Prize, and in his acceptance speech announced that he would be donating half his winnings to the London Black Panther Party. The prize sponsor, Booker McConnell, had made their enormous wealth through the exploitation of the Caribbean and he wanted to return some of it, to make a small restitution. His closing words were 'clarity is more important than money.' Few people have possessed such clarity, nor yoked it to such persistently generous political ends.

Art he saw as a communal and vital possession, to be written about with sensual exactness. His essays on painting are packed with unforgettable images, the diligent, inspired seeing of an artist who'd given himself over to written language. Vermeer's rooms, 'which the light fills like water a tank'. Goya, whose cross-hatched tones gave 'a human body the filthy implication of fur'. Bonnard's 'dissolving colours, making his subjects unattainable, nostalgic'. Pollock's 'great walls of silver, pink, new gold, pale blue nebulae seen through dense skeins of swift dark or light lines'. Art criticism is rarely this plain, this fruitful, or this adamant that what happens on a canvas has a bearing on our human lives.

Capitalism, he wrote in *Ways of Seeing*, survives by forcing the majority to define their own interests as narrowly as possible. It was narrowness he set himself against, the toxic impulse to wall in or wall off. Be generous to the strange, be open to difference, cross-pollinate freely. He put his faith in the people, the whole host of us.

Host: there's another curious word, lurking at the root of both hospitality and hospital. It means both the person who offers hospitality, and the group, the flock, the horde. It has two

origins: the Latin for stranger or enemy, and also for guest. It was Berger's gift, I think, to see this kind of perception or judgement is always a choice, and to make a case for kindness: for being humane, whatever the cost.

John Ashbery

1927–2017

September 2017

LATE, UP IN MY ROOM, night rain, three people tweet about Ashbery. That's how I heard about Bowie, that's how I heard about my friend Alastair Reid, that's how it is these days. Once I thought I was sitting opposite Ashbery on the 1 train, his big square head. I got all the way to Cathedral Parkway before I realised it was Edmund White. In Chelsea years ago, there was a show called *Ashbery Collects*, his front room remade, his rugs and pictures and Daffy Duck cartoons. Something sad there, misplaced. He washed language and put it back on the shelves all wrong. It looked so much better that way. The language will be arriving later, I misread this morning. Language = luggage, baggage, the ongoing upsettingness of water in the air. Ashbery has died, comma, Ashbery has died. I'm sorry about the pillars of grass, who are now illegal and will be deported. There is nothing to do for our liberation, except wait in the horror of it. And I am lost without you, the sweet black smuts moving upward.

Mr. Fahrenheit

FREDDIE MERCURY

October 2018

I ♥ FREDDIE MERCURY. I love to think of him on winter evenings in the 1980s, on the phone to Princess Di. Bored and restless, cooking up a plan to smuggle her into the Royal Vauxhall Tavern dressed as a twink, clone cap pulled low, ordering a giggly Sloane's round of V&Ts. Freddie the Puckish impresario of a comedy worthy of Shakespeare: royalty disguised to enter low taverns, girls transformed into apple-cheeked boys, the endless English thigh-slapping obsession with gender reversal. Freddie was the first celebrity death I cried about (the others: Derek Jarman and David Bowie, my holy trinity). There he was, the queen at the heart of pop culture, a flagrant hedonist, amped up on his own desirability, never mind the buck teeth, smuggling queer sensibility onto *Top of the Pops* week after week. Freddie the cat lady, posing with a pussy, letting his brood of ten piss against the Chippendale in his lavish mansion pad. He wasn't English but he was playing an English game, the fag in the Establishment, a light entertainer, undisguised yet somehow unseen, an open secret, like Noël Coward or Benjamin Britten, though it's hard to imagine Benji

B. cavorting in black leather. For the video of 'Don't Stop Me
Now', Freddie wore a Mineshaft T-shirt, a relic from the S&M
club he loved on Washington Street in New York City, where
the rooms smelt of shit and piss and Crisco and there were
glory holes and dungeons and you could fuck a dozen men in
a night. 'Tonight I'm going to have myself a real good time',
he sings, and you feel it too, the libidinal pleasure of pure appe-
tite, Dionysus incarnated into 1980s England, the uniform
grey-blue landscape of British Rail and Margaret Thatcher's
handbags. How did he get away with it? Bearded quite literally
by the cheesy bloke-rock of the other three, science teachers at
the disco, oozing heterosexuality. The *Top Gear* bloke-speak of
'remaster' and 'airplay', 'double platinum' and 'custom-built
guitar' rubbing uneasily against the mercurial swagger, a red
hankie flashing from a back pocket, two cultures in explosive,
unstable contact. Read it if you can: a coded signal sent out
from the epicentre of the mainstream, broadcast live from
Wembley Arena on Saturday night, a man who fucks men,
unmistakable and uninhibited, prancing and prowling, never
still, the sort of stud who sandpapers the crotch of his jeans.
When he died in 1991 of Aids-related bronchial pneumonia we
were three years into the sorry era of Section 28, explicit state
homophobia shot with Aids panic, thousands dying, the streets
of London full of prematurely ancient men with Kaposi's and
sunken cheeks. For his last video, 'These Are the Days of Our
Lives', Freddie is a walking skeleton, an ungainly puppet, the
old sexual charisma almost entirely vanished, dressed in track-
pants and a cat waistcoat, his face densely powdered, light
pouring from his palms. None of the attitudes of that time have

quite gone away. In 2018, the *Mail* published a piece that talked about Freddie's 'unshakeable bond' with an ex-girlfriend. The language was poisonously familiar: 'indiscretions . . . bedded hundreds of people . . . Freddie took advantage of the endless supply of men'. It's still seething under the surface, the belief that Aids is a punishment. On a fan website I found a comment: 'Honestly if Freddie had HIV before 1987 then he would be responsible to putting many people to death. As in murder.' The internet is the aspic that preserves these attitudes, so prevalent when I was growing up, a gender-fluid kid in a lesbian family, the walls around us closing in. Queer joy: that's what Freddie epitomised for me. The hottest man alive, something to become, a long-legged, doe-eyed boy, turning hunger into currency.

Say You're In

WOLFGANG TILLMANS

February 2019

1.

I don't know where we're going. I don't even always know
what I'm looking at. Some of it moves me and some of it scares
me and some of it leaves me at sea, disorientated, maybe already
obsolete.

2.

Just before the Brexit vote, a hot day, I went to Donlon Books
on Broadway Market to pick up a roll of Wolfgang's Europe
posters. We were all laughing, it was summer. I got the one
with the waves crashing against an eroding beach. No man is
an island, it said. No country by itself. It's in Ian's study now. I
haven't the heart to hang it up.

3.

Free bodies. In the 1990s I lived on road protests. We were
dirty, we smelled of wood smoke, we slept in tree houses and
washed in buckets. We wanted to protect the world, specifi-
cally forests, and so we put our bodies in the way of machines.

Often Wolfgang's photos remind me of that long-ago time in my life. I don't just mean *Lutz and Alex Sitting in the Trees*. I mean the protest pictures, the clubbing scenes, anything where people are embracing or on the streets. There are so many ways you can feel bad in your body, not just ugly but cut off or in transit, untouched, ineffectual, a vector or data point, a consumer, a subject. I love these pictures because they're truly utopian and because the utopia is so abundantly available, even now. I mean it's free. Just holding hands, maybe a blow job, two girls kissing, a boy cutting shapes in a silver dress. It's not that anyone's pretending that this isn't dangerous, that the free exercise of love, the free movement of bodies might cause a person to be killed. That's abundantly documented too.

4.

Bothering to see beauty, making beauty freely available (lemons, apple blossom, broken eggs). Showing that beauty is unstable, coming and going, requiring effort. I mean political in the sense of how you choose to be in the world, what you are willing to look at, what keeps you alive. I said lemons, but also *17 Years' Supply*.

5.

This is political too: that it isn't always clear what you're seeing. It's not a spoon, it's a fold of paper. It's not a stone, it's a potato. It's not the sun, it's a searchlight. Nothing doesn't not require attention.

6.

Once a friend and I had a fight and we met in the Wolfgang retrospective at the Tate and I was so overcome by the photo of soapy water pouring down a drain clotted with vegetation that I thought I'd faint. It was so beautiful it made me feel like I'd been hit round the head.

7.

I fear what is happening in the world. I am glad someone is watching how truth is made, diagramming the stages of its construction, or as it may be dissolution.

8.

If the photograph is a body (vulnerable, in congress, capable of replication, wounding and death), is the body at all like a photograph? Conceived, developed, regarded. I like the egalitarian way we group together. Is there enough room? It feels like yes.

TALK

A Conversation
with Joseph Keckler

February 2018/March 2019

JOSEPH KECKLER IS a singer and storyteller: a vagabond of the
outer boroughs with an eye for the unorthodox, irregular,
anomalous and eccentric. The *New York Times* describes him as
'a major vocal talent with a range that shatters conventional
boundaries'. Operatically trained, he puts his three-plus octave
range to good use, performing arias that sound like Schubert or
Handel until you read the surtitles and discover he's actually
telling absurdist tales about bad trips and bondage pants (Google
'Shroom Aria' to get a taste). He hails from Michigan, but is a
New Yorker from the tip of his crow-black hair to the toe of his
untied black boots. The first time I met him, on a residency in
New Hampshire in 2011, I was struck both by his silver jacket
and his impeccable manners. He's the most charming man I
know, also the most fragrant, and a dear friend. We both travel
a lot, so we often find ourselves in the same city, slipping back
into a long, ongoing, rambling conversation about art, perform-
ance, gender and sex. He describes himself in his new collection
of (trueish) stories *Dragon at the Edge of a Flat World* as an 'obscu-
rity impersonator'. I think that means he has a knack for
drawing strangeness to him. He absorbs anecdotes and

confessions from the people in his downtown, truly bohemian milieu – a witch called Thain; a voice coach haunted by a poltergeist; an ageing club kid–cum–academic secretary who turned her university department office into a lo-fi version of Warhol's Factory – alchemising them into mesmerising stories and performance pieces. As a writer and singer he nudges language to its limits; as a performer he is uncannily commanding.

OLIVIA LAING Have you had coffee?

JOSEPH KECKLER Yeah, I've been guzzling it for a half an hour.

OL Good, okay. Where are you?

JK I'm in Seattle, on tour. I was just performing in Austin. And Vancouver, where I was playing at a former porn theatre – every Vancouverite told me with glee, 'This used to be a porn theatre!' And where are you? What are you up to?

OL I'm sitting in my study, which is at the top of my house in Cambridge, trying desperately to steal the next couple of moments before *Crudo* comes out to write *Everybody*, the nonfiction book I need to finish by the end of the year. The chapter I'm doing at the moment is about violence and sex and Francis Bacon and the Holocaust. *(laughter)* I don't know why I write these cheerless, miserable books. I'm about to go to Berlin to do some research. Are you possibly staying at your friend Chavisa's?

JK Yes. *(laughter)* And we've put a blanket over her bird. To keep him quiet.

OL You know, rereading *Dragon at the Edge of a Flat World* last night, there's something I'm very bothered about and must mention. Although you don't say it in 'Cat Lady', the story about your mother having lots of cats, you mention in another that you're actually allergic, which retroactively makes things a bit disturbing.

JK *(laughter)* Yes. And I don't unpack it. Everybody asks about that, and some express fury at my mother—

OL I didn't feel fury. I felt amusement.

JK Amusement – that's good. Growing up I was interpreted as a sickly child who was allergic to a whole host of poisons – dust and ragweed and animal dander – but I also loved cats and even brought a kitten into the house. So I participated.

OL The stories in this collection don't run in chronological order; they open out. Something that happens later illuminates something that happened before, like with your allergy. Right at the beginning you describe yourself as an 'obscurity impersonator'. I thought that was such a great phrase.

JK As a child I was obsessed with many singers but also Mel Blanc, the voice of all the Looney Tunes. He was Bugs Bunny, Daffy Duck, Tweety, all these characters, and I was fascinated with his vocal shape-shifting. I wanted to learn about voice-over artists, and I was always imitating cartoon characters. Then when I was a teenager I decided to totally unhook from popular culture and stop watching television any more. So that gave way to me impersonating people in my life directly – often

people with great dramatic flair, who were unknown to the world at large. That's why I say I'm the opposite of a celebrity impersonator. I'm an obscurity impersonator.

OL The thing I like about it is the compulsion to repeat but also magnify and make operatic these odd little moments that you might otherwise ignore, populated by people you see out of the corner of your eye. You manage to draw out of these situations something that's quite shattering and moving but funny and preposterous at the same time. And it comes by way of a magnification and distortion that you're very gifted at doing.

JK In terms of describing these individuals or actually performing them?

OL Well I suppose it works both ways because they're pieces that are written and also performed, but I'm thinking particularly about the latter.

JK A lot of the people whom I am attracted to talking about are people who are sort of these performers without stages.

OL Yes, exactly. There are several stories in *Dragon* about the voice coaches you've had over the years: these eccentric, gifted women who never quite found stardom in their own right, and who work to draw it out in others, but who are at the same time weirdly fascinating and commanding.

JK Yeah, and they use the realm of their studio as a kind of stage. Or other people – there's a lengthy portrait of Gerry Visco, who is a departmental secretary at a university and the oldest club kid on the block. She makes a spectacle of herself

day to day at every moment, in her outfits and behaviour. Although I'm a performer by trade, I'm not a big personality socially. I'm more often a restrained observer, especially in the presence of these people I surround myself with, whom I couldn't possibly compete with in terms of largeness. By writing about them I'm creating, in my mind, some sort of stage for them.

OL Is it that you're powerfully drawn to them, or are they also powerfully drawn to you? I see it when we're hanging out in the street – you will enter into long exchanges with strangers, whereas I'll be like, Oh God, I don't want to talk to them at all. I'm interested in how that opens you up to these incredible confessions or performances that you get from these people.

JK Well, I would like to have, in many ways, more boundaries than I do. But historically, I've had very few.

OL Do you have bad boundaries? Are bad boundaries good in art?

JK There's one point in the book where I'm asking myself these questions. It's in 'Exhibition', where I talk about stumbling into an awkward and unwanted sexual situation, due to a miscommunication. The scene takes place at the high-rise apartment of a diplomat, in a bedroom with glass walls, with the lights and sky of Manhattan all around. For a moment I envision my boundaries as being like those glass walls. In the same moment I ask myself if I'm a sort of predator, allowing these stories to unfold, allowing people to perform around me so I can depict them later.

OL But these portraits you make always feel incredibly affectionate, even moving. It's not like you're mocking them.

JK No – there might be a little pinch of vampirism, but I have to love anyone who I talk about. I want to love them. I would never write about Donald Trump because I don't love him.

OL I feel like you probably would if you hung out with him for a while. You'd start seeing something.

JK I'm a little bit afraid of that, yeah.

OL Let's talk more about boundaries in art because you do a lot of crossing over or not seeing borders that others strictly enforce – for example, those of different genres.

JK That's true – how did the lack of personal boundaries translate to my lack of artistic boundaries? *(laughter)*

OL There's a looseness, a fluidity about lines in your work.

JK To me, it comes back to running up against categorical language, and it's not necessarily that I am rebelling against it. Often interviewers ask me, 'You sing, and you write, and you make videos. What language do you use to describe your work?' Or 'What is your essence?'

OL Oh, that's so boring.

JK There's this thought that I'm shifty or uncentred or something. But that makes me feel like a starfish who's being cut up, until I'm just a pile of parts, each trying to generate a new whole.

OL Especially if the essence is this criss-crossing back and forth.

JK Yeah. In your work, you talk about a similar movement.

OL Not wanting to settle into one thing but being excited by how I can move back and forth.

JK That makes sense to me – like when you're on a research mission, you're also retracing the steps of some artist.

OL Some dead artist.

JK *(laughter)* Yes, you're walking the length of the river in which Virginia Woolf drowned, or you're spending time in an old haunt of Tennessee Williams. You make this research visible and it becomes a kind of performance. You include yourself. Their biographies become intertwined with your own autobiography, associations and memories. Your writing is many things at once.

OL To just do one very circumscribed art form – I would find that frustrating.

JK Yes, to me it doesn't seem like you're intentionally rebelling against criticism or biography. It just seems like you're not confined.

OL That's why I find the first person really exciting. It lets you – without sounding hokey about it – report on consciousness, with all of these multiple layers you can shift into. You can have something very personal or intellectual, very abstract, sensual, but it feels like a free place to inhabit, and not necessarily much about the autobiographical self. Do you know what I mean?

JK I think so. Could you say more about that?

OL There's an assumption when you're writing in the first person that you're writing about yourself.

JK That you want to talk about yourself.

OL Yeah, but yourself in quite a superficial, narcissistic way.

JK And in a way that has to do with ego.

OL Yeah, rather than just the self actually experiencing the world, which is so much more interesting and resistant to being put into language, and so the challenge of trying to capture it in language is much more exciting. At the end of your story 'Sounds and Unsounds of the City' there's this amazing little sketch of being in a room in silence. It's got nothing to do with Joseph Keckler per se. But it's an experience a writer can convey with an 'I' that can't be done in any other way. Why do you use the first person? You write basically completely in the first person, right?

JK Mostly. I want to envision myself as some sort of living instrument of observation. And now wait – your new novel, *Crudo*, is in the third person! It's in many ways more revealingly autobiographical than your other works, yet it is your first book of fiction and you refer to yourself as Kathy Acker, at times blurring your life with hers. You're playing a variation on Acker's game of literary appropriation.

OL I'd read Kathy Acker back in the day, but when I reviewed Chris Kraus's *After Kathy Acker*, I was fascinated to find out

about her writing process. She'd go into libraries – this is before she'd written her first book, when she was studying under the poet David Antin in San Diego – and she would take a book about Toulouse-Lautrec, say, or a history of murderers, and she'd plagiarise it, putting it into the first person. So it would say, 'I did this, I did that,' enlivening these chunks of other people's writing, which I really loved. So then I was like, Well, what happens if I just take my life, but put it in the third person as Kathy Acker? So everything in this novel is me and my friends and relationships and what's going on in my thoughts, but it's all put into the Kathy Acker person, which was incredibly liberating and fun. Sometimes my biography gives way to hers and it's all quite slippery. Well, you're one of the friends who are in it. In fact, you're pretty much the first name mentioned. How did that feel? Did you like being depicted?

JK I was happy to be in it. Even though it says that I'm late. *(laughter)*

OL It doesn't! It literally doesn't say that! It says you were having an early phase!

JK Well, it implies that I'm usually late.

OL You were! Historically there was a period when you used to be late. *(laughter)*

JK Did it propel you in a different way to be constantly saying, 'Kathy did this. Kathy did that'?

OL Kathy could do anything. It was very freeing. I usually write very slowly and my work is very research-heavy.

Everything's got to be incredibly accurate, thought through and interrogated, and, to be honest, it's a fairly dismal process sometimes. But this book took seven weeks. It was a blast. It was just a totally different way of writing, with no editing or rewriting at all. And it was also a way of writing about a political situation that was getting out of control faster and faster. I was trying to write about violence in my other book, *Everybody*, in a world where the definitions and possibilities of violence were changing every five seconds. With every tweet from Trump the ground had changed again. And I couldn't keep up. I couldn't find a stable point to have perspective from. Turning to fiction allowed me to speed up. It allowed me to find a way of tracking what was happening without feeling like I needed to have an authority of tone. It was very freeing.

JK I had that sense from the rhythm of the writing. Your other books are very lyrical – this is virtuosic, but very staccato.

OL I was doing the proofs this evening and suddenly was like, I haven't put any commas in. Should I put more commas in? But you know Gertrude Stein's got this great line about commas being autocratic. People should breathe when they want.

JK I felt like the comma had been dismissed.

OL It has, it's been sacked. I fired it. Trump fired Comey and I fired the comma.

JK *(laughter)* Yes!

OL How much of what you write is stuff that's actually happened?

JK A lot. But then sometimes a bunch of stuff that's happened suggests another ending. I see a certain direction events could go, and I may follow that track. I might take an entire relationship with a certain person and events that happened over the course of years and reposition them all to occur within twenty-four hours.

OL Or turn it into an aria that's very structured and sculpted. I'm thinking of the GPS song, about driving to the airport.

JK Well, the GPS story is true, and I wouldn't have written about the relationship at all if that ten-minute episode hadn't occurred. My partner of five years was driving me to the airport, so I could fly back home across the country after our relationship had unravelled, and the GPS was on, but had strangely been set to a different location in the opposite direction and my partner refused to shut it off. So the GPS kept telling us to turn, on every single street we passed. It was the most heart-breaking moment of my life, yet it was also so ridiculous to have this disrupting automaton, breaking our silence to misdirect us at every moment. And I thought, What a strange moment of life this is. So I wrote an operatic aria in a broken, nonsense language, which I perform with English supertitles.

OL There's an ongoing fascination in this book with incidents of language breaking down – not just the GPS voice, but people speaking in baby voices, or people deforming speech or repeating things until they lose sense. You're incredibly articulate and at the same time besotted with moments where language breaks down.

JK Yes, because somehow language is very burdensome for me.

OL Do you mistrust language? Are you punishing language?

JK Well, I love language, but I'm often tracing miscommunications, the failure of language – and yes, baby talk! In the GPS song I ask if baby talk is the ultimate language of love or the atrophied language of love. I call the nonsense vocabulary a 'shadow language' and it's derived partly from baby talk. The other layer to that is that my partner had translated my earlier autobiographical operatic arias into other languages, so I was also without a translator and left to invent an imaginary foreign tongue to sing in.

OL Oh wow. In 'Cat Lady', there was a line I wrote down: 'She cuddled, morbidly, with language itself.' Which I thought was such a pleasing idea, that you might love language and be very proficient with it, but at the same time you might just want to push it over the edge into nonsense. The singer inevitably deals with nonsense as well because you're taking a phrase and distorting it in all kinds of ways. It's quite interesting to me, the idea of the singer as writer, someone who manipulates language in a way that a writer might not necessarily be able to do.

JK As a singer, when you're doing exercises, you're emptying a phrase of its literal meaning and imbuing it with a whole variety of meanings. And you do start to feel like someone who's alone in the asylum, just singing the same word or sentence over and over again. Voice is often discussed as a 'remainder' – something beyond the meaning of the words.

OL The emotional charge that the voice carries? Or the singer's personal history? What do you mean? I haven't heard that before.

JK I hate to go dragging him into this, but I believe it's a Lacanian thing – the voice is what's left over in the 'signifying operation'. I like picturing the voice as sort of a second body, which feels present but can't be seen. Anyway, the spoken word, the sung word, has another dimension.

OL I think there's a much more fearful dimension to the spoken word than the written. I talk about this in *The Lonely City*: there's a possibility of being unintelligible or not being heard properly. You feel the threat of the voice being lost or not reaching the ear. The gap between the voice and the ear feels much more potent and dangerous than the gap between the written word and somebody's eye. This is the threat that's always there in language, that at some point it might degrade to such a point that you can't make yourself understood any more.

JK Right. And there's more urgency in the uttered word.

OL Yeah. It comes up in the story 'Voice Lesson' about your voice teacher Grace, where you're singing phrase after phrase and they're all about this kind of horror – 'I have fleas. The dog has fleas. The cat has fleas.' This nightmarish speech, which I just love.

JK That came from a real voice teacher. The exercise begins, 'That cat has fleas.' It's a phrase that is designed simply for its sounds, the way the vowels and the consonants are and finding

the right space in the voice and so on. But then it progresses into 'The dog has fleas.' And then, 'I too have fleas. Do you have fleas? We all have fleas.' And it's chromatically ascending, a slow-growing horror of infestation.

OL Ew! I was going to ask you about the Goth sensibility – the book is full of demons, funerals and ghosts, even the disinterred corpse of a cat, and there's this playfulness about it, but I was really struck by how much actual violence there is around the edges. Several of the women are beaten up by their partners. A gay bar burns down. There are multiple kinds of darkness at work.

JK I'm often thinking about how a traumatic event shapes or reshapes a person. Regarding actual ghosts: I always say that I'm a sceptic on the streets and a spirit medium in the sheets.

OL Do you? *(laughter)*

JK I do say that.

OL 'I say that every day at the grocery store.'

JK I've always had a compulsive attraction to images of the occult. At the same time I find witchy culture rather silly, cheesy. I have a certain allergy to that world, but at the same time, I have a complete attraction to it. I didn't learn until I was about twelve that I was born on All Souls' Day, Day of the Dead, but as long as I can remember I was drawing skulls and skeletons and hooded figures with glowing eyes. This is what has always made me happy. This pantheon of spooks I find festive. So I'm kind of mocking the Gothic . . . but I think

irony can be a part of the Gothic. One of my early heroes is Screamin' Jay Hawkins. He typifies this to me: he's creating a theatre of the ridiculous and he's almost a novelty act, with his skull on a staff, getting out of a coffin, but at the same time his voice is so commanding and so powerful; there's an inherent seriousness in his sound and a kind of divinity. That's where I want to live – that point which can tip into the ridiculous or into something that's divine or commanding.

OL I feel like at heart we both do have a belief in the radical possibilities of art, in the power of seeing something that re-arranges you psychically. We want duende, right? We want absurdity or irony, but we also want, as James Baldwin put it, the peace to be disturbed.

JK Right.

OL I think one of the dangers in talking about art is that it can rapidly become sentimental or cosy. You said this great thing once about how a star should be like an alien crashing down, and it made me think, actually the work that's most affected me isn't reassuring. It's truly unsettling.

JK Art is like another reality that makes our reality feel more alive. I also think the best art has a space for the spectator. A lot of entertainment is sealed off.

OL The audience is excluded?

JK I'm excluded. It can only produce in me a kind of longing to enter the entertainment, but also a desire to flee my own existence. Whereas art, good art, there seems to be a sort of

emptiness to it. It might totally rearrange the molecules of my existence, but there's an open space there too. It doesn't over-determine what my experience will be.

OL Okay, let's end with a big question. What do you think the role of the artist is right now, in the current political moment? I know you wrote a great thing about this recently for *Somesuch Stories*, which I'm going to quote.

> Our task as artists – should we wish to be practical – is to create a culture that would never again dream of electing a raging xenophobe who absent-mindedly lapses into info-mercials advertising his line of steaks during political rallies, and speaks predominantly in non-sentences. Beyond that, we choose the course: some of us will observe and depict what is going on in a direct manner. Others will offer comic relief. Some of us will grope around in the dark in attempts to envision new ways of being. Now is as much a time for radical sensibilities and wild aesthetic manoeuvers as it is for bold political strategies.

Now I love that, but I was also surprised that you were talking about tasks or duties, because in some ways I don't think the artist has one.

JK Me too. I think the artist has a duty to be free. But I was led to that conclusion because I think a lot of the current polit-ical problems are cultural problems.

OL Yes! Part of why I think it's absurd to say that art can't change anything is that I don't think there's a political realm

that's truly separate from the cultural realm or the emotional realm or the emotional realm or the social realm. Which is what I was trying to get at with *Crudo*, the immense entanglement of everything.

JK And because of that entanglement it's tempting to place a burden on the artist.

OL As the person who sees clearly? As the person who offers alternatives?

JK As the person who is responding to and critiquing but also creating reality. It's an elusive task and I think the best art is probably always going to be – I'm trying not to use a bureaucratic phrase. 'Challenging the assumptions about what that means!' *(laughter)* The best work is always going to seem both deeply unfamiliar and familiar at the same time. It's always going to be operating outside of whatever job description you assign it.

Acknowledgements

The majority of these essays first appeared, often in different forms, in the *Guardian*, *frieze* and *New Statesman*, as well as the *Observer*, *Elle* and the *New York Times*.

'Close to the Knives' was first published as the introduction to *Close to the Knives* by David Wojnarowicz (Canongate, 2017).

'Sparks through stubble' was first published as the introduction to *Modern Nature* by Derek Jarman (Vintage, 2018).

'Chantal Joffe' was first published in *Chantal Joffe: Personal Feeling is the Main Thing* (Victoria Miro, 2018).

'The Abandoned Person's Tale' was commissioned by Refugee Tales and first published in *Refugee Tales II* (Comma Press, 2017).

'Party Going' was first published in *Goodbye Europe* (Weidenfeld, 2017).

'Vanished into Music: Arthur Russell' was commissioned as a documentary by Radio 3.

THANK YOU

Rebecca and PJ, superstars always. Everyone at Janklow, particularly the magnificent Kirsty Gordon.

Everyone at Picador, especially dream team Paul Baggaley, Kish Widyaratna and Paul Martinovic.

Jill Bialosky, Drew Weitman and all at Norton: thank you. Special thanks to Kelly Winton for her wonderful cover design.

Wendy Olsoff and all at P.P.O.W. for letting us use the magical photograph of David Wojnarowicz.

All my editors over the years, and especially those who have given long-term homes to my writing: Jennifer Higgie at *frieze*; Paul Laity, Nick Wroe and Liese Spencer at *Guardian Review*; Tom Gatti at the *New Statesman*; Jenny Lord.

Several of these essays are about shows at the Tate: my thanks to Frances Morris, Andrew Wilson and Catherine Wood for answering questions. Thanks too to Martin Williams, my producer on 'Vanished into Music', and to the Jarman estate, especially Tony Peake and James Mackay, for their kindness. Special thanks to Anna Pincus, David Herd, and all at Refugee

Tales and the Gatwick Detainees Welfare Group, for inviting me to contribute and for the brilliant, necessary work they do.

My friends, who have introduced me to material, read early work, collaborated on projects, talked endlessly, and sometimes served generously as subjects too: David Adjmi, Matt Connors, Jon Day, David Dernie, Jean Hannah Edelstein, Tony Gammidge, Philip Hoare, Chantal and Esme Joffe, La JohnJoseph, Lauren Kassell, Joseph Keckler, Mary Manning, Leo Mellor, Jack Partlett, Charlie Porter, Rich Porter, Francesca Segal, Ali Smith, Lili Stevens, Claire Williams, Carl Williamson, Matt Wolf, Sarah Wood, thank you.

My sister, Kitty Laing, who introduced me to Derek Jarman aged eleven. My father, Peter Laing, who taught us to look at art.

Denise Laing, hero

Ian Patterson, love

Index

INDEX